FINGERPRINT N°/2

FINGERPRINT

THE EVOLUTION OF HANDMADE ELEMENTS IN GRAPHIC DESIGN

No

2

With introduction by
JOSHUA C. CHEN

foreword by
DEBBIE MILLMAN

commentary by
COLIN BERRY

and visual essays from
STEFAN BUCHER
SHANAN GALLIGAN
CHRISTIAN HELMS
ROBYNNE RAYE

BY CHEN DESIGN ASSOCIATES

HOW

BOOKS

Cincinnati, Ohio
www.howdesign.com

For more excellent books and resources for designers, visit www.howdesign.com.

15 14 13 12 11 5 4 3 2 1

Library of Congress Cataloging-in-Publication Data

Chen Design Associates.
 Fingerprint No. 2 / Chen Design Associates. -- First edition.
 pages cm.
 ISBN 978-1-60061-865-9 (hardcover : alk. paper)
 1. Chen Design Associates. 2. Commercial art--United States--History--21st century. 3. Graphic arts--United States--History--21st century. 4. Handicraft--United States--History--21st century. I. Title.
 NC999.4.C44A4 2011
 741.60973'09051--dc22

 2010045534

Distributed in Canada by **Fraser Direct**
100 Armstrong Avenue
Georgetown, Ontario, Canada L7G 5S4
Tel: (905) 877-4411

Distributed in the U.K and Europe by **F+W Media International**
Brunel House, Newton Abbot, Devon, TQ12 4PU, England
Tel: (+44) 1626-323200, Fax: (+44) 1626-323319
E-mail: postmaster@davidandcharles.co.uk

Distributed in Australia by **Capricorn Link**
P.O. Box 704, Windsor, NSW 2756 Australia
Tel: (02) 4577-3555

DESIGN
Chen Design Associates
San Francisco
www.chendesign.com

CREATIVE DIRECTOR
Joshua C. Chen

INTRODUCTION BY
Joshua C. Chen

FOREWORD BY
Debbie Millman

COMMENTARY BY
Colin Berry

VISUAL ESSAYS BY
Stefan Bucher, Christian Helms, Shanan Galligan, Robynne Raye

CURATORS
Joshua C. Chen, Laurie Carrigan, Max Spector, Kathrin Blatter

LEAD DESIGNER
Kathrin Blatter

DESIGNERS
Kathrin Blatter, Laurie Carrigan, Joshua C. Chen

ILLUSTRATORS
Kathrin Blatter, Debbie Ladas

PHOTOGRAPHERS
Erik Gomez plus various

PRODUCTION INTERNS
Kyle Macy, Clement Van Vyke, Debbie Ladas

PROJECT ADMINISTRATOR
Louise Rice

FOR HOW BOOKS

MANAGING EDITOR
Amy Schell Owen

ART DIRECTOR
Grace Ring

PRODUCTION COORDINATOR
Greg Nock

Special thanks to: Judith Berliner of Full Circle Press, Tom Wright, Kathy Kemps and Christopher Lambert of Neenah Paper for your help in promoting this book. Additional thanks go out to all the designers who so eagerly provided examples of their work to add to the collective handmade tapestry, and patiently waited for this book to become reality. To the incredibly talented Stefan Bucher, Christian Helms, Shanan Galligan and Robynne Raye for the visual feasts you created especially for this book—your passion is unmistakable. To my good friend Debbie Millman, for your generosity and kindness. I am overwhelmed. To Colin Berry, your eloquence in words is a beautiful thing. To Amy Schell Owen and Grace Ring, your patience with us is astounding. To the entire CDA family, for your loyalty and tenacity through thick and thin. To Pam, Rachel and Ethan, for daily love and grace.

Chen Design Associates is a place for collaboration, education and dynamic invention. The award-winning design studio partners with a wide range of clients, from start-up ventures to established corporations, local to global, artistic to analytic. www.chendesign.com

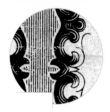

deferred

TABLE OF

03 PENCIL, PEN & BRUSH

p 065

p 096 **NOTHING EVER LOOKS LIKE IT DOES IN MY HEAD**

—
Stefan Bucher
344 Design

04 INK & PRESS

p 105

CONTENTS

05 SILKSCREEN & HAND WORK

p 135

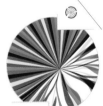

p 162 **BE-YOU-TY**

—
Christian Helms
Helms Workshop

06 WOOD, IRON, FOOD & FABRIC

p 171

07 CDA GALLERY

p 203

p 214 **DIRECTORY**

PERFECT

IMPERFEC

FEC

PERFECT

SO MUCH HAS HAPPENED since we last spoke...

In the first edition of *Fingerprint*, we celebrated the all-too-rare presence of the human hand in visual communication. It was 2006, and the design industry, by our judgment, was overrun with slick, emotionless layouts, many of which were the result of the profession's unabashed embrace of computer technology. Handmade, we suggested, could provide a breath of fresh air.

With that in mind, *Fingerprint* included a number of projects created solely by hand: silkscreened, typeset, hand-stitched, or otherwise made without the aid of digital tools. For many designers, handmade was a reaction — a response — to the computer, and many believed creating boutique projects using older, slower, or hand-manipulated media was a way to positively direct design back to its roots.

They were right. These and other such small, impassioned projects — created "under the radar" of what was happening five years ago — began to carve a channel of their own. Before long, everywhere you looked, from typography and illustration to book-making, film titles and beyond, the evidence of the handmade in design was appearing. What were once ideas on the fringe were beginning to thrive in the mainstream.

Fingerprint No. 2 reflects the evolution of those ideas. In this second volume, you'll still find plenty of boutique projects, as well as those created entirely without the aid of computer technology. But you'll also discover how designers are beginning to incorporate the two aesthetics — handmade and digital — in order to best communicate their message. A third, hybrid aesthetic is emerging, one that marries the technologies of the past and future into a vibrant, exciting present.

As social media and the Internet become ever-more entwined into our lives and livelihoods; as design studios struggling under global recession heed the call for sustainability and eco-awareness; as truth — in the media, in science and politics and advertising — becomes more and more valuable; the need to prove that a real human being, one with integrity and a clear conscience, stands behind a particular design has become more and more essential.

Our wish with *F2* is to show that, far from any particular style, handmade is a vital element living within excellent design. Listen for the pulse, which cannot be faked, forged, or falsified. Look for the fingerprint. It is the key to design's success.

Hope you like this book.

Josh Chen
Chen Design Associates

THE RIGOR

In spite of the huge progressions made by mechanical and digital technologies on graphics and printing throughout the twentieth century, the handmade graphic just refuses to go away quietly and bow to the authoritative precision of works mediated through metal type or digital bitmaps. The answers may lie in that assumed authoritative precision which edits out all the imperfections, the unfiltered emotions, the unpredictabilities and the vagaries of the human touch.

—Grant Carruthers, *Eye* magazine, 2005

BY **DEBBIE MILLMAN**

Little did he know it, but five years ago, when Josh Chen asked me to write an essay for his forthcoming book, *Fingerprint: The Art of Using Handmade Elements in Graphic Design,* he changed my life. Ostensibly, Josh asked me to pen the essay because I often write about design. What he couldn't have known was this: A very long time ago I considered myself a painter, but I had all but abandoned the practice when my career as a brand consultant took off. And I was missing it.

Badly.

OF SINCERITY

I

was

raised

in a household ruled by the handmade. My mother supported the family with a business called The Artistic Tailor, and she was just that: a professional seamstress and painter. The walls of our house were peppered with her realistic portraits of the characters in Dorothea Lange photographs, long deceased relatives, and heroes of the Bible; my closet was chock-full of her imaginatively goofy, handmade apparel. But I gave up hopes for a painting career when I couldn't pay the rent on my New York City tenement apartment one month after college graduation. Instead, I got a job as a graphic designer and consoled myself with the notion that I could still paint at night. For several years I did just that, and had a few shows of playful, thickly rendered word paintings. But when I was promoted to vice president at my day job, my artistic aspirations took a back seat to this suddenly burgeoning, better-paying career.

Until Josh's invitation. By then, I had moved on to become president of a brand design consultancy. Though I was a still a big fan of anything handmade, the closest I came to being involved with it was as a juror for the many design competitions I judged as part of my duties as a board member of AIGA, the professional association for design. There, the art of the handmade was *au courant*. And oh, how I loved to witness what other designers were doing! As my day job took me further and further into the world of high technology and manufacturing, here was work going in exactly the opposite direction. In contrast to the ultra-slick, glossy package design I helped construct for marketers of carbonated beverages, over-the-counter drugs and fast food restaurants, here was a world of unfettered, imperfect, sometimes amateurish-looking work that was always, always resolutely made by an individual hand, ***rather than by mass production.***

As I examined the successful pieces, what surprised me was the common denominator:

Here was evidence of the rigor of sincerity. Each piece contained a deeply felt, profound awareness—a consciousness of sorts—that captured what it meant to be alive.

While the style might be rough or rustic, crude or cloddish, the work elegantly and accurately combined language and hand-made imagery to convey the essence of the human experience.

I think this is the ultimate goal of design, and it is best expressed from the heart. When Josh invited me to write an essay for *Fingerprint,* of course I said yes. But in keeping with the theme of his book's contents, I asked if I could write and design it by hand. **Happily,**

he

said yes.

Nearly twenty years after I put it down, I picked up my paintbrush. After *Fingerprint* was published, I tentatively asked HOW Books if I could create an entire tome of hand-painted, hand-lettered essays. Happily, they said yes. Suddenly, I was painting once again. I think the author James Joyce describes this type of journey best in his classic novel, *Ulysses*: "The longest way round is the shortest way home."

I find it enormously satisfying that he wrote his entire masterpiece by hand.

Debbie Millman is president of the design division at Sterling Brands, New York, host of the radio show "Design Matters," chair of the new Masters in Branding Program at the School of Visual Arts, and president of the AIGA, the professional association for design.

EMBRACING

BY **COLIN BERRY**

Colin Berry is a writer, instructor, and design critic. He is a contributing editor
for *Print* magazine and the author, with Isabel Samaras, of *On Tender Hooks*,
published by Chronicle Books. He recently moved to Los Angeles.

I write at home, and every afternoon around 2:00, I get up from my desk, stretch my shoulders, carry my teacup into the kitchen, and step outside to the mailbox. Ninety-five percent of the time, what I find inside is uninteresting: bills and junk mail, plus my wife's trade mags and more stuff to recycle. A New Yorker once a week. Yet now and then, among the detritus, I find a surprise: an envelope with my address hand-written on it; a personal note; a postcard from my sister; a birth or wedding announcement; an invitation to a friend's party. It's rare, but now and then it happens. Among all the junk, do I have to tell you which I open first?

This personal act of outreach, requiring the sender to pick up a pen or, if I'm luckier, to create an entire, original, handmade piece of art or design, seems almost extinct. If you're like me, most of your "personalized" correspondence arrives these days via e-mail, or on Facebook, where the most personal act the sender can undertake is to upload a whimsical photo of him- or herself—in Chicago, say, grinning from underneath Anish Kapoor's giant silver jelly bean. Increasingly, personalized means technologized. Reduced to digital data. It's the same rationale behind the popularity of the iPod: 10,000 songs in your pocket, with playlists and preferences customized to fit your personal taste.

CONTINUED ON NEXT PAGE

INGREDIENT X

CONTINUED ON P. 40

EMBRACING INGREDIENT X

Here's another observation: we are becoming a culture of narcissists. A 2007 Pew Research Center report entitled "Portrait of Generation Next" identified the era's 18-to-25-year-olds as the "look at me" generation, a term remixed from the "me generation" of the 1970s with the added capacity for vanity afforded by social media and the Internet. MySpace, Facebook, YouTube—even the names scream selfishness. In 2006, when the first volume of Fingerprint appeared, all these sites were new. Today, Twitter boasts 4 million users; Facebook claims 400 million. Most of the world seems intent on broadcasting its signal out into the world.

The marketing people call this personalization, from the standpoint that you and I, by "friending" people or combing tweets or choosing a playlist or deciding whose RSS feed to add, are in some way better connected to other humans—that "personalizing" my life will make it better. That I'll be happier. Trouble is, it's not personal at all—it's cacophony. It's The Sorcerer's Apprentice. In the past ten years, content consumers have become content producers, each attempting to shout louder than the rest, feeding the culture of celebrity and making everyone deaf while binding more and more tightly to technology. Feeling stalked? It wasn't long ago, before Facebook, that "friends" were folks we wanted to spend time with, not amateur publicists whose every shared thought and pushed opinion made us feel exhausted. Personal didn't used to mean overwhelming. Take a look around. People might feel more personalized, but do they look happier to you?

01

SCISSORS & TAPE

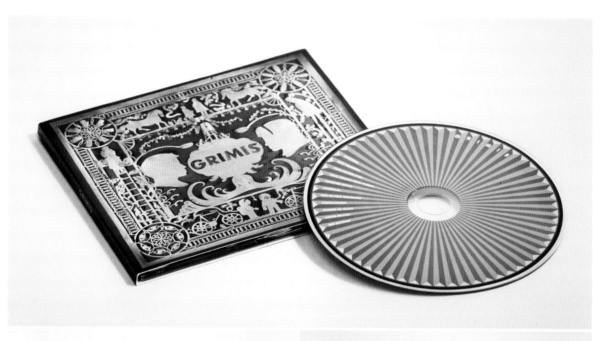

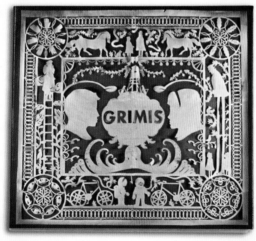

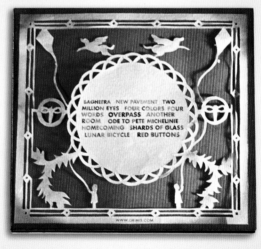

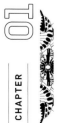

GRIMIS CD PACKAGING

DESIGNER
Christopher Monro Delorenzo

LOCATION
Andover, Massachusetts, USA

ART DIRECTOR
Christopher Monro Delorenzo

CLIENT
Grimis

MATERIALS
Newsprint, corrugated paper,
X-Acto knife

PRINTER
One Stop Media Shop

After many iterations of this album design, nothing
seemed to be working—in other words, nothing looked
true. The music had to show through the packaging but
also exaggerate it, take it higher, which could not be
achieved through digital imagery. Grimis is bittersweet,
nostalgic and optimistic. If music can be designed in
that way, then so can the design that accompanies that
music. Using newsprint and an X-Acto knife, I drew the
design freehand and began carving away. After four
days at the cutting board, I was finished.

DESIGN FIRM/DESIGNER
Daniel Zender

LOCATION
Springfield, Missouri, USA

MATERIALS
Cut paper

CHAPTER

01

CYRK POSTER

Experimental cut paper exercise meant to create illusion of space and atmosphere using three-dimensional illustration. This poster was meant to be an homage to the humorous and lighthearted art of the Polish circus poster.

MY SISTER HAS
A PHD IN PLANT
MOLECULAR
BIOLOGY. MY
BROTHER-IN-LAW
IS A PROFESSOR
OF NEUROBIOLOGY
AT HARVARD.
I AM A GRAPHIC
DESIGNER.

$5.00 BUY ME

CHAPTER 01

MICA GD/MFA ZINE 001
SCIENCE

DESIGN FIRM
Massive Graphic

LOCATION
Baltimore, Maryland, USA

ART DIRECTOR
Mike Perry

DESIGNERS
MICA GD/MFA Class of
2008 and 2009

MATERIALS
Sketches, Letraset, Letratone

Created under the discerning and watchful eye of guest critic Mike Perry, the GD/MFA Studio at MICA engaged in a weekend of no-holds-barred collaboration. The product: an oversized tabloid that explored all things related to the group's collective knowledge of the scientific field. Tracing paper, Letraset and any resource found within the studio walls resulted in an exciting and eclectic portrait of designers coming to terms with their scientific prowess. In other words, no actual facts were used in the creation of this zine.

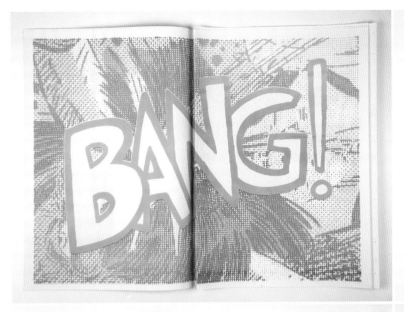

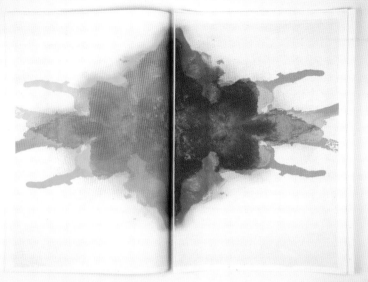

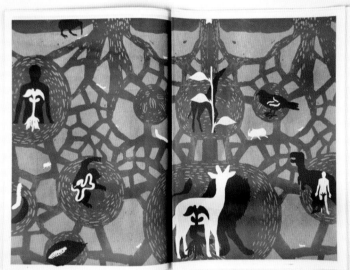

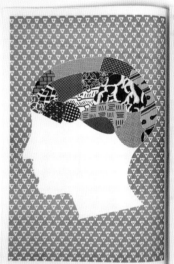

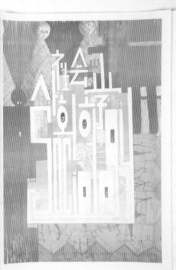

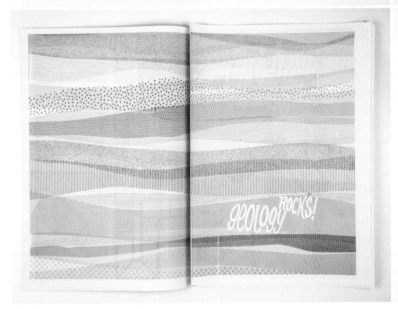

geology ROCKS!

"When a thing is current, it creates currency."

—Marshall McLuhan

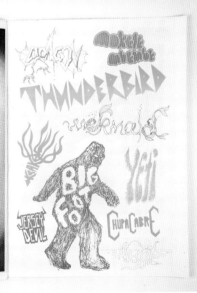

THUNDERBIRD

BIG

YETI

JERSEY DEVIL

CHUPACABRE

DIGGING DEEPER

The handwritten typography reads: "When I was a kid — I didn't have a computer. It wasn't our thing. I sat in my Dad's office on Wall Street & watched the World Trade Towers being built — panel by panel. From a distance, it was like a full-scale game of Tetris. I imagined I was a Director — a kind of pixel foreman, 'no not that one, yet. Yes-now-align the second row'. This is all I needed to trust machines. To fall in love with the things I had the audacity to command."

— Brian Grabell

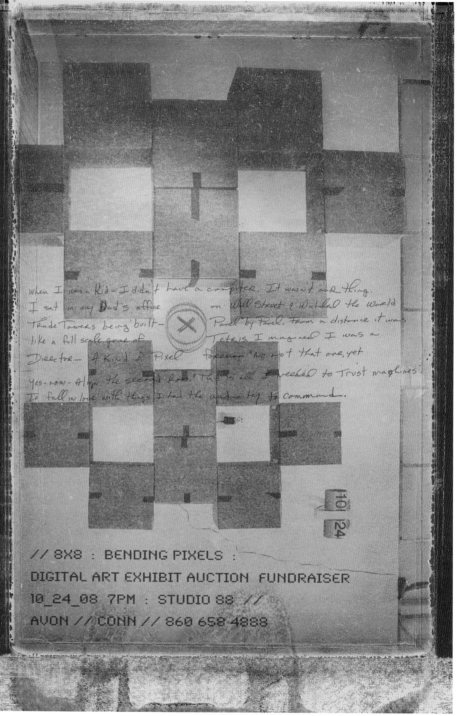

DESIGN FIRM
CO:Lab

LOCATION
Hartford, Connecticut, USA

ART DIRECTOR/DESIGNER
CO:Lab

CLIENT
Greater Hartford Arts Council

MATERIALS
Newsprint, cardboard, tape, ink

PRINTER
CO:Lab

Poster for a digital image auction/exhibit to benefit the Greater Hartford Arts Council. The exhibit was entitled "8x8 : Bending Pixels" and featured eight pieces of art from eight digital artists. The poster image is a manipulated and layered digital photographic representation of the 8x8 concept in sculpture form. The sculpture was created from constructing and adhering cardboard boxes together. The crude digital clock in the background captures the month and day of the event. Every time your hand touches something, it's personal.

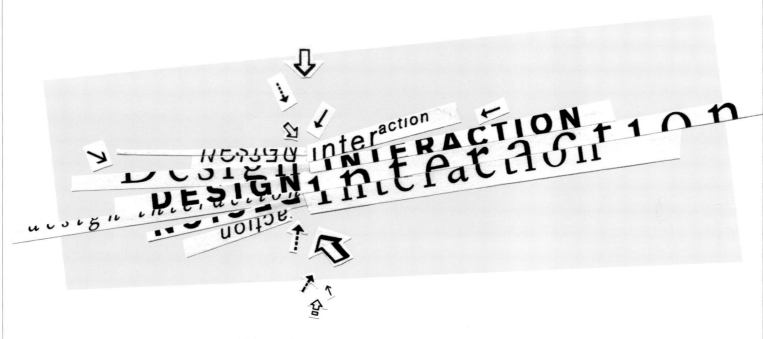

29th annual

D E S I G N **INTER**ACTION
symposium

This year's focus is on the design profession and its impact on *Industrial*, *Environmental* and *Graphic Design*. Speakers will be presenting their professional work and design strategies in **Dudley Hall's Parker Auditorium** with three morning sessions beginning at **8:30 AM** and two afternoon sessions beginning at **1:00 PM**.

An exhibit of Industrial and Graphic Design student work will be on display in the Dudley Gallery October 22–November 5, 2007.

Friday November 2, 2007

 AUBURN
UNIVERSITY
Auburn University is an equal opportunity educational institution/employer.

Department of Industrial Design **Auburn University** College of Architecture, Design and Construction
http://www.auburn.edu/ind/index.html

The entire design process for this poster was completely intuitive. This style of collage (hand-cut and assembled typography) is an extension of some other collage work I had done up to this time. I used it here in order to create an authenticity and dimensional aspect to overall design that I have never been able to achieve digitally. To be honest, I made several attempts at the illustration and had to return to sketching it and working by hand to achieve my idea. By working off the computer I was actually able to see the design come together in a physical way and respond as a designer with a sense of immediacy.

DESIGN FIRM
Kelly Bryant Design

LOCATION
Auburn, Alabama, USA

ART DIRECTOR/DESIGNER
Kelly Bryant

CLIENT
Department of Industrial and Graphic Design at Auburn University

MATERIALS
Collage, Adobe InDesign CS3

PRINTER
Walker Printing

**29TH ANNUAL
DESIGN INTERACTION
SYMPOSIUM POSTER**

CHAPTER 01

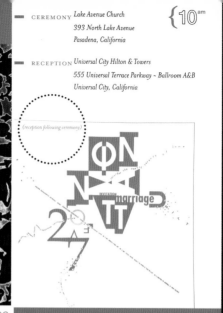

CEREMONY Lake Avenue Church
393 North Lake Avenue
Pasadena, California

{10 am

RECEPTION Universal City Hilton & Towers
555 Universal Terrace Parkway ~ Ballroom A&B
Universal City, California

(reception following ceremony)

CEREMONY + RECEPTION

DESIGN FIRM
HA Design

LOCATION
Glendora, California, USA

ART DIRECTOR/DESIGNER
Handy Atmali

CLIENT
HA Design

MATERIALS
X-Acto knife, fabric, glue,
digital camera, Adobe CS3

PRINTER
WHCC Press Printing

CHAPTER

01

WEDDING INVITATION

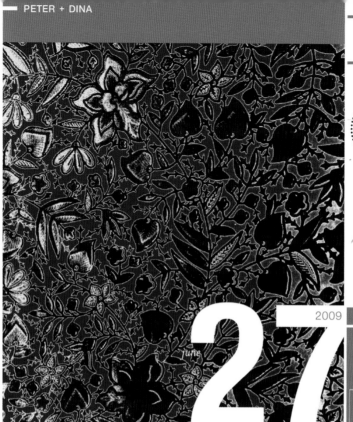

june **27** 2009

{ AT LAST }

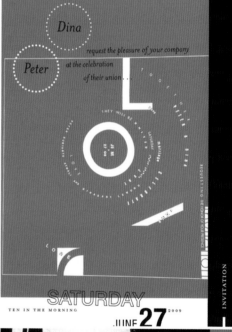

Dina

Peter
request the pleasure of your company
at the celebration
of their union...

INVITATION

SATURDAY
TEN IN THE MORNING JUNE **27** 2009

PETER + DINA CORDIALLY INVITES YOU

The idea of this project was to create something out of the ordinary—getting away from typical wedding invitations. The marriage of old and new became the inspiration for combining hands-on artwork and digital work. Artwork for all cards was cut-and-paste letters and sentences. The artwork was then photocopied and digitally photographed. The digital files were placed in InDesign file layout. The pocket sleeve's artwork is a batik material that has been scanned and color-manipulated to match the invite cards. Parts of the bridesmaids' dresses were made of this batik motif; the married couple is Indonesian and they wanted to incorporate some of the ethnic tradition. The whole package is presented in an organza bag; a few tags were tied to the bag.

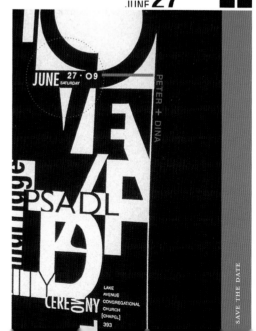

JUNE 27 · 09
SATURDAY

PETER + DINA

PSADL

CEREMONY

LAKE
AVENUE
CONGREGATIONAL
CHURCH
[CHAPEL]
393

SAVE THE DATE

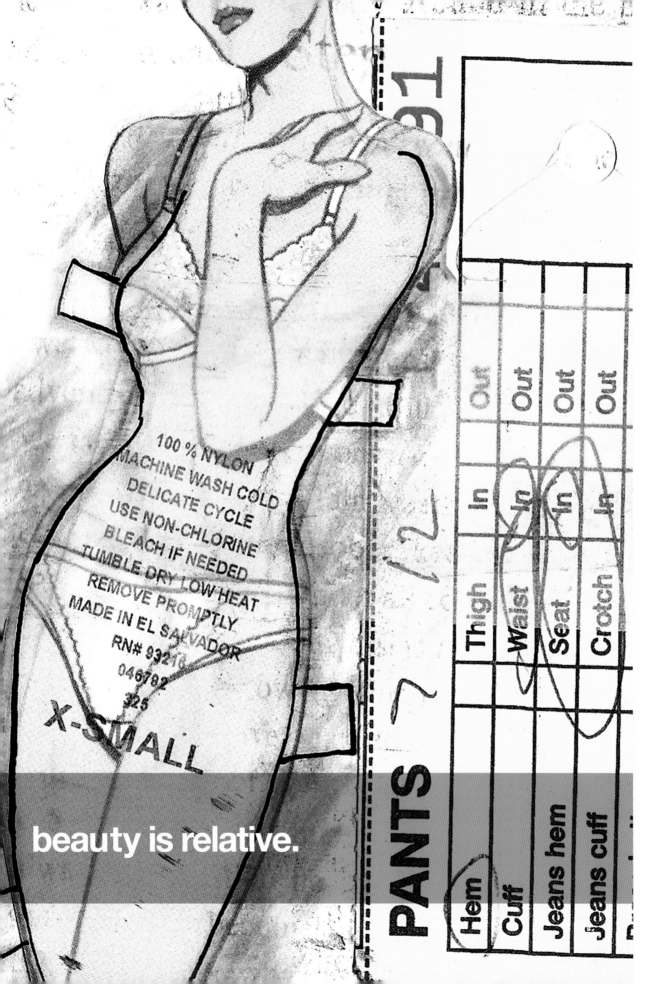

beauty is relative.

DESIGN FIRM
Brigette Indelicato

LOCATION
Philadelphia, Pennsylvania,
USA

DESIGNER
Brigette Indelicato

MATERIALS
Collage, tags, paper doll,
Adobe Illustrator

CHAPTER

01

**RELATIVE BEAUTY
POSTER**

For this poster design for a women's competition, I created a textural collage using book pages, tracing paper, charcoal, dry-cleaning and clothing tags and an antique paper doll, to communicate the pressures of a perfect body image that individuals are faced with today. I used Adobe Illustrator to add a simple tagline and emphasize the message.

DESIGN FIRM
Frank Strategic Marketing

LOCATION
Columbia, Maryland, USA

DESIGNER
Christina Bittinger

PHOTOGRAPHER
Luke Williams

CLIENT
The Production Club
of Baltimore

MATERIALS
30+ X-Acto blades, double-
sided tape, spray mount

CHAPTER

01

**2009 PCB PAPER
SHOW POSTER**

Hosted by the Production Club of Baltimore, the 2008 Baltimore Paper Show celebrated a multi-layered theme, encompassing printing techniques as well as core printing materials. Moiré patterning was the basis of visual appeal during the event, while the city of Baltimore and all of its neighborhoods were recognized throughout the evening's playful scavenger hunt. As a nod to the annual paper show, iconic buildings and landmarks from all throughout the city were neatly crafted from paper into miniature models. Using paper and ink—both donated from members of the PCB—and printed on a press also affiliated with the club, the overall effort was rounded out perfectly.

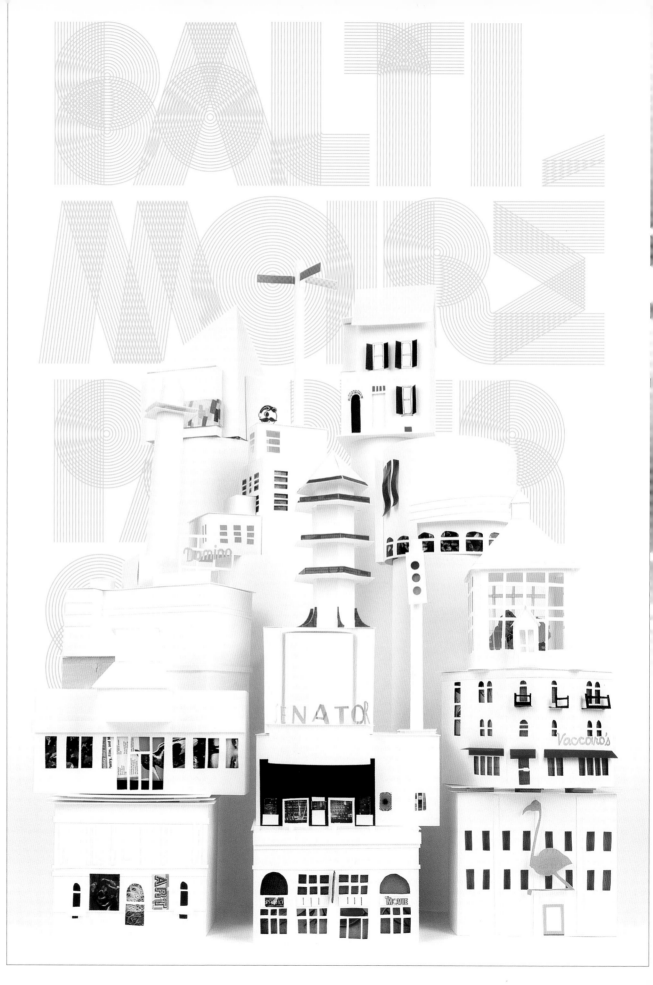

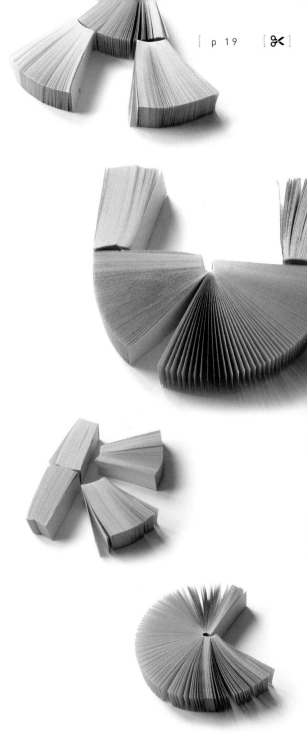

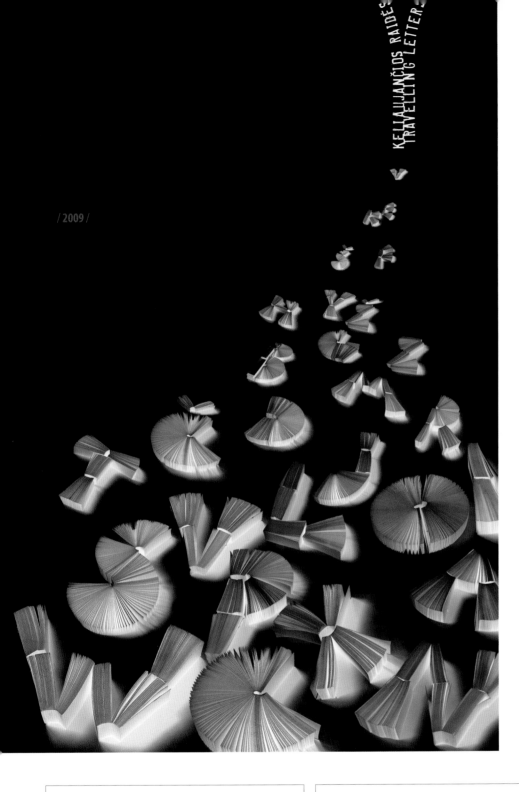

KELIAUJANČIOS RAIDÉS
TRAVELLING LETTERS

/ 2009 /

The experimental lettering project "Traveling Letters" contains a reference to the script as cultural baggage that is inseparable from the journey through time and countries—as well as people encountered on the way generously sharing their creative ideas. Separate handmade letters were created from 1 m x 2 m (3.3 ft by 6.5 ft) pieces of paper; a very simple and clear idea helped to create 3-D images in real space. After the letters were bound (by sewing and with glue), we shot digital pictures in natural light with natural shadow. These letters were used for designing the poster for the "Traveling Letters" project.

DESIGN FIRM
Vilnius Academy of Arts, Design Department

LOCATION
Vilnius, Lithuania

ART DIRECTOR/DESIGNER
Ausra Lisauskiene

CLIENT
Vilnius Academy of Arts

MATERIALS
KASKAD uncoated 90g paper

TRAVELING LETTERS, EXPERIMENTAL LETTERING PROJECT

CHAPTER

01

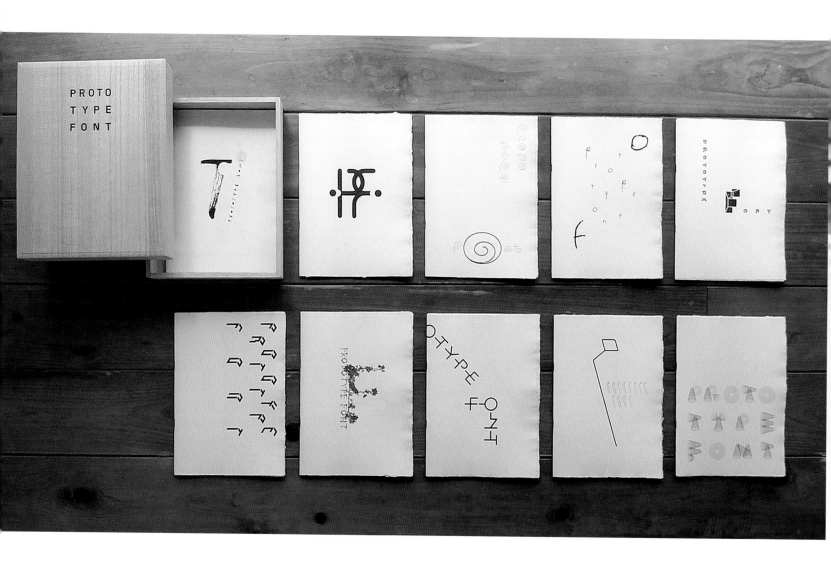

DESIGN FIRM
Taste Inc.

LOCATION
Osaka, Japan

**ART DIRECTOR/
DESIGNER**
Toshiyasu Nanbu

CLIENT
Taste Inc.

MATERIALS
Cotton paper, paulownia
wood case

CHAPTER 01

**PROTO TYPE FONT
(CONCEPT BOOK)**

Limited-edition self-promotional art books featuring original hand-done type design. Handmade cotton paper adds to the overall feel of the collector's set, a total of ten books housed in a wooden kiri box.

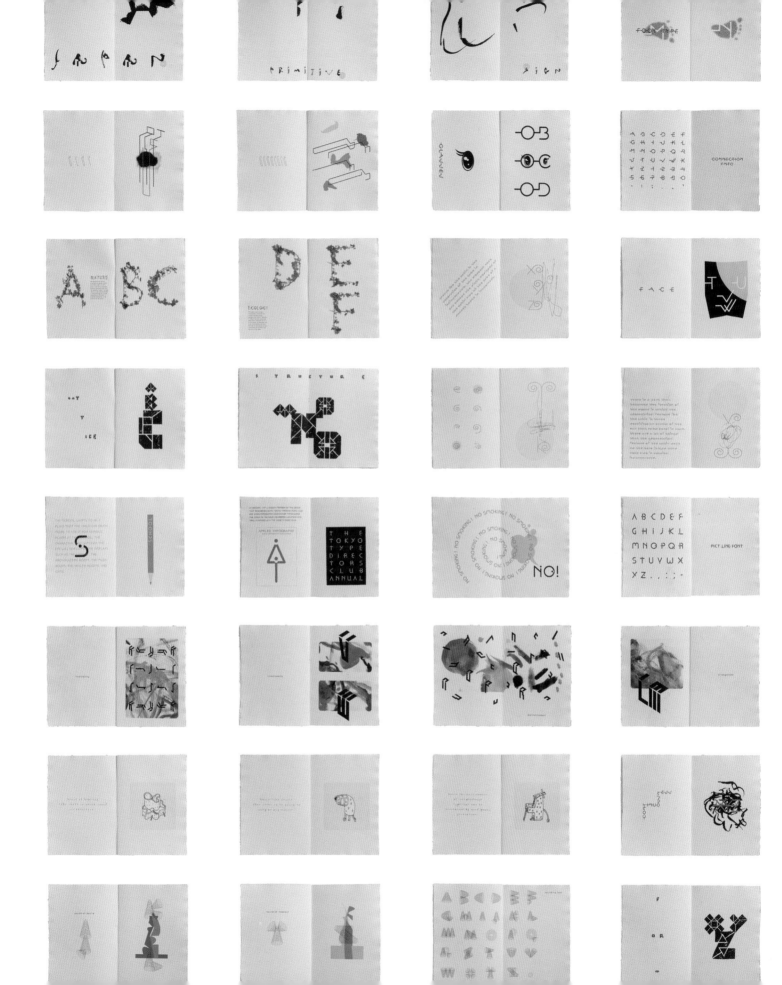

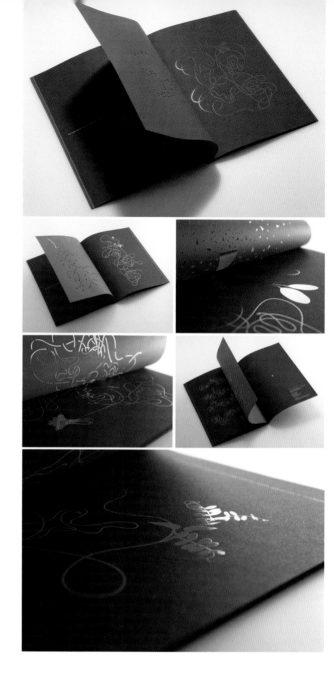

MESSAGE FROM THE EARTH

DESIGN FIRM
Taste Inc.

LOCATION
Osaka, Japan

ART DIRECTOR/ DESIGNER
Toshiyasu Nanbu

CLIENT
Taste Inc.

MATERIALS
Cotton paper, silkscreen, inkjet and laser print

This type specimen book features original type design based on a global environmental theme, silkscreened and bound by hand.

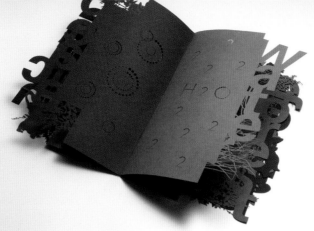

DESIGN FIRM
Taste Inc.

LOCATION
Osaka, Japan

**ART DIRECTOR/
DESIGNER**
Toshiyasu Nanbu

CLIENT
Taste Inc.

MATERIALS
Cotton paper, laser cut

CHAPTER

01

FOREST OF
TYPOGRAPHIC
DESIGN:
ECO MESSAGE

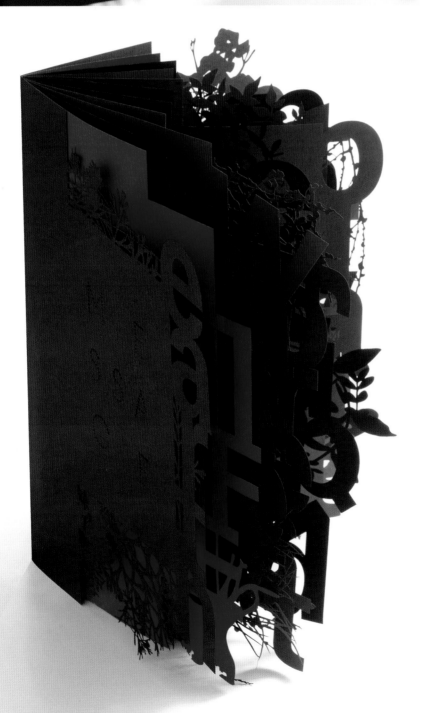

By combining pictures of plants and original type design, we created another take on the environmental theme, with each spread featuring a precious natural resource. Each page is laser cut, and then assembled and bound by hand.

DESIGN FIRM
Brezinka Design Co.

LOCATION
Old Hickory, Tennessee, USA

ART DIRECTORS
Craig Allen, Wayne Brezinka

DESIGNER
Wayne Brezinka

CLIENT
Universal Music

MATERIALS
Collage, mixed media, pen, ink

CHAPTER

01

WILLIE NELSON LP
AND CD DESIGN

I received a call from Universal Records inquiring about an illustration commission for an upcoming Willie Nelson project on Lost Highway Records. I was asked to create a pen and ink image depicting the front and back of Willie's tour bus. I began to explore by using three different mediums: playing with pen and ink, watercolor and collage. I felt the collage image was by far the strongest and represented the overall feel of the project the best, as Willie's music is very organic and natural, not forced or overproduced. I presented all three options and they agreed that the collage image was the way to go.

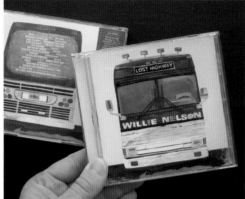

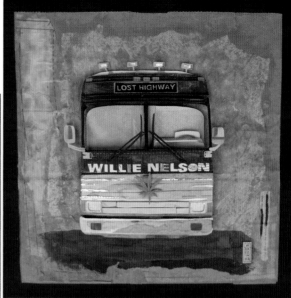

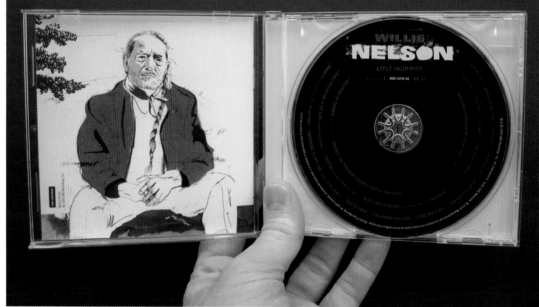

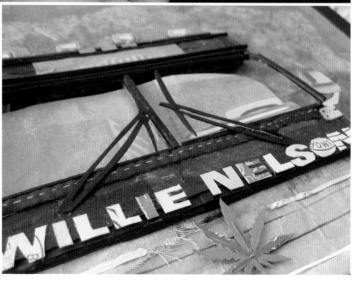

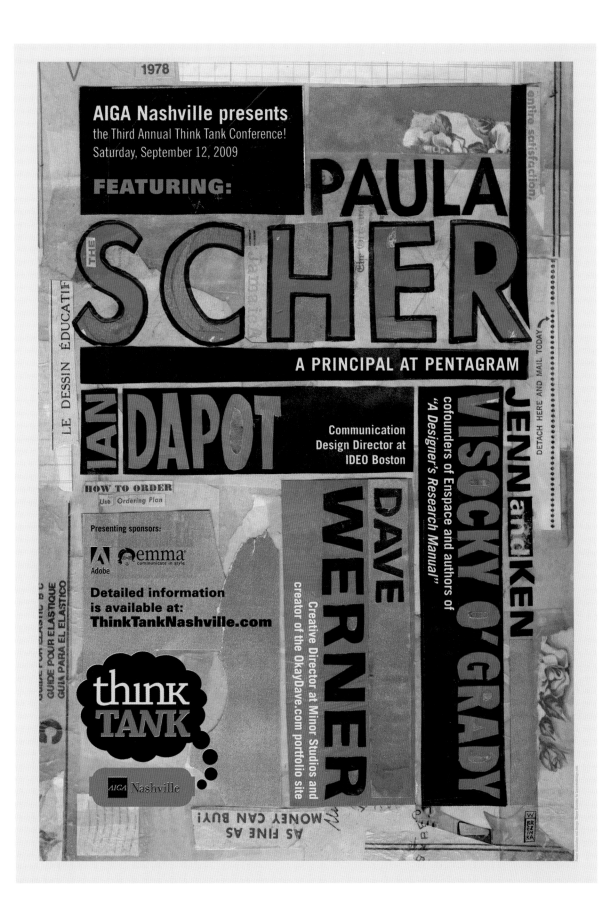

DESIGN FIRM
Brezinka Design Co.

LOCATION
Old Hickory, Tennessee, USA

ART DIRECTOR/DESIGNER
Wayne Brezinka

CLIENT
AIGA Nashville

MATERIALS
Collage, cut paper,
mixed media

PRINTER
Lithographics

CHAPTER

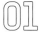

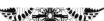

NASHVILLE AIGA THINK TANK POSTER/ ILLUSTRATION

The Nashville AIGA board of directors contacted me about creating the promotional materials for the 2009 Think Tank conference. The conference featured an incredible lineup with Paula Scher, Dave Werner, Ken and Jenn Visocky O'Grady and Ian Depot. I decided to create somewhat of a tribute to Paula Scher, and her famous mantra "MAKE IT BIGGER," by doing large paper-cut letters and collages as the main image since she was the headliner for the conference. It was a hit!

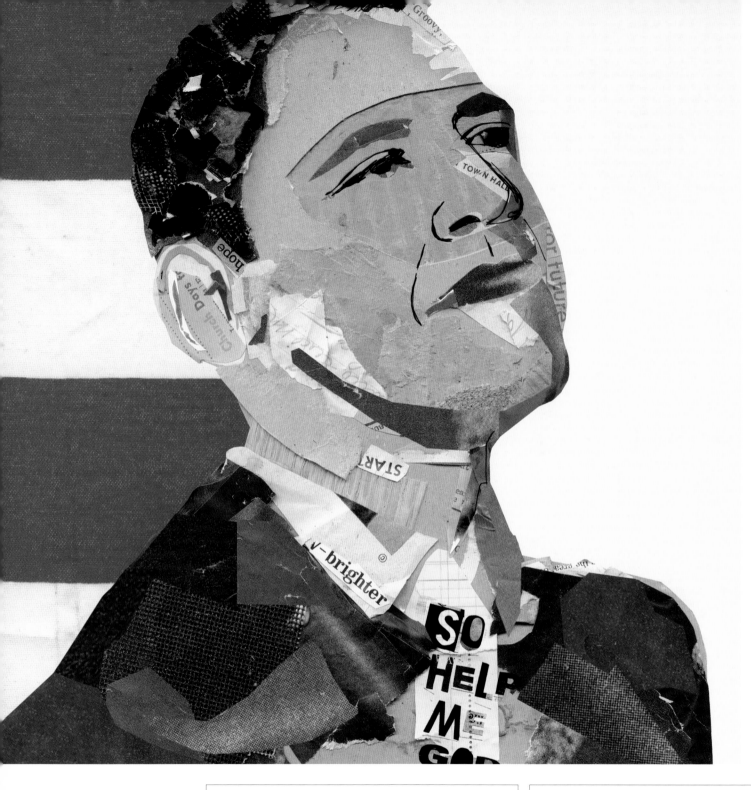

OBAMA COLLAGE PORTRAIT/ ILLUSTRATION

DESIGN FIRM
Brezinka Design Co.

LOCATION
Old Hickory, Tennessee, USA

ART DIRECTOR/DESIGNER
Wayne Brezinka

CLIENT
Los Angeles Times

MATERIALS
Collage, mixed media

During the 2008 presidential campaign and election process for the United States, I was inspired by Barack Obama. I wanted to create a portrait of him consisting of various textures, words and ephemera... sort of a piecing together of Obama reflecting the decomposing economy, government, diversity and the United States—along with the hope and change he was talking about: that some day, things might be different. This illustration was recently picked up by The *Los Angeles Times* to run in the Op-Ed section.

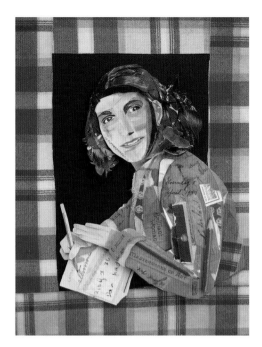

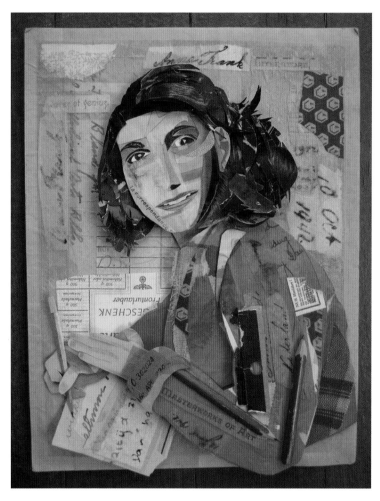

This is an illustration commission for a *Los Angeles Times* article that discusses Anne Frank's literary voice and the author's assertion that she knew her diary would one day be received as a work of art. They [the *L.A. Times*] wanted me to focus on making it a portrait of Anne, but perhaps use actual text from her book in parts, as well as bookbindings and materials associated with literary endeavors.

DESIGN FIRM
Brezinka Design Co.

LOCATION
Old Hickory, Tennessee, USA

ART DIRECTOR
Wes Bausmith

DESIGNER
Wayne Brezinka

CLIENT
Los Angeles Times

MATERIALS
Collage, mixed media

PRINTER
Los Angeles Times

ANNE FRANK ILLUSTRATION

CHAPTER 01

DESIGN FIRM
Brezinka Design Co.

LOCATION
Old Hickory, Tennessee, USA

ART DIRECTOR
Kristin Lenz

DESIGNER
Kristin Lenz

CLIENT
The Washington Post

MATERIALS
Collage, mixed media

CHAPTER

01

SHOP AT DAVID'S NOT GOLIATH'S

An illustration commissioned by the *Washington Post* for an article about the death of small business. I presented several sketches and ideas but felt that a tiny two-drawer "Mom and Pop" file cabinet up against an extremely large one would communicate perfectly. I began by looking for collage elements that reminded me of corporate strength and power—money, suits, ties, pinstripes, large buildings, steel beams, etc. These were applied in various ways, including slicing my son's play money in half. To signify old school and vintage, I used wood for the smaller cabinet. I originally had a skull on top but the AD thought a wilted flower might work better. I agree... subtle, direct and symbolic!

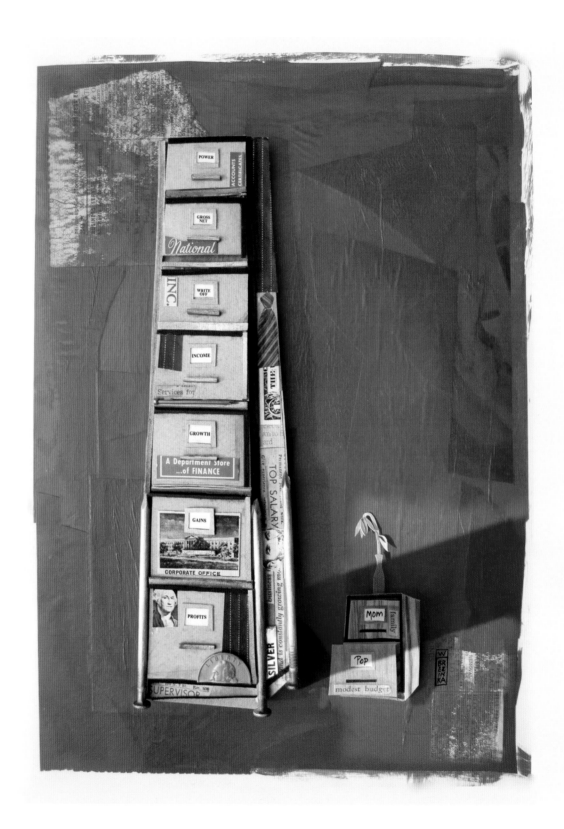

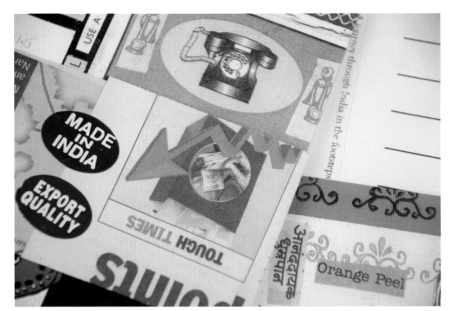

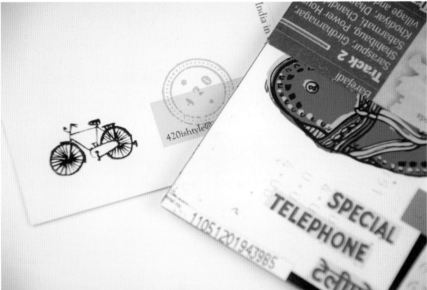

DESIGN FIRM/DESIGNER
Akhila Krishnan

LOCATION
London, England

CLIENT
Self

MATERIALS
Handmade collage (digitally printed), screenprint

PRINTER
Kodak digital offset printer

CHAPTER

01

PAIRS OF SHOES POSTCARDS

This project was born out of a love of collage as well as a sense of nostalgia associated with letters and postcards, which are a highly personal method of communication. The postcards were intended to be an authentic window into contemporary India, where tradition and mo-dernity lie side by side. A collage of ordinary items—bus tickets, toffee wrappers, cigarette (bidi) packets, etc.. was hand-assembled, scanned and then reprinted in larger numbers. Hand-drawn shoes completed the package. To reinforce the idea of the old and the new, of tradition and modernity, I printed the shoes onto the postcards using the screenprint technique. In this way, I was also referencing Indian street graphics—hand-painted signs, symbols and movie billboards.

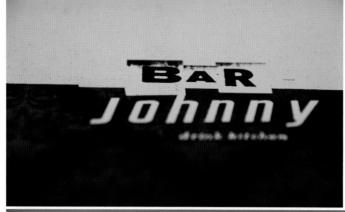

DESIGN FIRM
Markatos Moore

LOCATION
San Francisco, California, USA

ART DIRECTORS
Peter Markatos, Tyler Moore

DESIGNER
Jessica Huang

CLIENT
John Jasso

MATERIALS
Scissors, photocopy, glue, tape, blender marker

CHAPTER

01

BAR JOHNNY

For Bar Johnny, the goal was to create a mood for the restaurant/ bar that was the visual intersection where Punk meets 1960s Madison Avenue. We developed a found-type language from newspapers and ads from the 1960s. We began by cutting out all of the letter forms and spent hours with the Xerox machine, much like how the old punk posters were made. From there we decided to add the elegant wallpaper graphic (which was wheat pasted in the restaurant) in deep blue, to both help elevate the tone of the brand to Madison Avenue and to develop a nice contrast with the street aesthetic. The menu system was designed so the owner could easily print off a new menu each night.

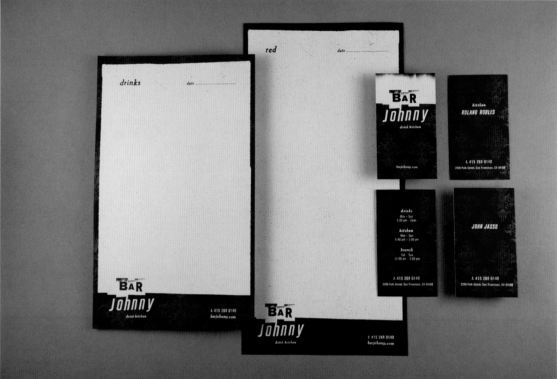

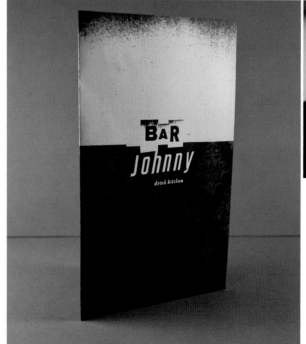

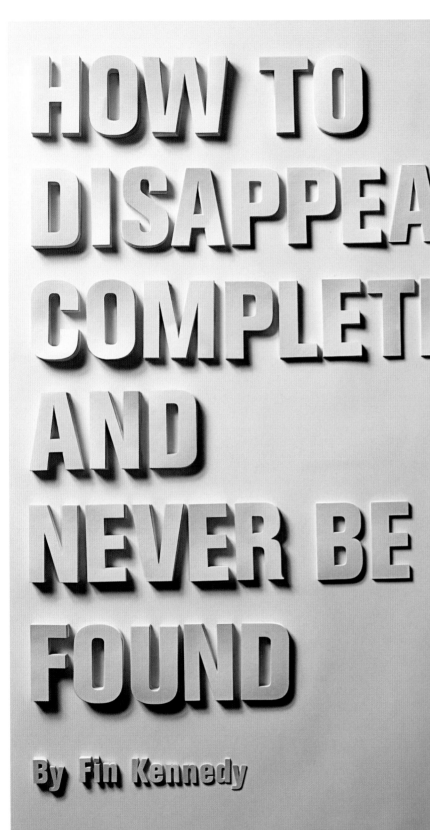

HOW TO DISAPPEAR COMPLETELY AND NEVER BE FOUND

By Fin Kennedy

DESIGN FIRM
Plazm, Studio J

LOCATION
Portland, Oregon, USA

ART DIRECTOR
Joshua Berger

CREATIVE DIRECTOR
John C. Jay

DESIGNERS
Joshua Berger,
Thomas Bradley

CLIENT
Portland Center Stage

CHAPTER

01

PORTLAND CENTER STAGE FIN KENNEDY POSTER

For this poster promoting Fin Kennedy's play at the Portland Center Stage, all letters were individually cut out and stacked up; there are about seventy-five in a stack on the left side of the poster and it tapers down to three or four in a stack on the right. Kerning was a major challenge. We shot the entire thing in one image, with the exception of the running man, which was Joshua Berger. Once we had the poster shot, we turned on a fan and blew all the letters off the table to make a fifteen-second video spot. View the spot on the Fingerprint No. 2 Facebook page: www.facebook.com/fingerprint2. An overview description of the series this poster belongs with can be found on page 68.

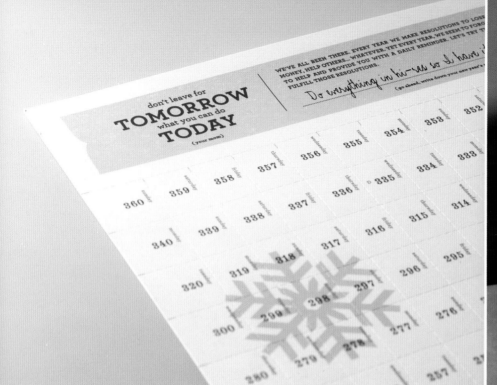

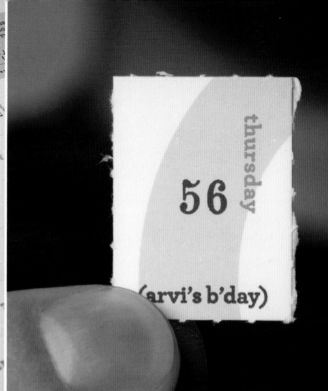

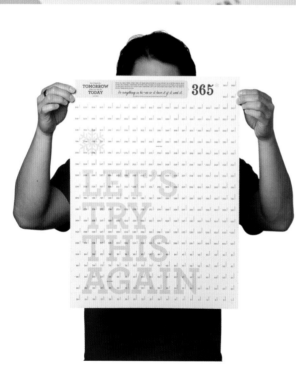

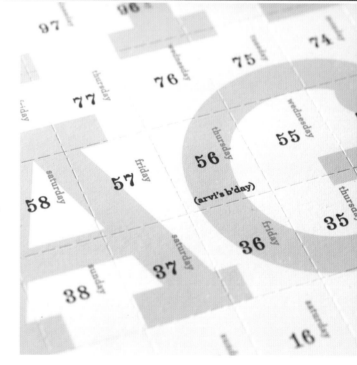

2009 HOLIDAY GIFT/ 365 NEW YEAR'S RESOLUTION POSTER

DESIGN FIRM
No Work/No Play

LOCATION
San Francisco, California, USA

ART DIRECTORS/ DESIGNERS
Arvi Raquel Santos,
David Muro II

CLIENT
No Work/No Play

MATERIALS
Silkscreen, hand-perforated
with a "Carl," a tool that looks
suspiciously like a pizza cutter

PRINTER
Bloom Press

The 365 New Year's Resolution Poster is a visual reminder showing recipients the amount of time they have left to fulfill their New Year's resolution(s). In the hope that they will actually stick to their resolutions this year, recipients are asked to write down their resolution and for every day that the resolution isn't fulfilled, recipients would tear off a daily chip. In total, we hand-perforated 3,900 individual cuts to complete the design for a hundred posters. And yes, our hands are still cramped.

OLD NEWS

NEW YEAR

DESIGN FIRM
No Work/No Play

LOCATION
San Francisco, California, USA

**ART DIRECTOR/
DESIGNER**
Arvi Raquel Santos

CLIENT
No Work/No Play

MATERIALS
Two months worth of
newspapers, screenprinting

PRINTER
Bloom Press

CHAPTER

01

**2009 HOLIDAY GIFT:
OLD NEWS/NEW YEAR
POSTER**

A limited edition of one hundred unique silkscreened posters on different newspapers collected over a span of two months, this was my New Year's gift in 2009 and was sent to friends and colleagues in Jan. 2009 when Obama became president. I created a poster that had one simple message: The new year is an opportunity to put the past behind us, start over and work towards a better tomorrow.

LET'S CUT TO THE CHASE. WE ALL KNOW WHY WE'RE HERE. THIS IS FINGERPRINTZ, AFTER ALL— WE'RE PRACTICALLY ADDICTS. WE'RE ALL HERE BECAUSE WE LOVE WORK WITH LOOSE STRANDS, THAT'S AS MUCH ABOUT THE PROCESS AS ANY FINAL PRINT. WE WANT WORK WITH DIRTY FINGERNAILS. AND SPATTERED CLOTHES.

WE WANT WORK THAT TASTES GOOD WITH BEER.

AT OUR STUDIO, IT COMES DOWN TO WANTING TO MAKE SOMETHING IMMEDIATE AND PERSONAL, SOMETHING WE CAN HOLD AND TURN IN OUR HANDS.

OUR FAVORITE WORK IS OFTEN CLUMSY WITH CRUTCHES AND IMPERFECTIONS. BUT AT IT'S BEST, IT HAS A LITTLE OF THE SAME STOMP AND NOISE AS OUR FIRST STABS WITH A CRAYON.

Maybe not perfect, but honest. And that's probably why we find it beautiful.

My family

What's on my mind right now

My favorite color

My happy place

Guilty pleasure

My nemesis

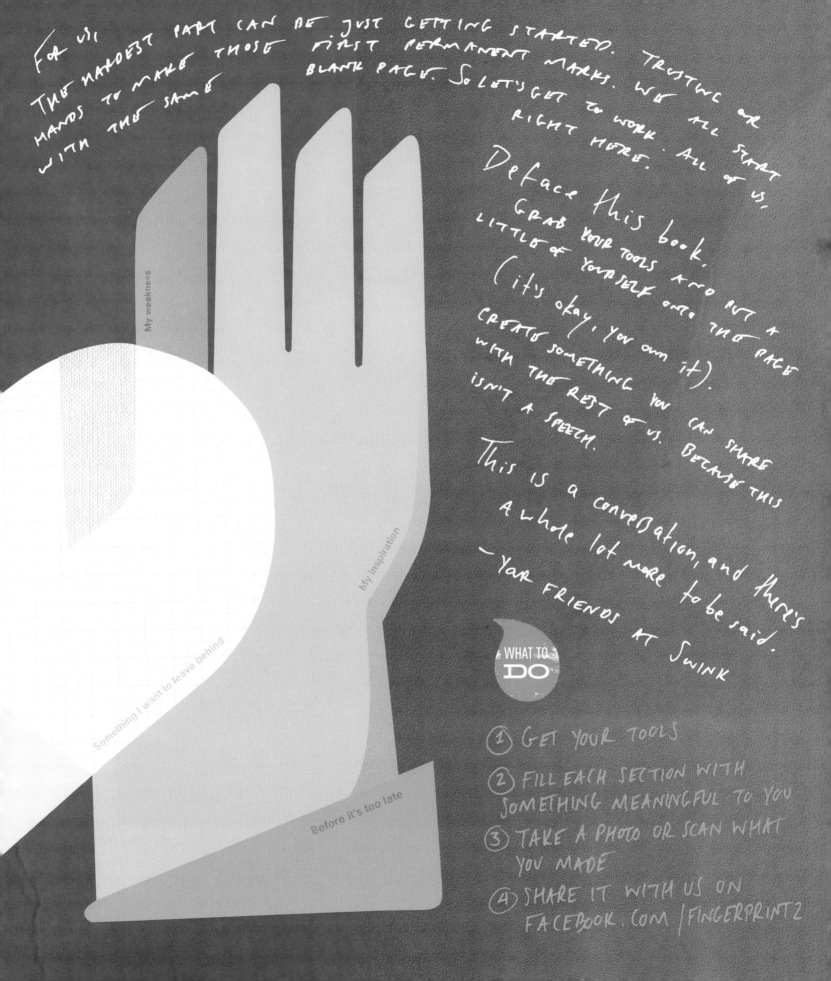

For us, the hardest part can be just getting started. Trusting our hands to make those first permanent marks. We all start with that same blank page. So let's get to work. All of us, right here.

Deface this book. Grab your tools and put a little of yourself onto the page (it's okay, you own it). Create something you can share with the rest of us. Because this isn't a speech.

This is a conversation, and there's a whole lot more to be said.

— Your friends at Swink

My weakness

My inspiration

Something I want to leave behind

Before it's too late

WHAT TO DO

① GET YOUR TOOLS

② FILL EACH SECTION WITH SOMETHING MEANINGFUL TO YOU

③ TAKE A PHOTO OR SCAN WHAT YOU MADE

④ SHARE IT WITH US ON FACEBOOK.COM/FINGERPRINTZ

DESIGN FIRM
Swink

LOCATION
Madison, Wisconsin, USA

ART DIRECTOR/DESIGNER
Drew Garza

CLIENT
Majestic Theatre

MATERIALS
Pencil, scanner,
silkscreen, beer

PRINTER
Delicious Design League

CHAPTER

01

**HOLD STEADY
POSTER**

The Hold Steady turn traditional Midwestern Americana rock music on its head, replacing the rocking chair and lawn mower with a BB gun and a keg of beer. Their music reminds us of growing up in the Midwest—restless and fearless, jumping fences at night. This 4-color silkscreened poster is a collage of hand work, found imagery, and scanned textures honoring summer, girlfriends, and drinking.

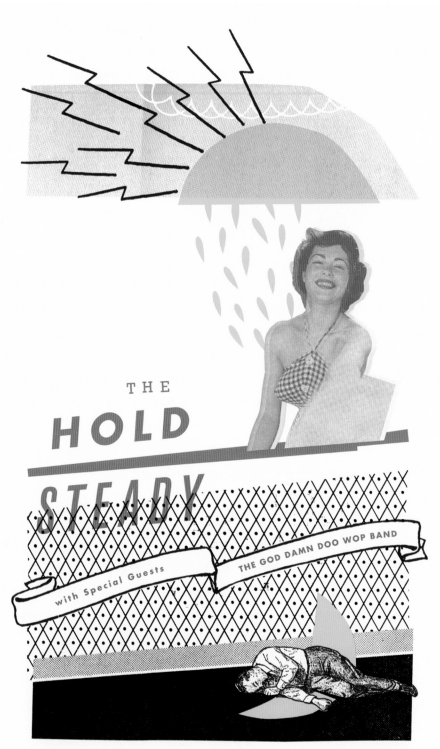

THE
HOLD
STEADY

with Special Guests THE GOD DAMN DOO WOP BAND

Friday, July 10th 9PM MAJESTIC THEATRE MADISON, WI

MAJESTIC

115 KING STREET
MADISON, WISCONSIN
BOX OFFICE: 608.255.0901

ARTIST INFORMATION CONTACT

MARQUEE EVENT CALENDAR GALLERY HISTORY VENUE RENTAL INFO

WELCOME NOW PLAYING

VIDEO
MP3
WEBSITE

Matt & Kim

First off a note of warning: Matt and Kim aren't a typical band and this isn't going to read like your average biography. For example, although Matt and Kim know they met while taking classes at Pratt Institute in New York, Kim's not sure what year she graduated, let alone when they decided to start playing music as a two-piece. What they do know is that when Matt and Kim started out approximately four years ago, they had no idea how to play their respective instruments—a fact that makes the band's success story almost as unique as their distinctive brand of synth-and-drums dance punk.

After being forced to play their first show by a friend months after picking up their instruments, keyboardist/vocalist Matt Johnson and drummer/vocalist Kim Schifino played their first show as Matthew and Kimberly in October of 2004—and after slightly altering their name they spent the next year playing every chance they could get in their home base of Brooklyn. Along the way they also released an EP called To/From and started touring the United States non-stop, burning CDs in the van on the way to their self-booked shows and seemingly playing every art space and basement in the country.

Show Date:
Tue, September 21

Special Guests:
tba

Show Time:
Doors at 7:30
Show at 8:30

Tickets
$16 advance
$18 day of
$30 opera box
***On Sale 6/23**

PURCHASE

Upcoming Shows

Roots Collective
Free SummerJam!

PURCHASE

Jul 1 Thu

Special Guests
Taki All-Stars

Tickets
FREE
$5 under 21

Show Time
9pm

* MORE INFO *

Jul 3 Sat

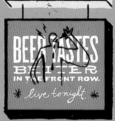

Independence Day Bash

Tickets
$10 Cover

Show Time
Doors at 9pm

* MORE INFO *

Jul 7 Wed

One Eskimo

PURCHASE

Special Guests
tba

Tickets
$12 advance
$14 day of show

Show Time
Doors at 7pm
Show at 8pm

* MORE INFO *

JUST ANNOUNCED

Rocky Horror Picture Show	7/16	TIX
Thriving Ivory	7/23	TIX
80s vs 90s: Old School Hip Hop	7/23	
Glitch Mob	8/21	TIX
Sam & Ruby + Abalone Dots	9/2	TIX
School of Seven Bells	9/18	TIX
Matt & Kim	9/21	TIX
33 Miles	10/24	TIX

SIGN UP
*** * ***

TO RECEIVE EMAIL UPDATES FOR UPCOMING SHOWS.

Enter Email Address

SUBSCRIBE

BEER TASTES BETTER IN THE FRONT ROW.
live tonight

NEWS

Tonight: SummerJam Presents: Warm Wet Rag (WEEN Tribute) w/ Nama Rupa - FREE! Yay!!! http://fb.me/yw8mqhfu about 15 hours ago

@stephanie04 - not that we know of! about 16 hours ago

@terrenceisdaman - performed. looks like just rocky horror was wrong, but thanks! about 16 hours ago

Come to "33 Miles" Sunday, October 24 from 10:00 pm to 1:00 am. 33 Miles with Special Guests: Chris & Conrad and... http://fb.me/CiMq8x0I about 18 hours ago

Come to "Glitch Mob" Tuesday, August 17 from 10:00 pm to 1:00 am. Glitch Mob with Special Guests TBA Saturday,... http://fb.me/uE4OkPJi about 18 hours ago

Come to "Thriving Ivory" Friday, July 23 at 7:00 pm until
Saturday, July 24 at 9:00 pm. Thriving Ivory with... http://fb.me/AVHUTCBn about 18 hours

Follow us on **twitter**

FEATURED ARTIST

Janelle Monáe - Tightro...

DESIGN FIRM
Swink

LOCATION
Madison, Wisconsin, USA

ART DIRECTOR
Shanan Galligan

DESIGNER
Drew Garza

CLIENT
Majestic Theatre

MATERIALS
Pencil, scanner

CHAPTER

01

MAJESTIC THEATRE WEBSITE

Our next-door neighbors at the Majestic Theatre needed to make some more noise here in Madison. Their website is the first place locals look to see what's happening at the club. So we started with the giant historic marquee sign outside our window as inspiration and set out to put a little grit in their polish. We love that the web doesn't have to be all gradients and gloss and can make you feel like you're getting a little dirt under your fingernails just clicking around.

DESIGN FIRM
Swink

LOCATION
Madison, Wisconsin, USA

ART DIRECTOR
Shanan Galligan

DESIGNERS
Drew Garza, Nicole Lahy,
Shanan Galligan

CLIENT
Cicero, Inc.

MATERIALS
Sharpies, pencil, scanner,
X-Actos, glue, TextMate,
CSSEdit, ExpressionEngine

CHAPTER

01

CICERO WEBSITE

Cicero is an international business software provider specializing in desktop integration for call centers. Their business, by its nature, is highly technical and thick with industry jargon. However, Cicero simply wants to use their technology to bring people together better. We looked to cut through the noise and highlight their human touch with cut paper illustrations, hand-rendered text, and found textures.

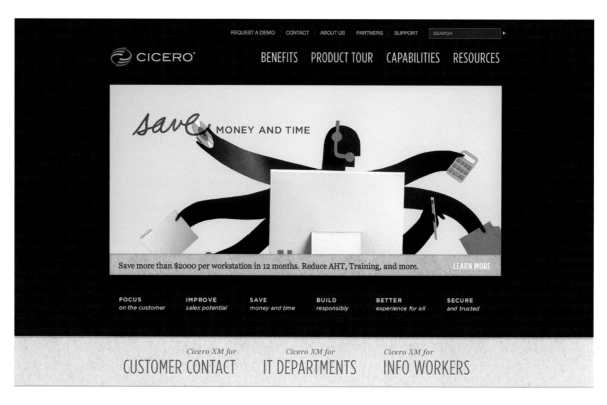

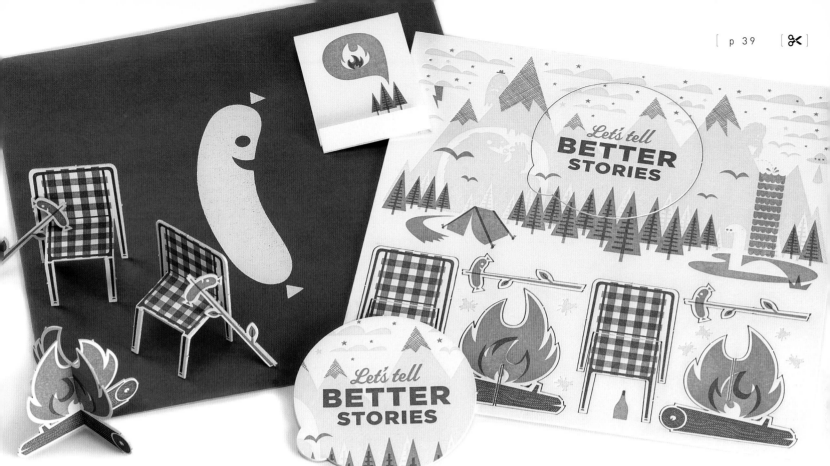

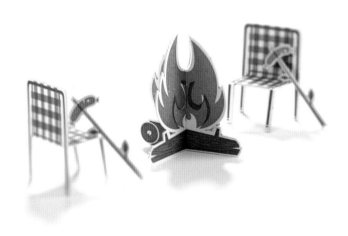

There's nothing like a good campfire to get people talking. We put together a direct mail piece to invite people to reconsider the way they've been marketing themselves and to believe in the power of a good story—their story.

DESIGN FIRM
Swink

LOCATION
Madison, Wisconsin, USA

ART DIRECTOR
Shanan Galligan

DESIGNERS
Drew Garza, Yogie Jaraca

CLIENT
Swink

MATERIALS
Letterpress, laser die cut

PRINTER
Studio on Fire

LET'S TELL BETTER STORIES PROMOTION

CHAPTER 01

CONTINUED FROM PAGE 8

EMBRACING INGREDIENT X

Yet wait a moment before you answer, because while all this has been happening, something else was, too—and has been ever since digital technology began hijacking our lives. Quietly, in design studios and coffee shops and at kitchen tables across the planet, people are making stuff. By hand. With pens and paper and ink and paint and scissors and pipe cleaners and glue guns. They'd always done so, but at this particular moment in history, when computers seem to have taken over and the global economy is in a snit, making stuff seems to feel particularly good. People find it purging. Cleansing. Deeply connective. A nascent revival of the handmade is fostering a growing community of artists and designers and heralding a new era of personal projects—a realm that exists in a wonderful, parallel universe to all the twittering, tweeting, blasting digital noise. It's like Platform 9¾ in Harry Potter: secret and awesome and visible only to a certain few.

Many folks, you see, are sick of technology. While computers offer many interesting options and can speed up certain mechanistic processes, they've turned out not to be everything we hoped. Photoshop has its pros and cons. InDesign may be awesome, but it doesn't have everything you need in order to create good design. While our associations with "hand-crafted" may make us think of art (and, by contrast, "computer-made" with commerciality), the truth is that artful design can be created anywhere. What handmade does have, however, is the fingerprint of human creation—and, more and more, that humanity is what we're hungry for these days. A project that reveals human DNA is more likely to possess what

CONTINUED ON P. 64

02

STENCIL, COPIER & SPONGE

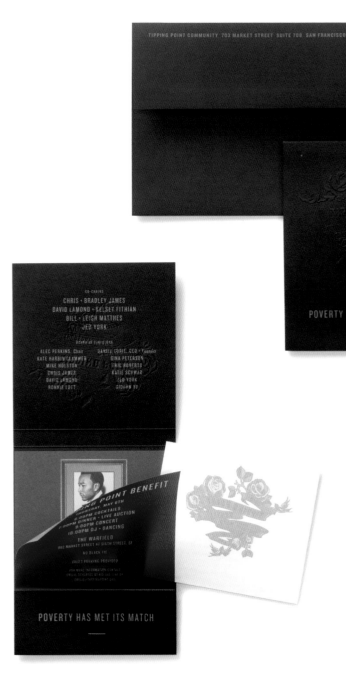

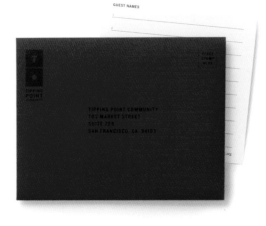

CHAPTER 02

**TIPPING POINT
COMMUNITY 2010
BENEFIT INVITATION**

DESIGN FIRM
Elixir Design

LOCATION
San Francisco, California, USA

ART DIRECTOR
Jennifer Jerde

DESIGNER
Scott Hesselink

CLIENT
Tipping Point Community

MATERIALS
Temporary tattoo, embossing,
vellum paper

PRINTER
Oscar Printing, Tattoo Fun

Elixir's invitation for Tipping Point Community's 2010
annual benefit was designed as an oversized match-
book. Art created for a temporary tattoo insert was
blind embossed on the cover with the copy "Poverty
has met its match." The one-night event succeeded
in raising $6 million to fund the best poverty fighting
programs in the San Francisco Bay Area.

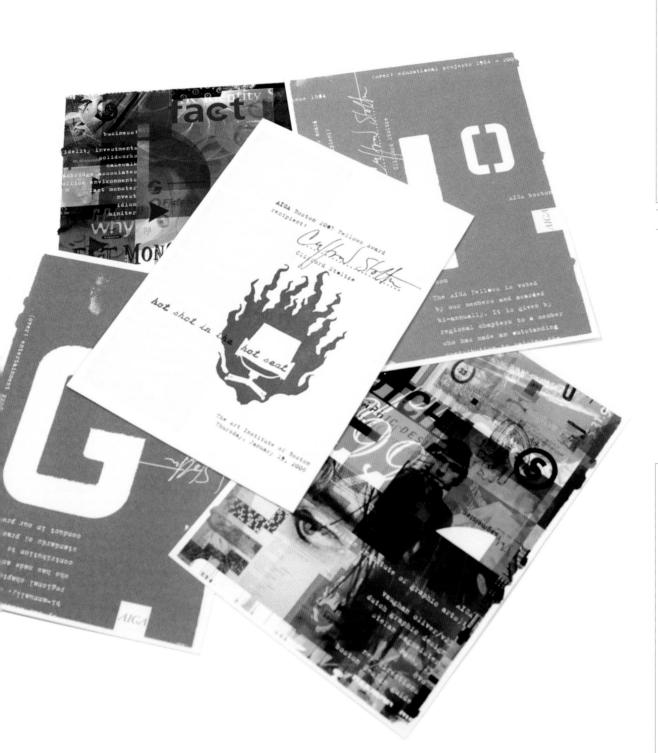

DESIGN FIRM
Stoltze Design

LOCATION
Boston, Massachusetts, USA

ART DIRECTOR
Clifford Stoltze

DESIGNERS
Roy Burns, Clifford Stoltze

CLIENT
AIGA Boston

MATERIALS
Stencil

PRINTER
EM Letterpress

CHAPTER

02

**AIGA FELLOWS
AWARD INVITE**

I wish everything we did could have handmade elements, but it's not always appropriate. When creating an invitation to your own award ceremony and roast, however, it's an opportunity to make it reflect your own personality and taste in design. Plus you can get away with poking fun at the subject. In this case, it was for an AIGA/Boston Fellows Award I was receiving. This card combines stencil, handwriting, drawing, xeroxing and typewriting as a nod to the process of designing I learned many years ago... long before the computer was an everyday tool. The card was printed letterpress which adds to the tactile and limited-edition quality.

DESIGN FIRM
University of Art &
Design Helsinki

LOCATION
Helsinki, Finland

**ART DIRECTORS/
DESIGNERS**
Heidi Gabrielsson,
Laura Suuronen

CLIENT
Nihil Interit

MATERIALS
Apple G5, photocopier,
silkscreening equipment,
toxics, ink

PRINTER
Art-Print

The client wished for something fruity, colorful and mixed for this special issue on concrete/visual poetry. Due to the history of concrete poetry, we were inspired by the simple 1950s silkscreen style. We wanted to combine the fruits with this style, so fruit stickers and packaging felt like a natural choice. Since the issue is on visual poetry, the editorial material varies greatly. We had to come up with a style that would carry throughout the whole magazine, to give it a strong personality, while avoiding getting mixed with the editorial content.

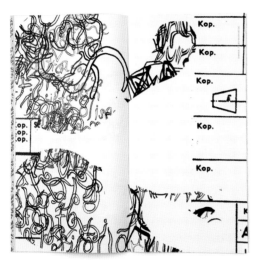

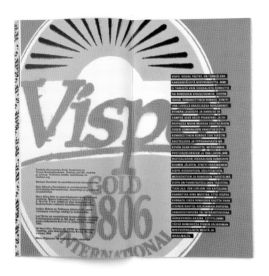

DIGGING DEEPER

Old printing techniques have a humane feel to them, since a lot of the production was still controlled manually—resulting in characteristic mistakes and irregularities. We misused cutting-edge technology to build typography, for example, by hand. A lot of the process was doing things wrong, such as printing and scanning images and type in wrong sizes to acquire the desired look. Most of the graphic elements in this magazine were either created manually or printed out and hand-manipulated before allowed in the layout. We believe that a holistic design approach makes the work not only more characteristic but also bigger and stronger than just the sum of its parts. It kind of makes the work an independent creature with a soul.

— Heidi Gabrielsson & Laura Suuronen

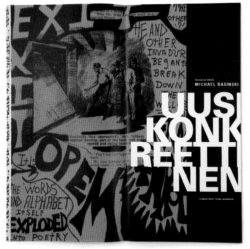

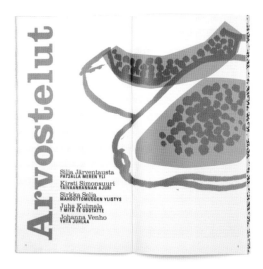

DESIGN FIRM
WorktoDate

LOCATION
York, Pennsylvania, USA

ART DIRECTOR/DESIGNER
Greg Bennett

CLIENT
So-Cal Fire Poster Project

MATERIALS
Hands, sponge, X-Acto blade,
lighter, paper, ink, ash, water

PRINTER
Shapco Printing

CHAPTER

SO-CAL FIRE POSTER

Brighter Days Ahead was designed to commemorate those affected by the Southern California Wildfires of 2007. It was donated to the So-Cal Fire Poster Project and is being sold to benefit the victims affected by the fires. The destruction of the wildfires was portrayed by physically making, photographing and then compositing various textures, such as burnt paper, water stains, ash and grit. These elements are juxtaposed with beautiful illustrations of life occurring all around them. The beauty lies in the fact that life carries on. Even the scorched tree shows signs of new life through its sprouting buds. The text sprinkled throughout the poster are facts regarding the wildfires.

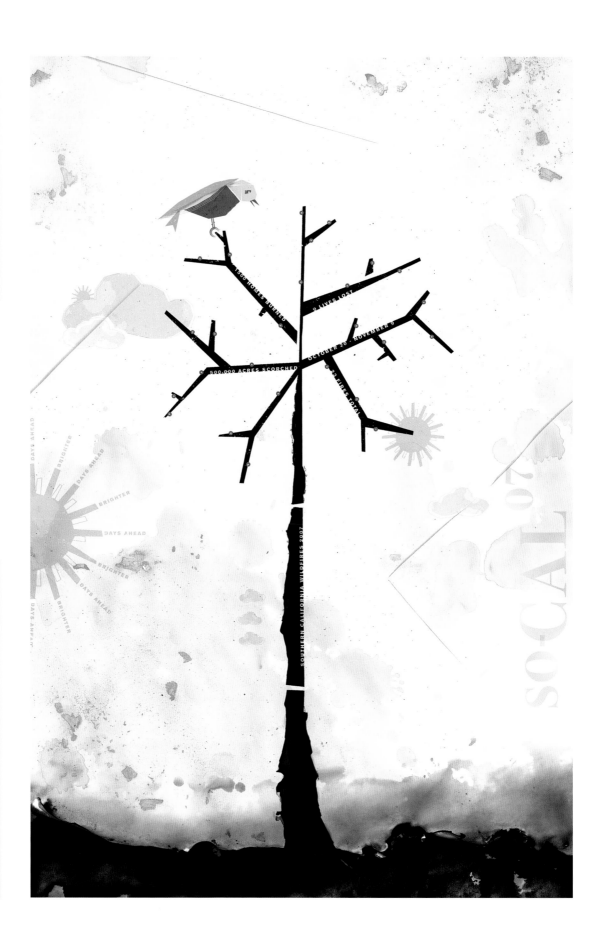

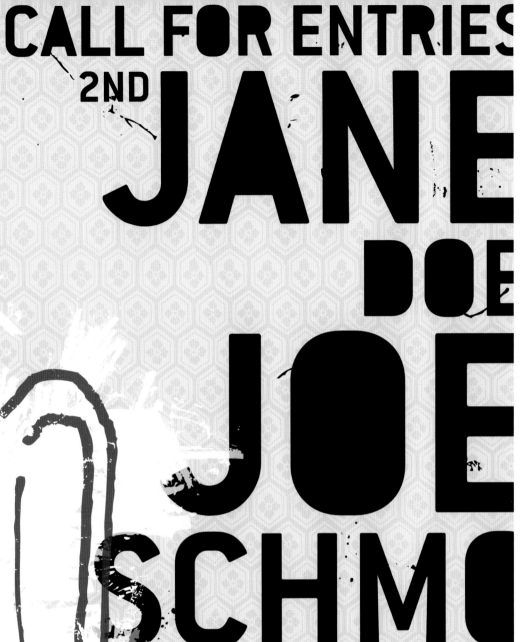

CALL FOR ENTRIES
2ND
JANE
DOE
JOE
SCHMO
ART SHOW
IF YOU THINK IT'S ART THEN SO DO W

TO SUBMIT ANY WORK CONTAC
MEREDITH AT MBFM9D@MIZZOU.EDU
OR ROBIN AT ROBIN@RAGTAGFILM.CO
BY FEB. 28, 2007. SHOW IS MARCH 9-10

FOR QUESTIONS CONCERNING MUSIC
CONTACT SAM AT KAPELYE@GMAIL.COM

DESIGN FIRM
Never Sleeping Inc.

LOCATION
Columbia, Missouri, USA

DESIGNER
Ben Chlapek

CLIENT
Jane Doe Art Show

MATERIALS
Pen, pencil, paint, scanner

CHAPTER

02

JANE DOE
ART SHOW FLYER

This was a flyer for a community art show, with the premise being that everyone is accepted no matter what your experience level. I figured there would be lots of handmade elements in the show, and I should make a piece that promoted that.

DESIGN FIRM
Aufuldish & Warinner

LOCATION
San Anselmo, California, USA

ART DIRECTOR
Bob Aufuldish

CLIENT
California College of the Arts

MATERIALS
Silk flowers, scanner

CHAPTER

02

AN EVENING WITH DAVID SEDARIS POSTER

To work on a project having anything to do with David Sedaris is to labor under the weight of all the terrific covers that have graced his books. For this poster promoting a reading by Mr. Sedaris benefiting scholarships at the California College of the Arts, I was inspired by his early book *Holidays on Ice.* I liked the idea of using a Christmas tree on a poster for an event in October and using fall colors. Having the shabby tree (found on a San Francisco curb in March) upside down seemed to add the right feeling. The crazy amalgamation of type-faces and sizes was typeset, printed out, distressed with sandpaper, scanned back in as line art and mixed with some decorative material.

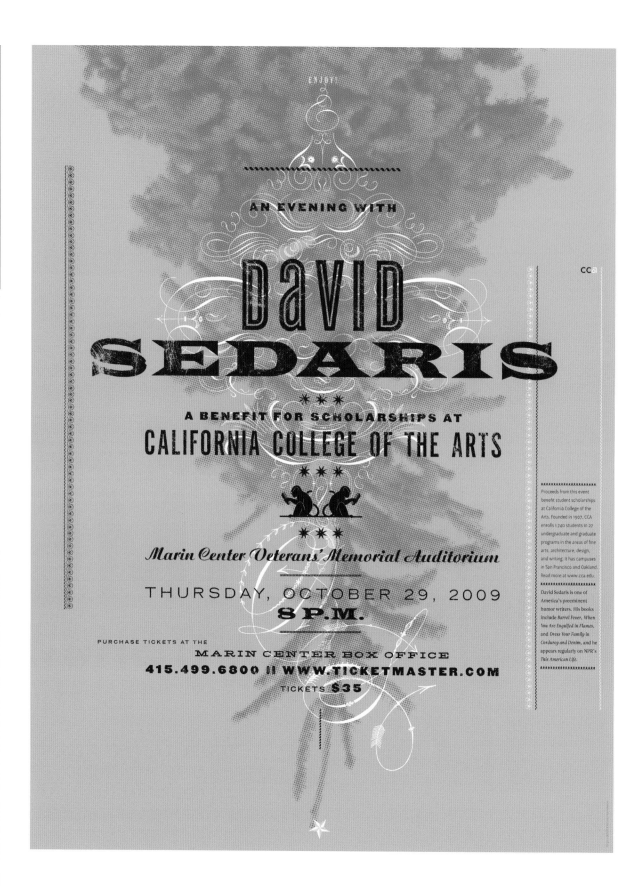

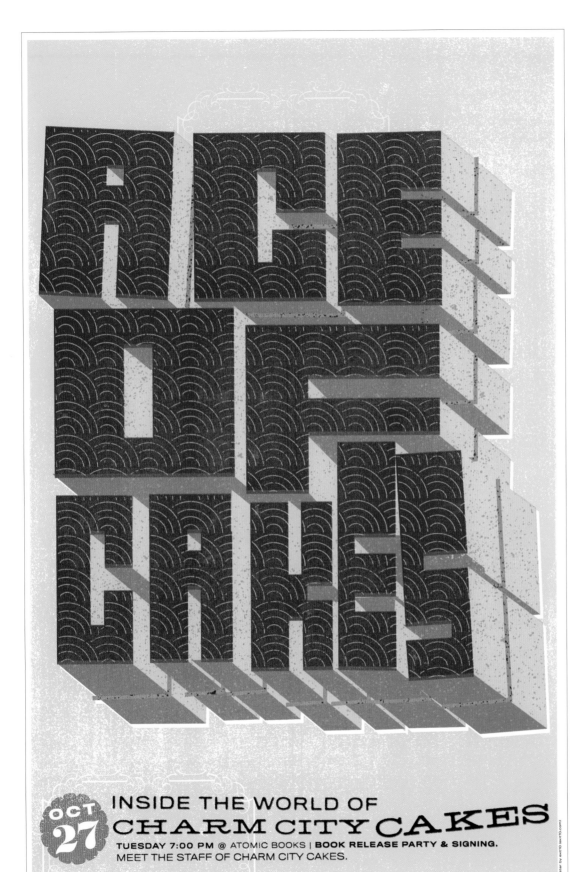

DESIGN FIRM
Exit 10

LOCATION
Baltimore, Maryland, USA

ART DIRECTORS
Scott Sugiuchi,
Jonathan Helfman

DESIGNER
Carl Nielson

CLIENT
Atomic Books

MATERIALS
Collage, Xerox

CHAPTER

02

ACE OF CAKES BOOK SIGNING POSTER

Charm City Cakes is a Baltimore cake-decorating company featured on the popular Food Network reality series *Ace of Cakes*. The owner, Duff Goldman, is known for his amazing cake decorating skills and for his somewhat unorthodox background as a part-time rock musician. This rock 'n' roll attitude was the underlying stylistic concept for this poster. The hand-drawn cake/type is an obvious tie-in because all of the Charm City Cakes are decorated by hand. Rock 'n' roll, in its most basic form, is all about ragged glory—gritty and unrefined. This too played into the handmade elements of the poster. The textures were generated by photocopying and ink, followed by processing in Photoshop.

DESIGN FIRM
Stoltze Design

LOCATION
Boston, Massachusetts, USA

ART DIRECTOR
Clifford Stoltze

DESIGNERS
Roy Burns, Clifford Stoltze

CLIENT
The Society of
Typographic Aficionados

MATERIALS
Xerox, collage, ink

CHAPTER

04

TYPECON POSTER

When Alan Haley approached us about designing the identity for the 2006 TypeCon (SOTA's annual gathering of typographers, type designers and various users and appreciators of typographic forms). I felt the pressure of designing for self-described typographic aficionados. The conference was held in Boston that year, so the logo is an interpretation of the 2006 theme: the Boston T Party. We created it with manipulated/distressed graphic elements and typography as a nod to Boston's rich history, making it look as if it might be found in an antique tea-party invitation. The graphics were used on an assortment of branded items, including postcards, bags, the website and silkscreened posters.

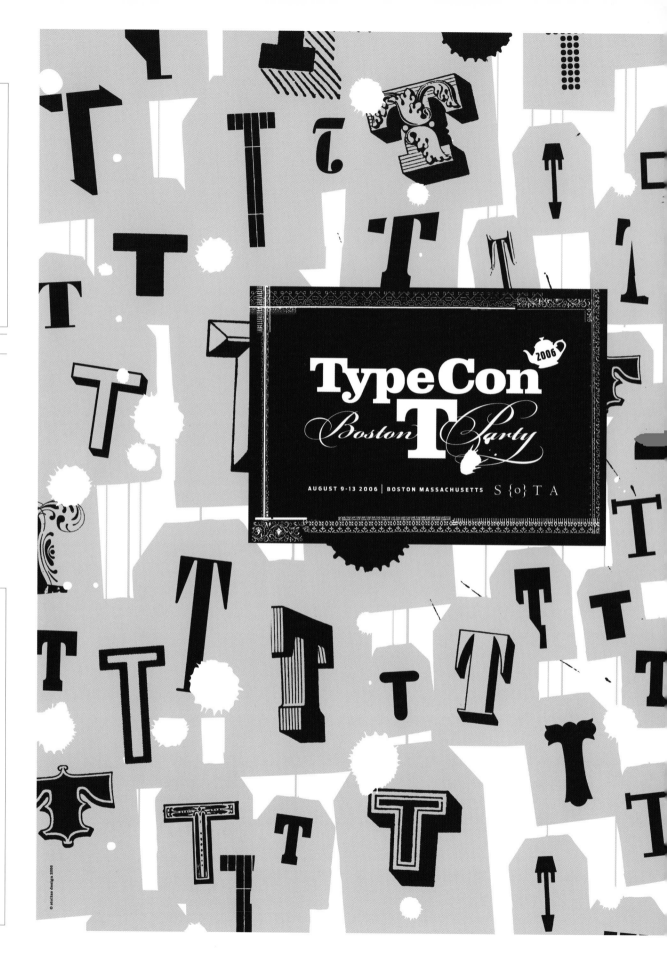

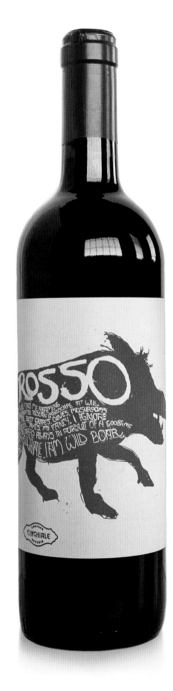

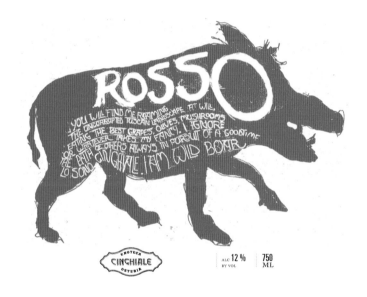

This wine label design was created for an upscale restaurant called Cinghale, which is Italian for "wild boar." Exit 10 was commissioned to create the entire identity for the restaurant, including large charcoal renderings of boars and a label for the restaurant's own wine, Rosso. All elements of the label were created using pen, ink and pencil, with photocopier manipulation of the contrast and resolution. The imagery was meant to capture the energy and attitude of a wild boar. This is manifested by the use of ragged lines, expressionistic typography and claustrophobic use of white space.

DESIGN FIRM
Exit 10

LOCATION
Baltimore, Maryland, USA

ART DIRECTORS
Scott Sugiuchi,
Jonathan Helfman

DESIGNER
Carl Nielson

CLIENT
Cinghiale

MATERIALS
Pencil, pen, photocopy,
Adobe Photoshop

ROSSO WINE LABEL

CHAPTER 02

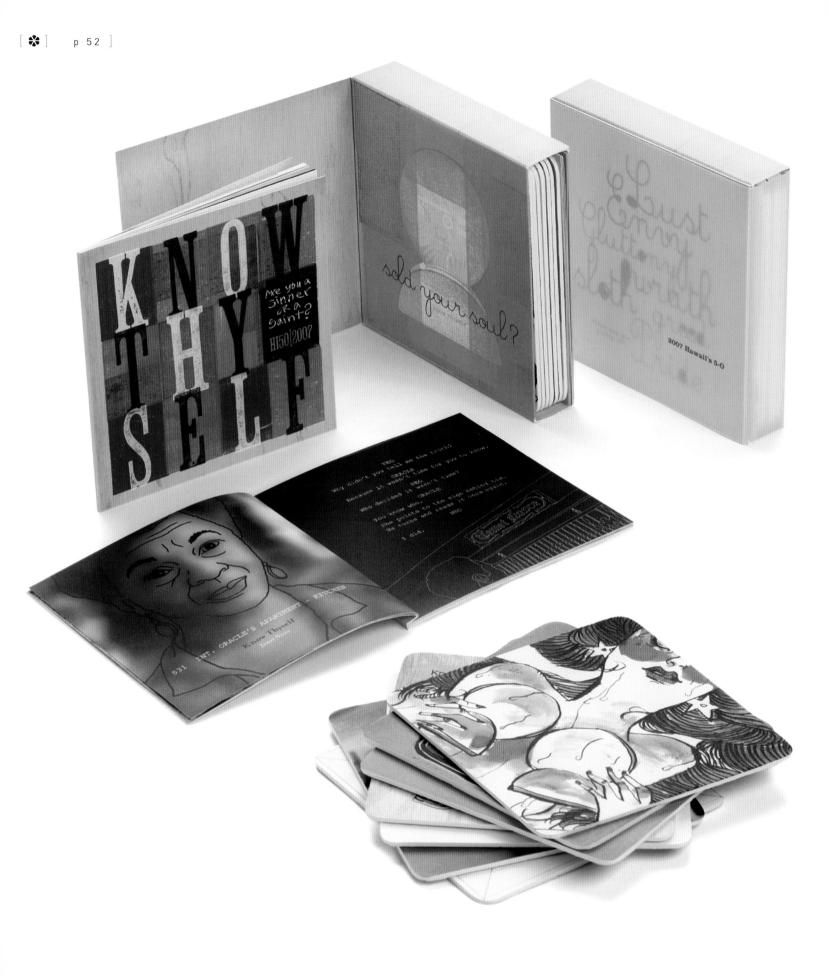

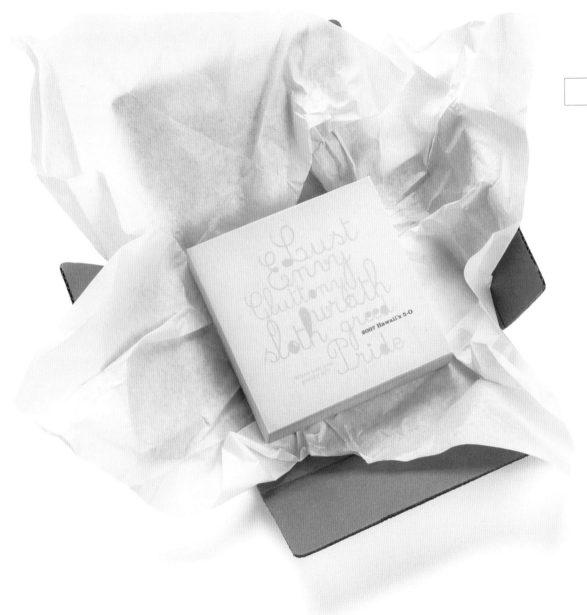

DIGGING DEEPER

Illustrators were each given a sin to interpret. They were free to use whatever style they wanted. They were then featured on seven coasters that were included as part of the CFE. The awards showcased excellence in both the design and printing industries. The visual style referenced early printing techniques such as letterpress and wood block printing. This allowed for the layering of rich colors and graphic images. The piece also used found objects along with a combination of hand lettering and traditional typefaces. All pieces were packaged and presented in a custom box and translucent vellum sleeve. The use of column-textured paper gave the box a look and feel of wood, which tied into the visual style. They were all individually hand numbered.

– Clifford Cheng

It was Socrates who said the most important thing in life is to know oneself. He believed that the Knowledge of self was the starting point of all creative and personal growth. *Sinners and Saints* was the call for entries piece for a design competition presented by the AIGA Honolulu and Hawaii's Printers. The concept was an exercise in self-examination in the context of one of the seven deadly sins, as it relates to the design profession.

DESIGN FIRM
VOICE

LOCATION
Honolulu, Hawaii, USA

ART DIRECTOR/DESIGNER
Clifford Cheng

ILLUSTRATORS
Jesse Arneson, Kris Chau, Clifford Cheng, Arne Knudson, Scott Na'auao

CLIENT
AIGA Honolulu

PRINTER
Edward Enterprises, Inc

AIGA SHOW CALL FOR ENTRIES

CHAPTER 02

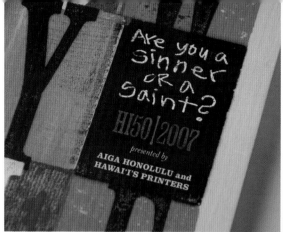

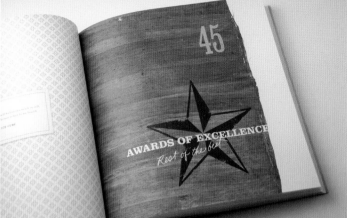

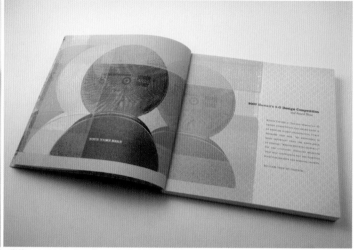

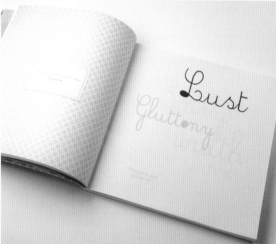

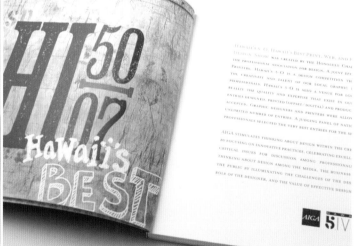

**KNOW THYSELF—
AIGA DESIGN
SHOW CATALOG**

DESIGN FIRM
VOICE

LOCATION
Honolulu, Hawaii, USA

ART DIRECTOR
Clifford Cheng

CLIENT
AIGA Honolulu

MATERIALS
Offset printing, textured paper,
hand numbered editions

PRINTER
Electric Pencil

The concept and graphic elements of the call for
entries was used as the foundation for this showcase
catalog (see previous spread). We included some
illustrations that didn't make it into the CFE. Divider
pages featured an eclectic mix of quotes from
Socrates, Oscar Wilde, Shakespeare and Ice Cube.
Each book was also hand-numbered.

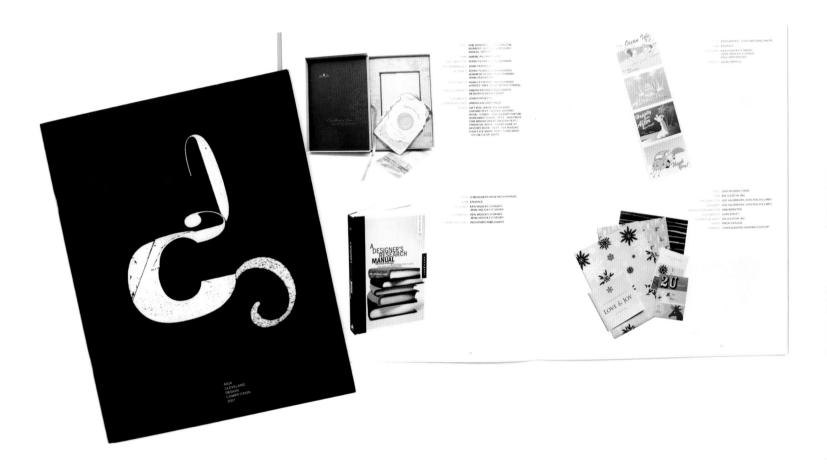

Frankensteined letterforms announce the bi-annual AIGA Cleveland Design Competition. The letterform collages reflect the numerous creative institutions in the Greater Cleveland Area coming together in a celebration of their exceptional work. Created by gluing different photocopied letters together, each character becomes an alien version of a familiar form. Pulled from Galbreath's ever-expanding trove of typographic brutalities, the results are an arresting plea for participation and a congratulatory awards book.

DESIGN FIRM
The Motorcycle Gang

LOCATION
Baltimore, Maryland, USA

DESIGNERS
Joe Galbreath, Randy Johnson, Kirsten Vollmer

CLIENT
AIGA Cleveland

MATERIALS
Photocopied collage letters

PRINTER
Genie Repros, Inc.

**AIGA CLEVELAND
DESIGN COMPETITION
CALL FOR ENTRIES**

CHAPTER 02

WHY THE WAXER STAYS WARM

Like many designers who began their careers in the mid-80s, I cut my teeth on hand skills and it was only much later that I incorporated the computer into my work. Even after 23 years, I still keep the Lectro-Stick handheld waxer warm and my exacto knives nearby. (if you are younger than 40 years old this is where old geezers like me talk affectionately about "the good old days".) Collage has remained an oft-used technique throughout my career; I started using it in my illustrations as a way to camouflage my lack of real drawing skills. I've selected three posters created over the last 15 years to show how my use of hand done design has evolved over the course of my professional life.

Robynne Raye
Modern Dog Design Co.

I started playing with stencils in 1994. The first ever poster I attempted to do with stencils was for two bands, Barbeau and Inflatable Soule. I have always experimented with posters and this one was no exception. I was greatly influenced by a talented young designer, George Estrada who was working alongside me. George had grown up skateboarding and stenciling, and I watched him just go for it without any inhibitions

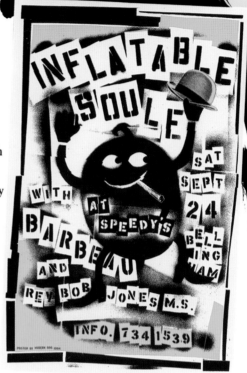

I went to the studio on a Saturday so that I could work on the poster uninterrupted and away from my co-workers. I modeled the stencils for the main character after the "M + M" candy guy and bought enough letters to spell out all the information. Then I started working. I took large pieces of butcher paper outside and just I went for it. My studio had a stat camera – a big horizontal black and white box that could take a photo and shrink things down.

The only problem was that my original artwork was too big for the camera.

So I had to do it in "pieces". When I started putting the illustration back together again, no matter how hard I tried I couldn't get the pieces to line up exactly.

The copier camera had a lens that was constantly going in and out of focus. After fighting my urge to perfect it, I decided that the misalignment made things even more interesting and so I left it alone. You can see the alignment issues in the final illustration. The addition of the orange acted as a container to the poster. And since I was still a collagist at heart, I couldn't help but add the hat and cigarette.

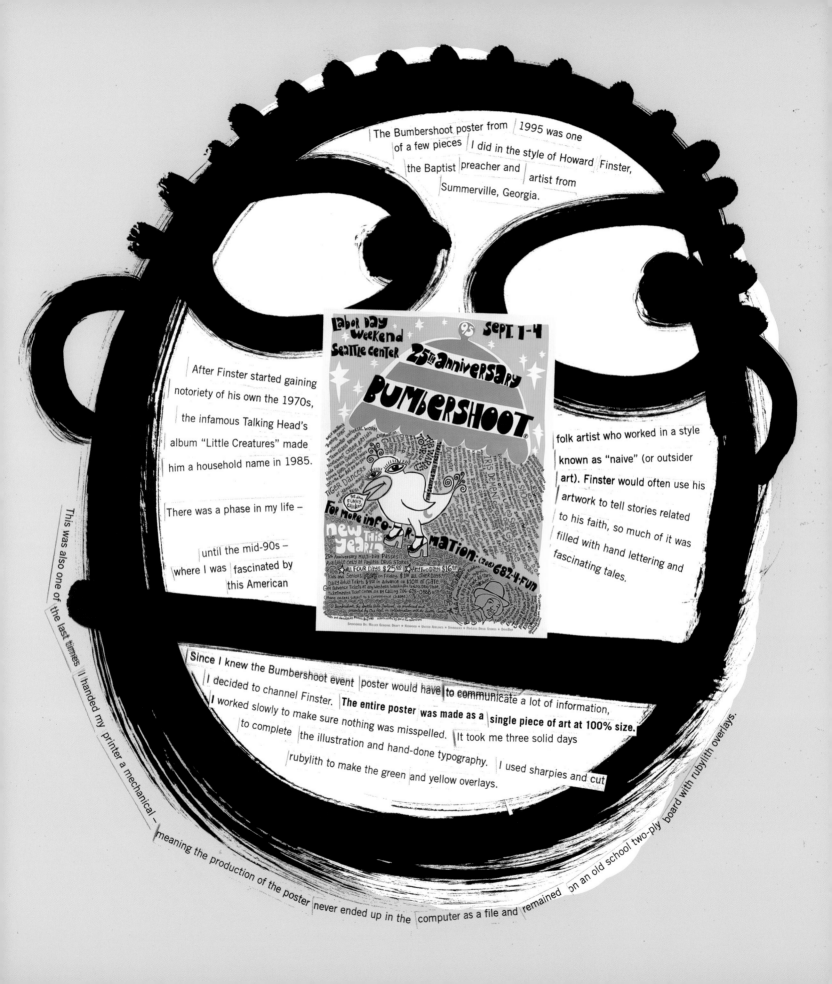

The Bumbershoot poster from 1995 was one of a few pieces I did in the style of Howard Finster, the Baptist preacher and artist from Summerville, Georgia.

After Finster started gaining notoriety of his own the 1970s, the infamous Talking Head's album "Little Creatures" made him a household name in 1985.

There was a phase in my life – until the mid-90s – where I was fascinated by this American folk artist who worked in a style known as "naive" (or outsider art). Finster would often use his artwork to tell stories related to his faith, so much of it was filled with hand lettering and fascinating tales.

Since I knew the Bumbershoot event poster would have to communicate a lot of information, I decided to channel Finster. **The entire poster was made as a single piece of art at 100% size.** I worked slowly to make sure nothing was misspelled. It took me three solid days to complete the illustration and hand-done typography. I used sharpies and cut rubylith to make the green and yellow overlays.

This was also one of the last times I handed my printer a mechanical – meaning the production of the poster never ended up in the computer as a file and remained on an old school two-ply board with rubylith overlays.

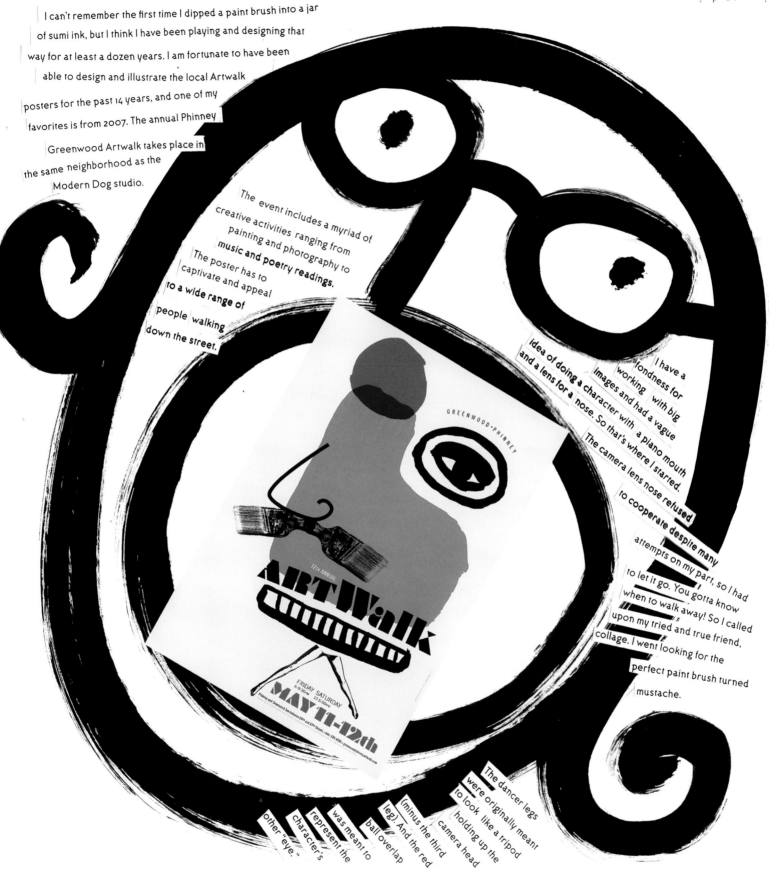

I can't remember the first time I dipped a paint brush into a jar of sumi ink, but I think I have been playing and designing that way for at least a dozen years. I am fortunate to have been able to design and illustrate the local Artwalk posters for the past 14 years, and one of my favorites is from 2007. The annual Phinney Greenwood Artwalk takes place in the same neighborhood as the Modern Dog studio.

The event includes a myriad of creative activities ranging from painting and photography to **music and poetry readings.** The poster has to captivate and appeal **to a wide range of** people walking down the street.

I have a fondness for working with big images and had a vague idea of doing a character with a piano mouth and a lens for a nose. So that's where I started. The camera lens nose refused to cooperate despite many attempts on my part, so I had to let it go. You gotta know when to walk away! So I called upon my tried and true friend, collage. I went looking for the perfect paint brush turned mustache.

The dancer legs were originally meant to look like a tripod holding up the camera head (minus the third leg). And the red ball overlap was meant to represent the character's other "eye."

GREENWOOD·PHINNEY

12TH ANNUAL

ARTWalk

FRIDAY SATURDAY
MAY 11-12th

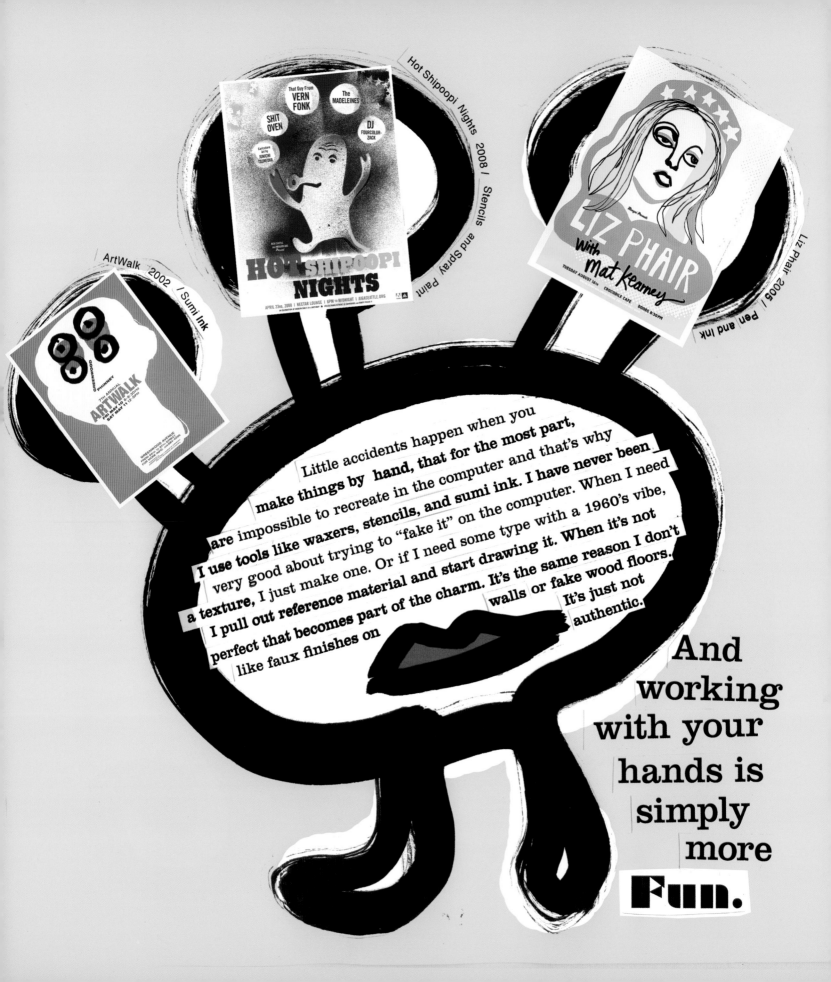

Little accidents happen when you make things by hand, that for the most part, are impossible to recreate in the computer and that's why I use tools like waxers, stencils, and sumi ink. I have never been very good about trying to "fake it" on the computer. When I need a texture, I just make one. Or if I need some type with a 1960's vibe, I pull out reference material and start drawing it. When it's not perfect that becomes part of the charm. It's the same reason I don't like faux finishes on walls or fake wood floors. It's just not authentic.

And working with your hands is simply more Fun.

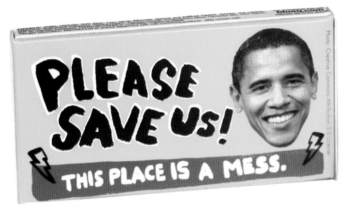

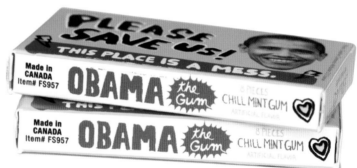

We tried several different variations on this little gum package, all of them had some sort of obvious hand done element. This was one of the first ideas—done very quickly with a brush and sumi ink. The message represents how a lot of Americans feel living in a country in financial trouble and at war. The handmade element is representative of all the people who want to see change. It's a heavy message done in a light-hearted treatment.

DESIGN FIRM
Modern Dog Design Co.

LOCATION
Seattle, Wahington, USA

ART DIRECTOR
Mitch Nash

DESIGNERS
Robynne Raye, Robert Zwiebel

CLIENT
Blue Q

MATERIALS
Sharpie, sumi ink, collage

OBAMA GUM CHAPTER 02

DESIGN FIRM
Modern Dog Design Co.

LOCATION
Seattle, Wahington, USA

ART DIRECTOR
Shogo Ota

DESIGNER/ILLUSTRATOR
Shogo Ota

CLIENT
Seattle Theatre Group

MATERIALS
Black ink pen, spray paint,
sumi ink

CHAPTER

02

BEN HARPER

I made this poster by stenciling the background with spray paint first, and then used sumi and bamboo pen drawings for the face and type. Robynne told me to fix the number 7 in the "Relentless 7" and drew me a sketch. I just scanned her drawing and dropped it in without changing it. (She doesn't know!)

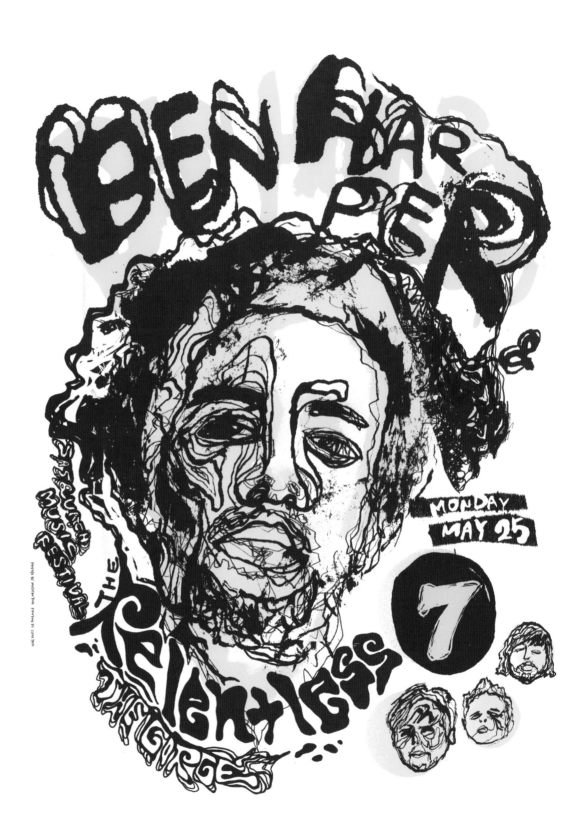

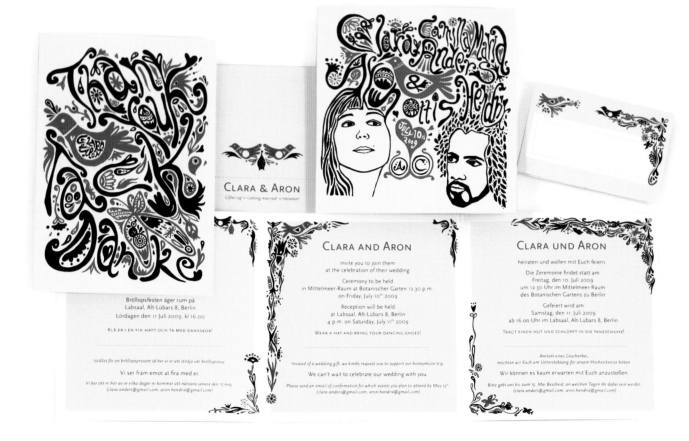

Clara Anders, a German student, graced the halls of Modern Dog as an intern for five months in 2003. After her internship ended, our relationship went from employer to friend. In July 2009, Clara married the love of her life in Germany. Clara wanted us to design a custom piece, in three languages: English, German and Swedish (since she was marrying a Swede). The illustration is based on photos of Clara and Aron. With a nod to the naïve and outsider art, we delivered and were told that people thought it was the best wedding announcement they'd ever seen. (Robynne even made the trek across the Atlantic to be Clara's maid of honor.)

DESIGN FIRM
Modern Dog Design Co.

LOCATION
Seattle, Wahington, USA

ART DIRECTOR
Robynne Raye

DESIGNERS
Shogo Ota, Robynne Raye

CLIENT
Clara Anders

MATERIALS
Black ink pen

**CLARA & ARON
WEDDING INVITE**

CHAPTER 02

CONTINUED FROM PAGE 40

some designers call "perfect imperfection": a quality of indelible beauty with the clear, delightful possibility for limitation; the presence of a human heart, moving blood through the veins of the hand that created the piece. This is tangible, visible. It's inherent in the design.

Born of this tech backlash, the handmade movement has spawned a thousand craft fairs, magazines such as Make and ReadyMade, and various sub-movements from book design to illustration and resurgences in letterpress, silkscreen, and stop-motion video. Freed of the tyranny of pixels, designers can be inspired to create, collect, and collaborate on their own hand-crafted designs.

Take hand-drawn lettering, which requires no technology except a pen or pencil and something to write on. For designers, the trend was jolted to life in 1999, with an unforgettable poster image for which the designer Stefan Sagmeister carved the details of an AIGA event into his own chest and arms with an X-acto knife. For the general public, hand-drawn letterforms probably drew notice with Geoff McFetridge's title sequences for The Virgin Suicides and the Freaks and Geeks TV show. Much as I loved them, I couldn't help recalling the opening sequence for Dr. Strangelove: whereas Pablo Ferro's crude lettering stands in playful contrast to the 1964 film's gloomy doom, the hand-drawn titles that have danced across screens in the past ten years—in movies such as Juno, Napoleon Dynamite, or Spike Jonze's weird, wonderful Where the Wild Things Are—effectively create a visual connection to the real-ness of their main character:

EMBRACING INGREDIENT X

CONTINUED ON P. 104

03

PENCIL, PEN & BRUSH

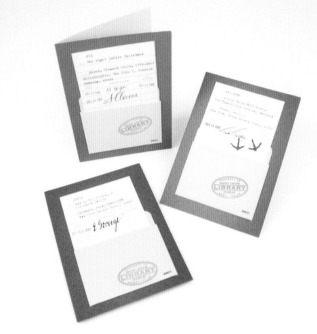

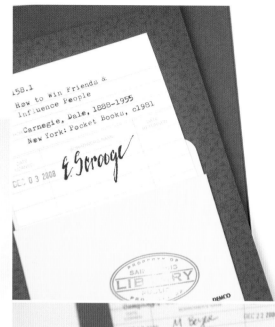

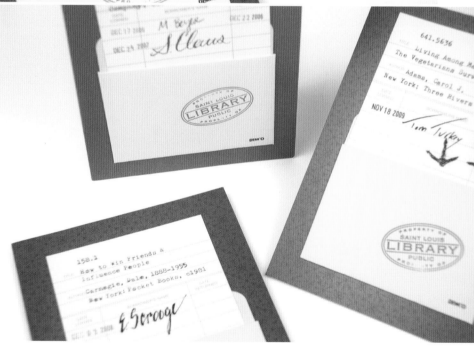

Here's to a happy and humbug-free holiday season.

ST. LOUIS PUBLIC LIBRARY FOUNDATION HOLIDAY CARDS

DESIGN FIRM
TOKY Branding + Design

LOCATION
St. Louis, Missouri, USA

ART DIRECTOR
Eric Thoelke

DESIGNER
Katy Fischer

CLIENT
St. Louis Public
Library Foundation

MATERIALS
Typewriter, Adobe Suite

For the past several years, the St. Louis Public Library has commissioned us to design their holiday card. In the spirit of the library, we created various "checked-out" books from beloved holiday characters. We typeset the cards with an actual typewriter in order to keep with the time-honored tradition of a card catalog.

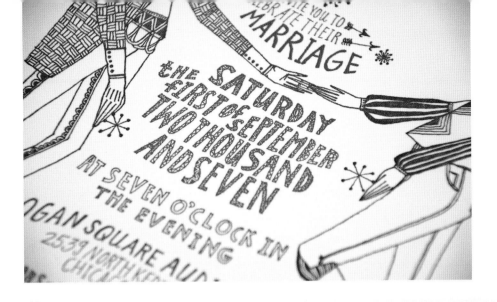

DESIGN FIRM
Rohner Letterpress

LOCATION
Chicago, Illinois, USA

DESIGNER
Ursula Arsenault

CLIENT
Ursula Arsenault

MATERIALS
Crane Pink 134# cover

PRINTER
Rohner Letterpress

CHAPTER

03

ARSENAULT/ADAMS
WEDDING INVITE

A wedding at its best is an intimate celebration of love between two people, as well as the love of family and friends that surrounds them. This particular wedding invitation is a literal illustration of that intimacy. The art was hand-drawn and lettered by a friend of the couple, then digitized and transformed into a letterpress plate. The impression of the printing layers yet another tactile dimension onto an already striking piece.

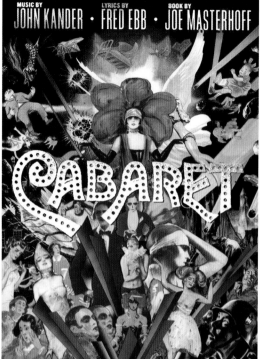

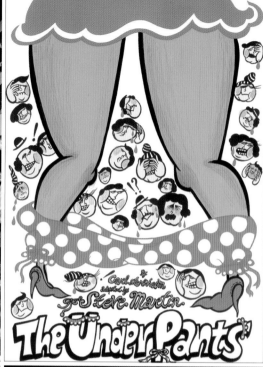

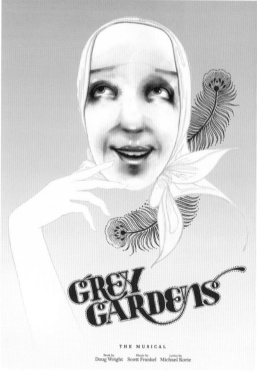

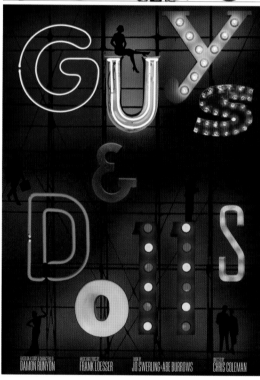

CHAPTER 03

PORTLAND CENTER STAGE POSTER SERIES

DESIGN FIRM
Plazm, Studio J

LOCATION
Portland, Oregon, USA

ART DIRECTOR
Joshua Berger

CREATIVE DIRECTOR
John C. Jay

DESIGNERS
Joshua Berger, Thomas Bradley,
Todd Houlette, Andrew Marshall

ILLUSTRATORS
Winston Smith, Cho Chan,
Michael Brophy, Storm Tharp

PHOTOGRAPHER
Swanson Studio

CLIENT
Portland Center Stage

Throughout the theater season at Portland Center Stage, audiences experience a roller-coaster ride of emotions and responses from laughter to despair. Plazm's posters for the campaign capture the emotional ride, as the city's most prestigious theater company produces comedies, musicals, traditional Shakespeare and dramas that take on serious contemporary issues—including the world premiere of the stage adaptation of Ken Kesey's classic novel *Sometimes a Great Notion*. Like Portland Center Stage, we work with internationally acclaimed artists alongside top local talent.

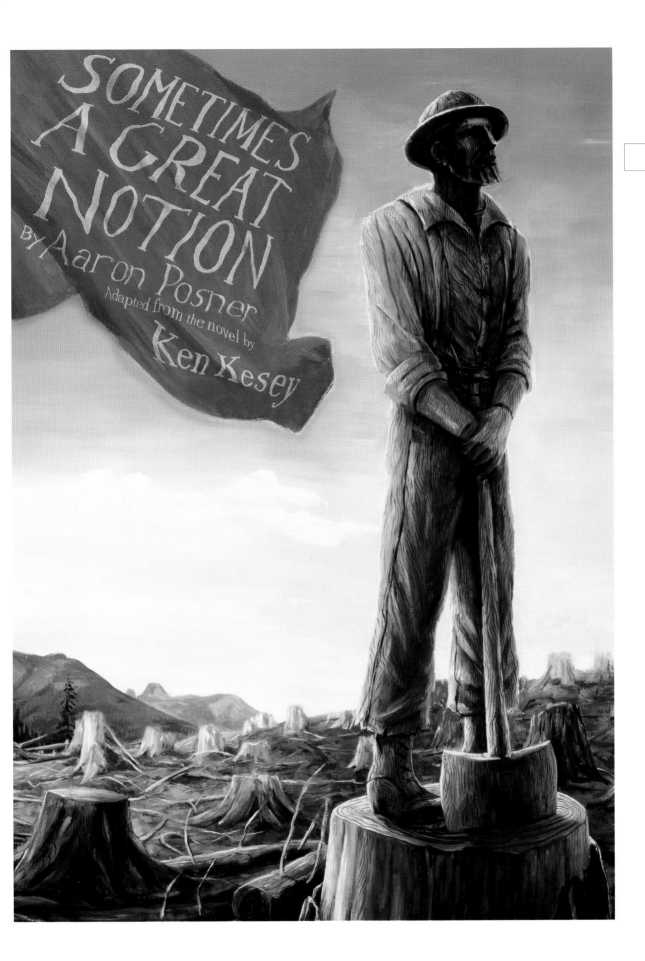

DIGGING DEEPER

This is one of those instances when I knew from the moment the theater's artistic director began talking about this play what the poster would look like. Michael Brophy, the illustrator whose work is featured on the poster, is an accomplished Northwest artist who carefully balances a narrative of human intervention with the romance of the frontier. When I called Mike, he had a great story about chasing goats around on Kesey's ranch. So that pretty much cinched it. The idea of an immovable, stoic lumberman was a great metaphor for the key character, Hank Stamper, who often is quoted saying "never give an inch."

— Joshua Berger

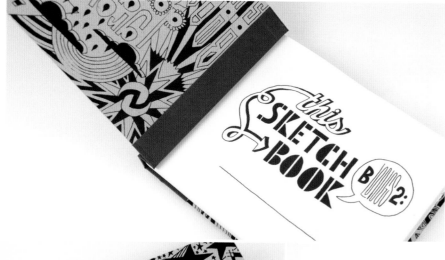

DIGGING DEEPER

In addition to wanting the sketchbook handmade, I wanted this book to be as customizable and green as possible. The cover is screenprinted on recycled chipboard and is reversible (giving the owner four cover options). The interior pages are 30 percent recycled, and the screw-post binding allows the user to replace the book with more blank pages, rather than buying a new one. We also left the printing to just black ink, hoping the book's owner would feel compelled to color it in.

— Carolyn Sewell

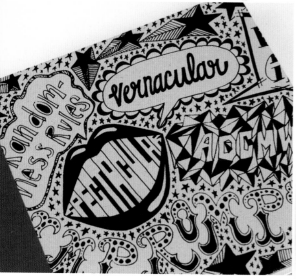

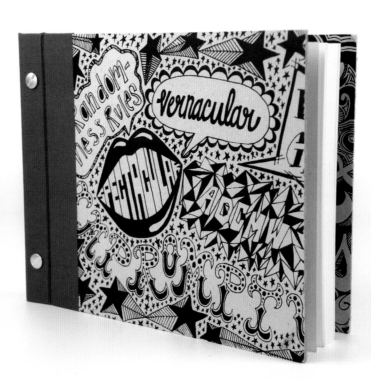

CHAPTER 03

ART DIRECTORS CLUB OF METROPOLITAN WASHINGTON MEMBER SKETCHBOOK

DESIGN FIRM
Carolyn Sewell Design

LOCATION
Arlington, Virginia, USA

ART DIRECTOR/DESIGNER
Carolyn Sewell

CLIENT
Art Directors Club of Metropolitan Washington

MATERIALS
Recycled paper, recycled chip board, screw posts, book-binding tape

PRINTER
Print Promotions Inc. (cover); Sue Conway Printing (interior)

The Art Directors Club of Metropolitan Washington wanted to give a gift to all its members as well as encourage new membership. The client and I agreed that a sketchbook would be ideal. I immediately wanted this book to be done entirely by hand, hoping to inspire designers to drop the mouse and pick up a pen. The style is a throwback to my junior high school days, bored in study hall, doodling on my book covers.

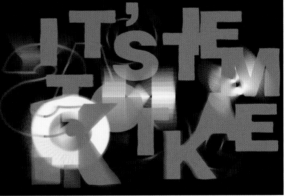

DESIGN FIRM
Tonya Douraghy

LOCATION
Brooklyn, New York, USA

DESIGNER
Tonya Douraghy

CLIENT
School of Visual Arts
MFA Design

MATERIALS
Hand-rendered typography,
animation

CHAPTER

"FIRST DAY" MUSIC VIDEO

A typographic music video for the song "First Day" by British band the Futureheads, using only black-and-white type. All type in the video was hand-rendered and then animated using Adobe After Effects. It features two original hand-drawn typefaces called Dann and Jerky. The hand-drawn typography helps to illustrate the frenzied impact of the music. Completed in the MFA Design program at the School of Visual Arts, New York City.

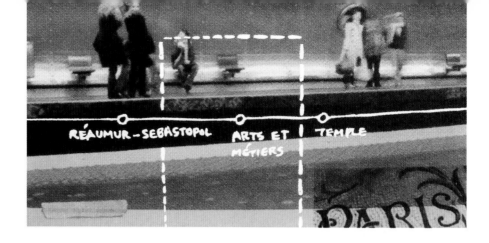

DESIGN FIRM
Helena Seo Design

LOCATION
San Jose, California, USA

ART DIRECTOR/ DESIGNER
Helena Seo

CLIENT
Ineke, LLC

MATERIALS
Hand-drawn illustrations and lettering

PRINTER
Alliora (France)

CHAPTER

PACKAGE DESIGN
FOR FIELD NOTES
FROM PARIS

Ineke is a niche perfume that combines the perfumer's love of design, literature and the arts. Field Notes From Paris is a new addition to the Ineke line, telling the story of the perfumer's study journey in Paris. The carton is composed of a series of nostalgic photos taken in Paris and multiple layers of handwritten graphics, such as illustrations of perfume ingredients, study notes and metro/street maps in Paris. The bottle is colored in deep amber and decorated with a hand-drawn street map with a small icon of the Eiffel Tower on the back. The original handmade illustrations and writings were essential tools to convey the feel of the perfumer's personal and narrative travel journal.

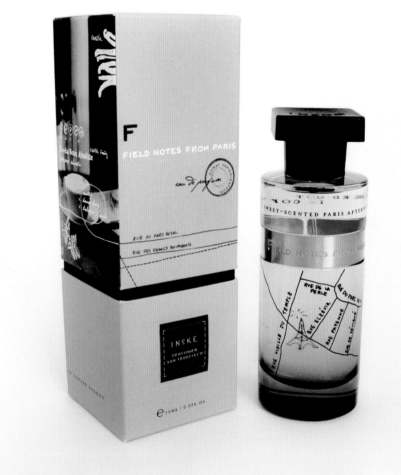

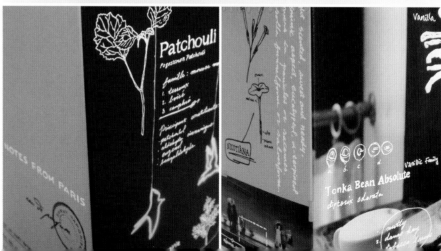

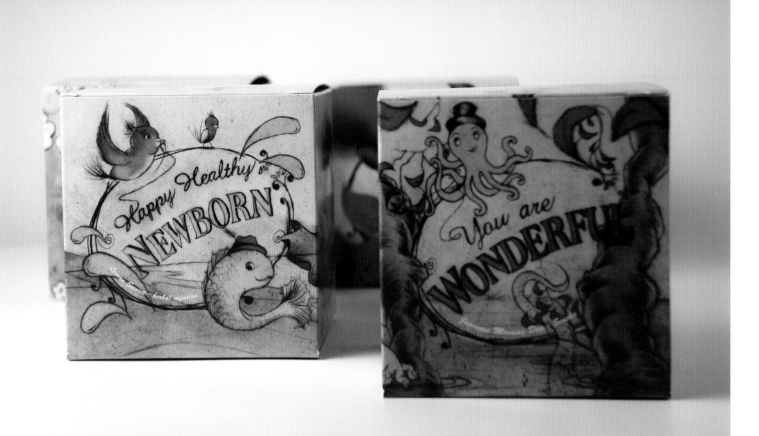

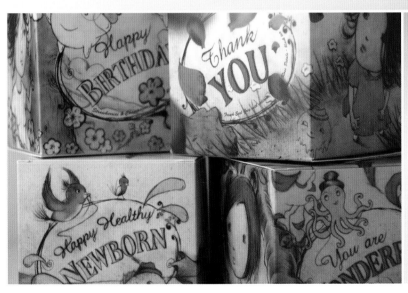

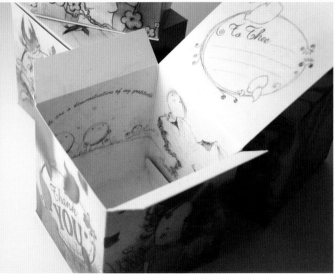

These boxes of flavored teas and infusions were tar-
geted toward female shoppers, as an affordable gift
for loved ones. Surprisingly, the main instruction I was
given was that the packaging need not promote the
contents of the box. For the themes, I tried to steer
away from traditional celebratory imagery, concentrat-
ing instead on the subtleties of relationships. What I
loved most about working on the design was that the
inside of the box is fully illustrated in graphite pencil,
providing a perfect contrast to the colorful outside.

DESIGNER
Nathaniel Eckstrom

LOCATION
New South Wales, Australia

ART DIRECTORS
Elie Azzi, Ludivine Bourdigal

CLIENT
Home and Human Fashion

MATERIALS
Graphite, digital

PRINTER
Cardboard Box Company P/L

DESIGNER
Jürgen Schlotter

LOCATION
Berlin, Germany

ART DIRECTOR
Armin Lindauer

CLIENT
Hochschule Mannheim

MATERIALS
Linocut, digital

PRINTER
Print Media Network,
Oldenburg

CHAPTER

03

"EIN HUNGER-
KÜNSTLER" STORY
ILLUSTRATIONS

The illustrations for the short story "Ein Hungerkünstler," by Franz Kafka, interpret the text in a typographic manner. The story is a parable on the human quest for attention, recognition and prestige, and it deals with the deep, inevitable psychological and emotional fall that comes from failure to achieve. All 26 letters of the alphabet, punctuation marks, and the illustrations, were cut on lino plates by Jürgen and then digitalized. The typeface is rough and edgy, which perfectly suits Kafka's story, and reflects the emaciated protagonist on the verge of self-annihilation. The book is not a quick read, so you stumble upon the letters. With a print run of only eight hundred copies, it is also a collectible item.

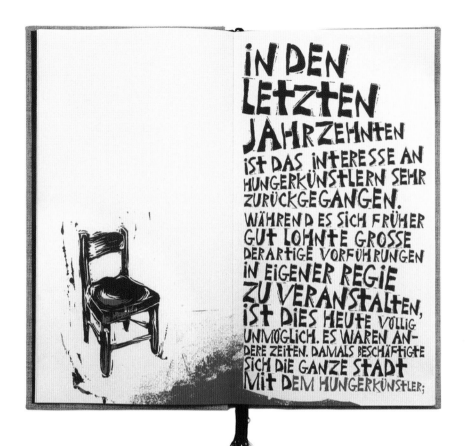

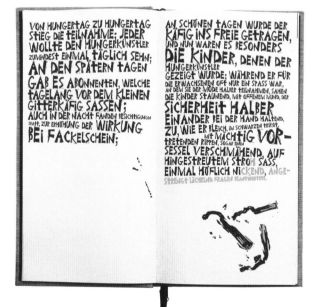

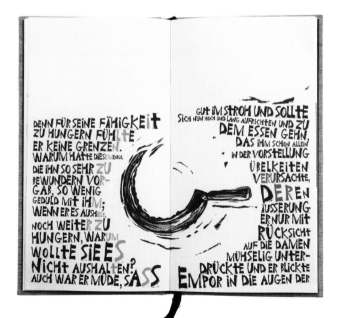

SELBST UNTER ZWANG NICHT, AUCH DAS GERINGSTE

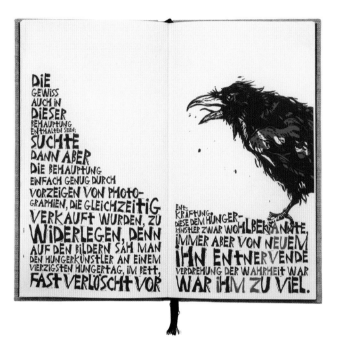

DIE GEWISS AUCH IN DIESER BEHAUPTUNG ENTHALTEN SEIN; SUCHTE DANN ABER DIE BEHAUPTUNG EINFACH GENUG DURCH VORZEIGEN VON PHOTO-GRAPHIEN, DIE GLEICHZEITIG VERKAUFT WURDEN, ZU WIDERLEGEN, DENN AUF DEN BILDERN SAH MAN DEN HUNGERKÜNSTLER AN EINEM VIERZIGSTEN HUNGERTAG, IM BETT, FAST VERLÖSCHT VOR ENT-KRÄFTUNG. DIESE DEM HUNGER-KÜNSTLER ZWAR WOHLBEKANNTE, IMMER ABER VON NEUEM IHN ENTNERVENDE VERDREHUNG DER WAHRHEIT WAR IHM ZU VIEL.

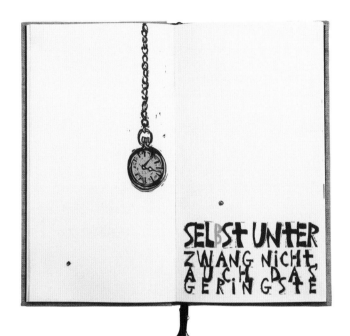

DENN FÜR SEINE FÄHIGKEIT ZU HUNGERN FÜHLTE ER KEINE GRENZEN. WARUM HATTE DIESE MENGE, DIE IHN SO SEHR ZU BEWUNDERN VOR-GAB, SO WENIG GEDULD MIT IHM; WENN ER ES AUSHIELT, NOCH WEITER ZU HUNGERN, WARUM WOLLTE SIE ES NICHT AUSHALTEN? AUCH WAR ER MÜDE, SASS GUT IM STROH UND SOLLTE SICH NUN HOCH UND LANG AUFRICHTEN UND ZU DEM ESSEN GEHN, DAS IHM SCHON ALLEIN IN DER VORSTELLUNG ÜBELKEITEN VERURSACHTE, DEREN ÄUSSERUNG ER NUR MIT RÜCKSICHT AUF DIE DAMEN MÜHSELIG UNTER-DRÜCKTE UND ER BLICKTE EMPOR IN DIE AUGEN DER

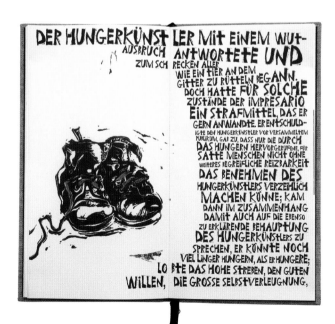

DER HUNGERKÜNST LER MIT EINEM WUT-AUSBRUCH ANTWORTETE UND ZUM SCH RECKEN ALLER WIE EIN TIER AN DEM GITTER ZU RÜTTELN BEGANN. DOCH HATTE FÜR SOLCHE ZUSTÄNDE DER IMPRESARIO EIN STRAFMITTEL, DAS ER GERN ANWANDTE. ER ENTSCHULD-IGTE DEN HUNGERKÜNSTLER VOR VERSAMMELTEM PUBLIKUM, GAB ZU, DASS NUR DIE DURCH DAS HUNGERN HERVORGERUFENE, FÜR SATTE MENSCHEN NICHT OHNE WEITERES BEGREIFLICHE REIZBARKEIT DAS BENEHMEN DES HUNGERKÜNSTLERS VERZEIHLICH MACHEN KÖNNE; KAM DANN IM ZUSAMMENHANG DAMIT AUCH AUF DIE EBENSO ZU ERKLÄRENDE BEHAUPTUNG DES HUNGERKÜNSTLERS ZU SPRECHEN, ER KÖNNTE NOCH VIEL LÄNGER HUNGERN, ALS ER HUNGERE; LOBTE DAS HOHE STREBEN, DEN GUTEN WILLEN, DIE GROSSE SELBSTVERLEUGNUNG,

PARADIGM PARABLES

DESIGN FIRM
Taxi Studio

LOCATION
Bristol, England

CREATIVE DIRECTOR
Spencer Buck

DIRECTOR
Ryan Wills

CLIENT
Paradigm

MATERIALS
Hand-drawn scraperboard
illustrations

Paradigm is a leading secure communications company providing services for the armed forces. To them, customer service is paramount, as lives are at stake. Taxi Studio was briefed to design an inspirational internal communication to set out their brand values for all employees to read and absorb. We created the *Paradigm Parables*—a collection of memorable stories that illustrate their brand values in a simple, fun and compelling way. Deliberately avoiding modern cues, we adopted a traditional feel, commissioning over forty scraperboard illustrations to bring the stories to life.

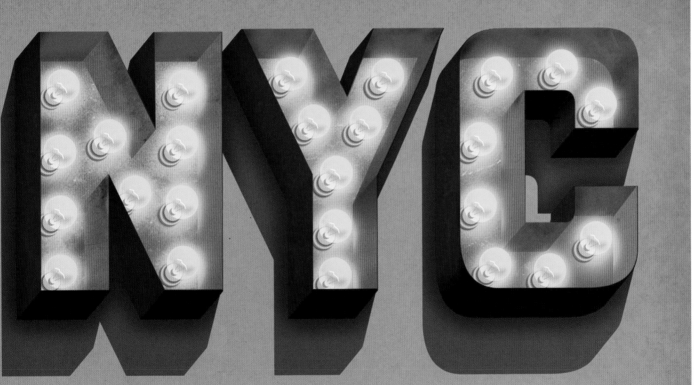

This mark was created for ABI/NYC, a design exhibition featuring several NYC designers organized by the Department of Art & Design at Abilene Christian University. The type is designed to express the personality of the two cities. ABI (the airport code for Abilene, Texas) was drawn by hand and expresses the ruggedness and climate of the city. The illustration of NYC uses some good ol' light bulb type to convey the glamour of New York. A beautiful juxtaposition is created when the two come together. If ABI were not hand drawn, the contrast between the two sets of letters would not have the same impact.

DESIGN FIRM
Der Bergman

LOCATION
New York City, New York, USA

DESIGNERS
Jeff Rogers, Ryan Feerer

CLIENT
Abilene Christian University

MATERIALS
Paper, pencil, scanner, Illustrator, Photoshop

ABI/NYC LOGO MARK

CHAPTER

03

DESIGNER/ILLUSTRATOR
Kyle Pierce

LOCATION
San Francisco, California, USA

CLIENT
Kyle Pierce

MATERIALS
Photographs, pencil,
ink, oil pastel

CHAPTER

03

HANDMADE

I am an illustrator and photographer who enjoys building layered narratives from photographs, illustrations and bits of hand-drawn type. My drawings used to serve as sketches for larger paintings until I realized that I enjoyed making the drawings more. There is immediacy to drawing (by hand), and as a result, the end product tends to feel more "alive." I primarily use pencil, ink and oil pastel, and I draw from life, photographs and memory. In recent years, my illustrations have incorporated photography, allowing me to merge the real and surreal in an authentic way.

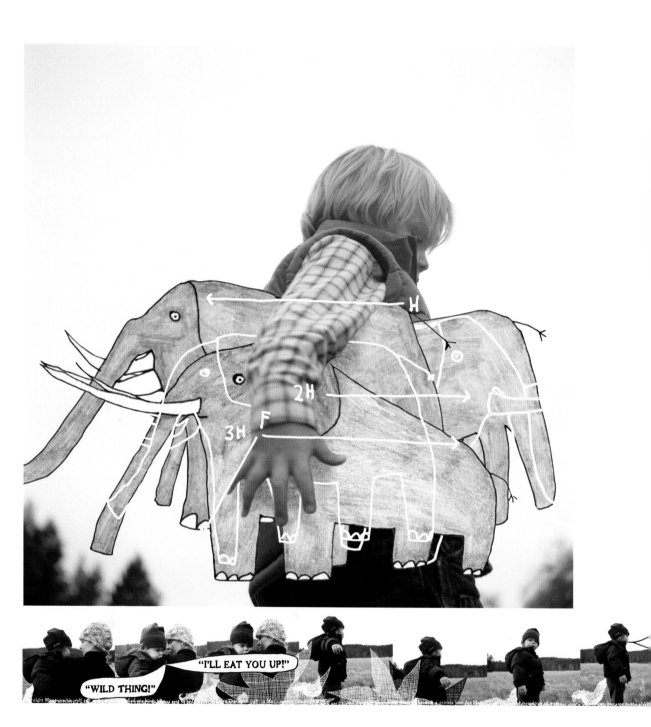

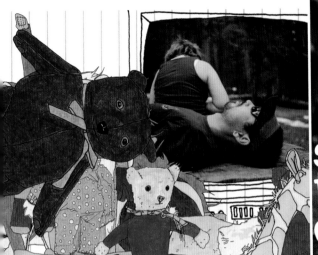

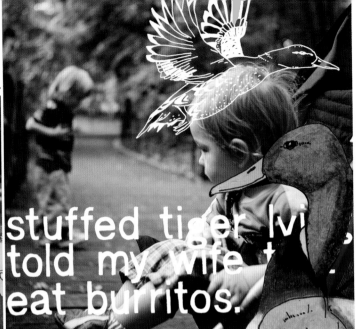

stuffed tiger lvi
told my wife t
eat burritos.

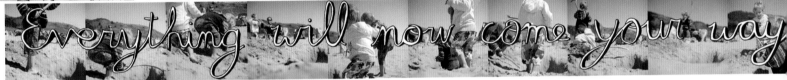

Everything will now come your way

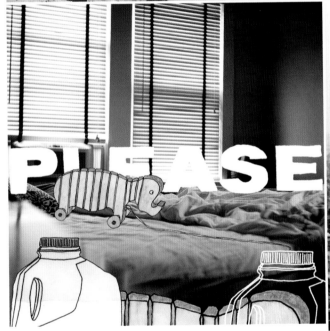

PLEASE

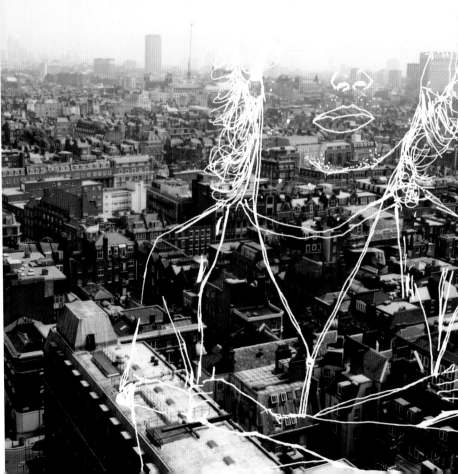

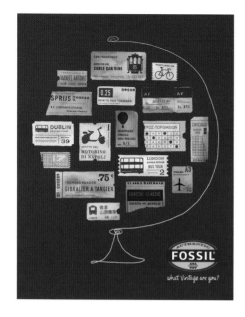

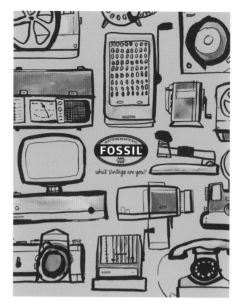

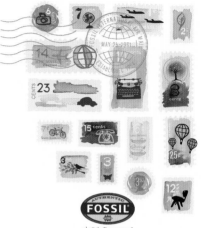

Fossil International
134872 Berlin
Germany

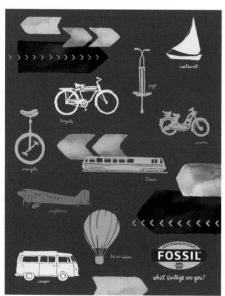

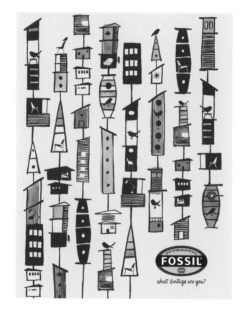

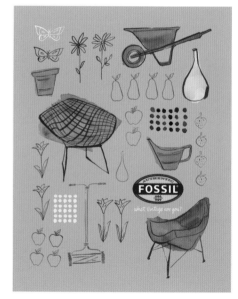

CHAPTER 03

FOSSIL 2009 BRAND POSTERS

DESIGN FIRM
Fossil

LOCATION
Richardson, Texas, USA

CREATIVE DIRECTORS
Stephen Zhang, Dru McCabe,
Betsy Jones

DESIGNERS
Rachel Voglewede, Pamela
Jackson, Bekah Wertz, Brent
Couchman, Caroline Duncan

CLIENT
Fossil

MATERIALS
Pen and ink, watercolor

Because creativity and design are core values of the Fossil brand, we rely on our seasonal graphics to communicate our evolving brand story to consumers. In recent years, we've used hand-rendered techniques to not only convey our friendly and approachable brand personality but also add a personal touch to all of our communications. These individual pieces were all hand-rendered in ink and watercolor, then assembled together digitally. The subjects we focused on in each piece hearken back to our product assortment, seasonal themes and the vintage creative culture that's at the heart of the Fossil brand.

DESIGNER
Daniel Zender

LOCATION
Springfield, Missouri, USA

CLIENT
20th Century
American Poetry

MATERIALS
Ink, pencil, found
photography, crayon

CHAPTER

03

**POETRY COLLECTION
BOOK COVER**

Pencil, ink, found photography and paint were combined to illustrate the modern language of contemporary American poetry. By contrasting the imagery of birds singing with the image of a skull, an eye-catching and attractive cover is created, without being banal.

DESIGN FIRM
TOKY Branding + Design

LOCATION
St. Louis, Missouri, USA

ART DIRECTOR
Eric Thoelke

DESIGNER
Katy Fischer

ILLUSTRATOR
Noah Woods

CLIENT
St. Louis Public
Library Foundation

CHAPTER

03

ST. LOUIS PUBLIC LIBRARY FOUNDATION BANNERS

The St. Louis Public Library had seen a drop in attendance over the past few years. It seemed that people forgot it was there. TOKY was enlisted to increase attendance and get people excited about the downtown library again. We collaborated with illustrator Noah Woods to create large, exterior banners. The illustrations, filled with bright colors and whimsical images, brought energy and attention to the library while highlighting some of the many advantages the library has to offer.

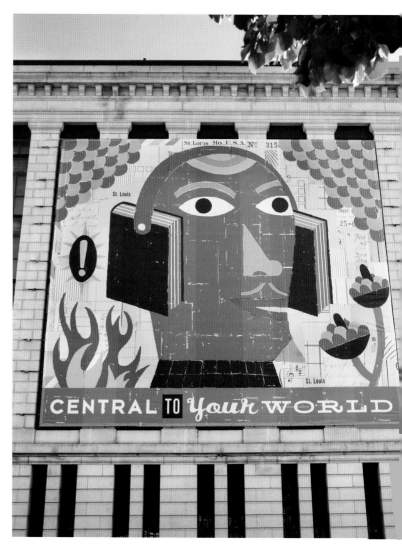

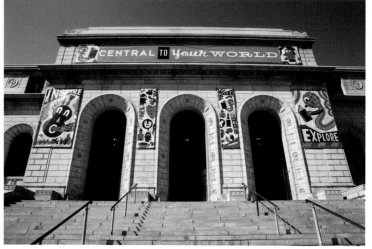

Many Denver Public Schools lack funding to provide library access to kids. The "Reading Rocket" bookmobile, which is operated by the Denver Public Library, brings books and a renewed excitement about reading to underserved schools.

DESIGN FIRM
Tomorrow Partners

LOCATION
Berkeley, California, USA

ART DIRECTOR
Gaby Brink

DESIGNERS
Nate Williams, Jeff Iorillo

CLIENT
Janus

READING ROCKET BOOKMOBILE

CHAPTER 03

DESIGN FIRM
Sagmeister Inc.

LOCATION
New York City, New York, USA

ART DIRECTOR
Stefan Sagmeister

DESIGNER
Yuko Shimizu

CLIENT
The Robin Hood Foundation,
New York Public School 96

CHAPTER

03

EVERYBODY WHO IS HONEST IS INTERESTING

The New York-based nonprofit organization Robin Hood instituted a successful program planning, designing and constructing complete libraries for grade schools in poor neighborhoods. As organizers implemented the program, they found they were always left with a rather large strip of wall above the kid-size bookcases. Rather than painting them an institutional color, they decided to commission murals.

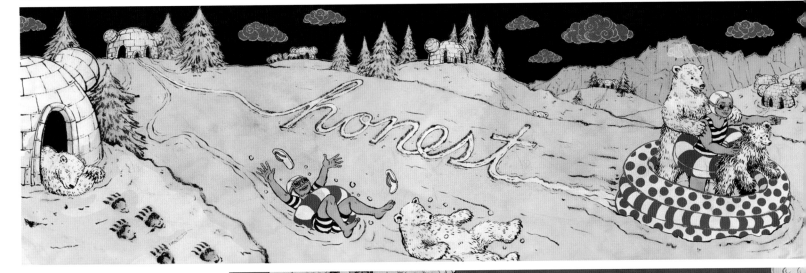

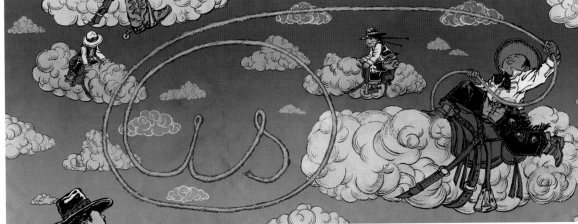

DESIGN FIRM
TOKY Branding + Design

LOCATION
St. Louis, Missouri, USA

ART DIRECTOR
Eric Thoelke

DESIGNER
Mary Rosamond

CLIENT
The Unconscious

MATERIALS
Hand-drawn illustration,
typography

CHAPTER

03

THE UNCONSCIOUS POSTER

The Unconscious was originally formed in 1986. Their punk-funk sound with a New Orleans bent won them local popularity through the late 80s, with increasing national appeal through 1990. We were asked to create a poster for their Labor Day Weekend reunion performance at Blueberry Hill. All the poster imagery—including the band's logo, as well as the typography detailing the event information—was hand drawn with pencil onto tracing paper. The drawing was then scanned and converted to vectors for coloring and printing. The hand-drawn illustration and typography were necessary to create the unique variability in line weight that married beautifully with the band's existing logo.

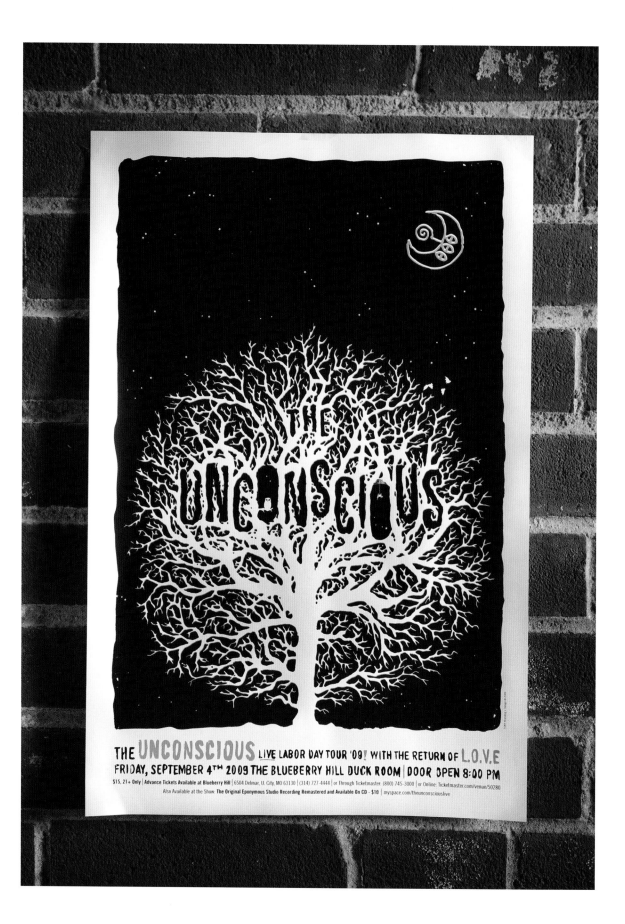

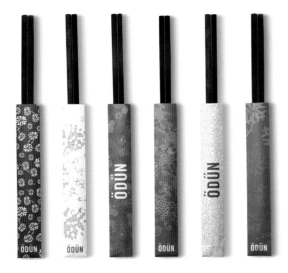

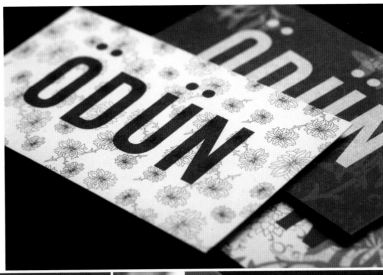

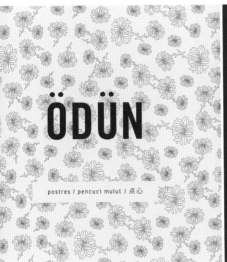

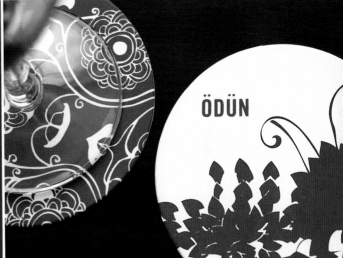

ÖDÜN

postres / pencuci mulut / 点心

ÖDÜN

bebidas / minuman / 饮料

ÖDÜN

For a new restaurant opening in Mexico City, with a mixed menu featuring cuisines from Thailand, China, Japan and Vietnam. We needed to define an identity that would carry the flavor and scent (spices and sensibility) of the region without reflecting one specific country. We designed patterns based on the diverse cultures, with a color palette that feels Asian yet contemporary.

DESIGN FIRM
Blok Design

LOCATION
Mexico City, Mexico

ART DIRECTOR
Vanessa Eckstein

DESIGNERS
Vanessa Eckstein, Patricia Kleeberg, Mariana Contegni

CLIENT
Odun

MATERIALS
Illustration

PRINTER
Grupo Fogra

ODUN

CHAPTER 03

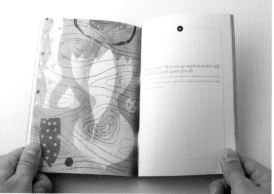

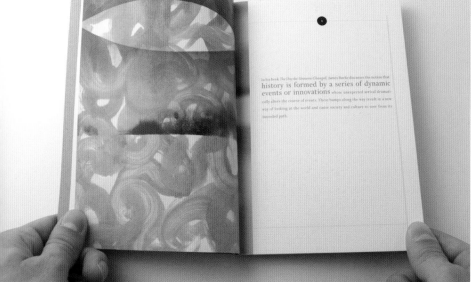

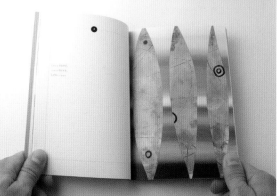

DESIGN FIRM
Aufuldish & Warinner

LOCATION
San Anselmo, California, USA

DESIGNER
Bob Aufuldish

ILLUSTATOR
Katherine Warinner

CLIENT
SWA Group

MATERIALS
Monotypes, paintings, scanner

PRINTER
Hemlock Printing

SWA Group are landscape architects headquartered in Sausalito, California. To celebrate their fiftieth anniversary, we designed a book of fifty quotes by SWA partners, associates and employees about the future of landscape architecture. Juxtaposed with the quotes are evocative details of monotypes and paintings by A&W partner Katherine Warinner. Katherine's work was the perfect way to allude to landscape without having to show it. And by using such nontraditional, nonlinear imagery for landscape architecture, the booklet helped communicate SWA's intention to continue to innovate into the future.

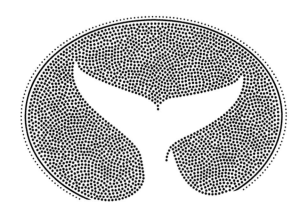

THE
PRESERVE
LA BALLENA
BAJA MEXICO

The Preserve at La Ballena is truly an undiscovered expanse of Western Pacific land. The specific area is known as a pathway for the whale migration during the fall months, which became the basis of our concept. We edited the mark down to the whale's tail and gave it an organic tone by literally placing each of those dots by hand, evoking the imperfections of golden sand. This, paired with textured type by use of printing methods and blender markers, gave the identity a sense of history.

DESIGN FIRM
Markatos Moore

LOCATION
San Francisco, California, USA

ART DIRECTORS
Peter Markatos, Tyler Moore

DESIGNER
Kerry Williams

CLIENT
The Preserve

MATERIALS
Handmade logomark,
type, blended pen

THE PRESERVE

CHAPTER 03

DESIGN FIRM
Mitre Agency

LOCATION
Greensboro, North Carolina, USA

ART DIRECTOR
Troy Tyner

DESIGNERS
Rachel Martin,
Catherine Pipkin

CLIENT
Brew Nerds Coffee

MATERIALS
Various

CHAPTER

03

BREW NERDS COFFEE BRAND IDENTITY & PACKAGING

"The ancients spoke of a day when a fellowship of highly intelligent strangers would journey to earth to discover the magical coffee fields of middle earth. Together they would harvest this crop and forever break the decades-old curse of the evil mermaid. That day is now, and that magical coffee can be found at Brew Nerds." Brew Nerds is a coffee shop franchise that micro-roasts on site. It's a place for people who are serious about coffee—but who don't take themselves too seriously. Staying true to that ideal, Mitre Agency partnered with Brew Nerds from their inception to create a lo-fi, dry-witted and whimsical brand identity and packaging that would appeal to smart folks who just want good coffee.

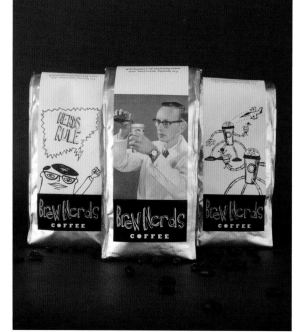

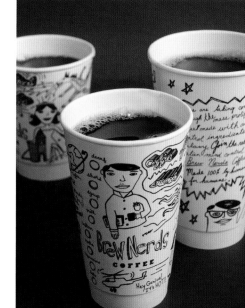

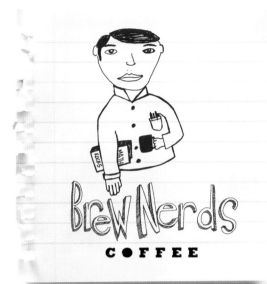

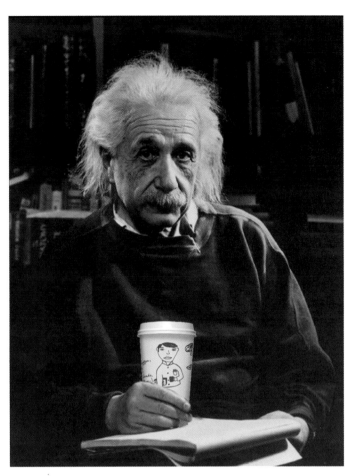

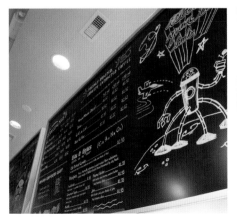

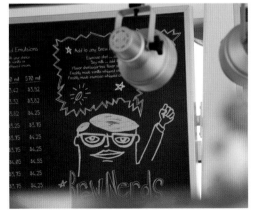

DESIGN FIRM
TOKY Branding + Design

LOCATION
St. Louis, Missouri, USA

ART DIRECTOR
Eric Thoelke

DESIGNER
Travis Brown

CLIENT
Art the Vote

CHAPTER

03

ART THE VOTE
CAMPAIGN

Art the Vote is a non-partisan organization that uses artist-designed outdoor boards to broach topics and drive voter registration. Billboards were placed throughout urban and rural Missouri. The website features a public gallery, allowing anyone to design, upload and vote on their own billboard design. The winning billboard design was used throughout Missouri.

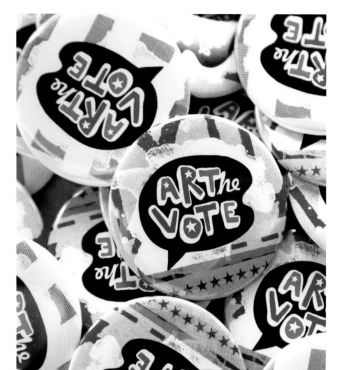

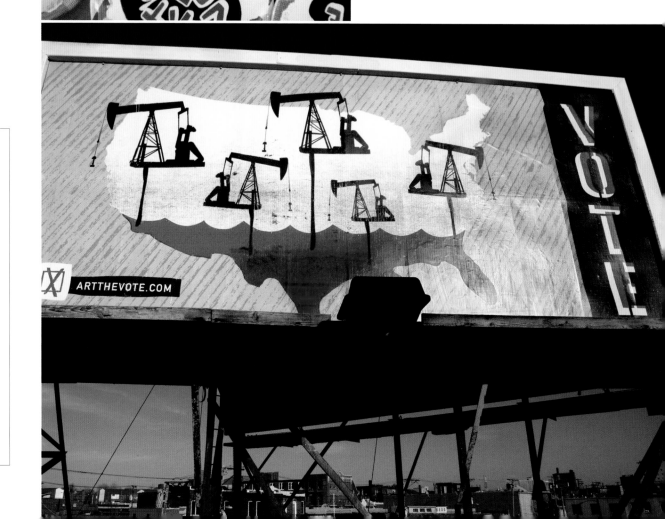

DIGGING DEEPER

The swatchbook features multiple innovative prints-finishing techniques, such as hybrid UV printing, flock printing and 3-D embossing, as well as traditional finishings such as French-fold and handsewn binding. The combination of storytelling, well-executed design and excellent print finishing generated a very positive response and awareness from the target group.

— Victor Lim

When Antalis looked to launch a new line of shiny metallic papers, it commissioned Trine to create a promotional swatchbook that not only showcased the quality of the fine premium papers, but created desirability with the target audience—predominantly designers, printers and end-clients from luxury and retail industries. Through a collaborative effort with a group of talented local illustrators and writers, the swatchbook transformed into an enchanting storybook inspired by the magpie's unbridled natural fascination with shiny objects.

DESIGN FIRM
Trine Design Associates Pte Ltd

LOCATION
Singapore

ART DIRECTOR
Victor Lim

COPYWRITER
Clare Lee

ILLUSTRATORS
Adeline Tan, Arlene Rieneke, Cherie Tan, Drewscape, Eeshaun, Mindflyer, Neo Ann Gee, Xin, Ralph Samson

CLIENT
Antalis (Singapore) Pte Ltd.

PRINTER
Kin Yiap Press Pte Ltd.

MARLEY MAGPIE & THE SEARCH FOR THE SHINIEST OBJECT

CHAPTER 03

DESIGN FIRM
Volume Inc.

LOCATION
San Francisco, California, USA

ART DIRECTORS
Adam Brodsley, Eric Heiman

DESIGNERS
Talin Wadsworth, Kim Cullen

ILLUSTRATOR
Jasper Wong

CLIENT
Yerba Buena Center
for the Arts

CHAPTER

**YERBA BUENA
CENTER FOR
THE ARTS**

YBCA wanted to reassert itself as the Bay Area's primary venue for showcasing diverse, cutting-edge contemporary art in a variety of disciplines, including visual art, performance and film/video. One of the words that came up in early discussions to describe YBCA was "subversive," and the design concept came out of studies around how to express this trait visually. This dovetailed nicely with the need to separate YBCA from the other local art museums and organizations whose promotion primarily tended towards the more stately and reserved. Jasper sketched out the illustrations with pencil on pieces of vellum. Once we were happy with the look of the characters, he finalized the drawing by inking it. The design assemblages for the final campaign were done digitally.

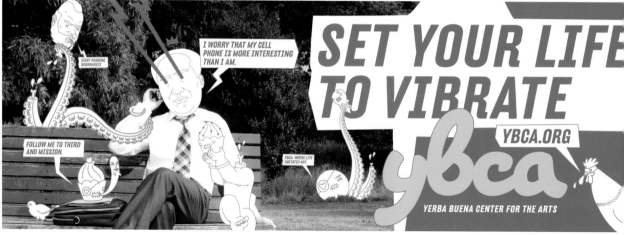

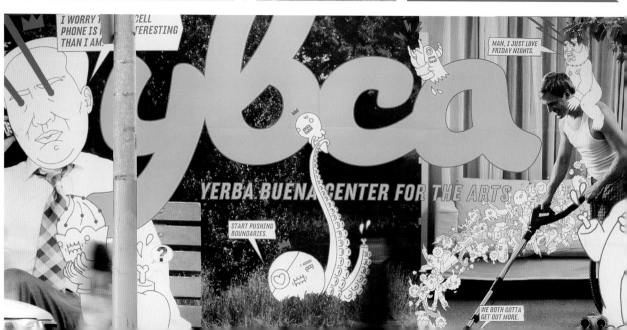

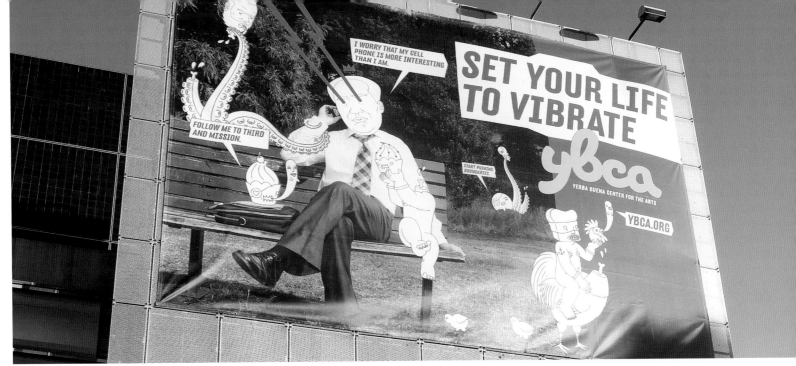
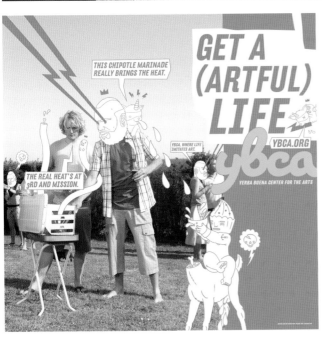
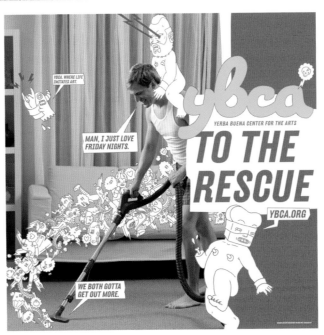

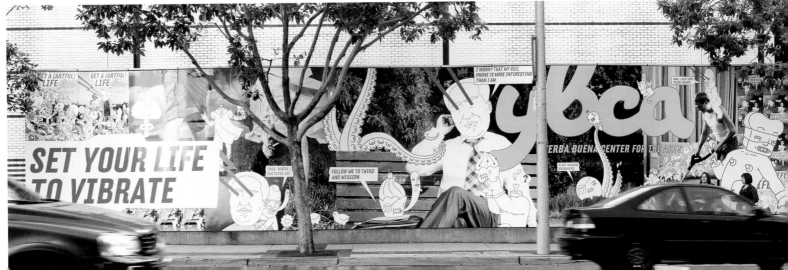

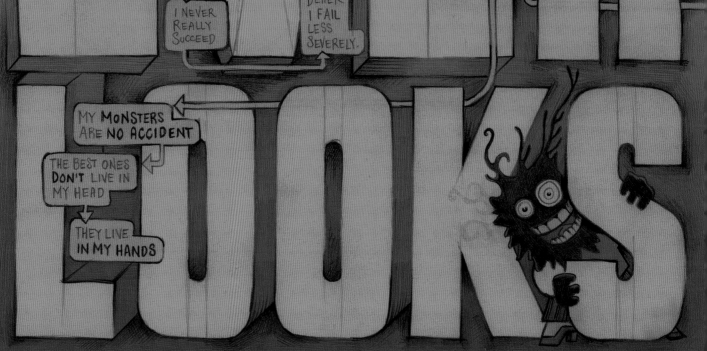

**CREATIVE REVIEW
COVER**

DESIGN FIRM
344 Design, LLC

LOCATION
Pasadena, California, USA

ART DIRECTOR
Paul Pensom

EDITOR
Patrick Burgoyne

DESIGNER/ILLUSTRATOR
Stefan Bucher

CLIENT
Creative Review

MATERIALS
Pen, ink

When the British design magazine *Creative Review* featured me in their August 2010 issue, they also invited me to design their cover. As it was the Summer Fun issue, I thought I'd let the monsters go to the beach and get their surf on. Sadly, we weren't able to perforate the cover, as it would've caused too much damage during shipping and on the newsstand, but only about three minutes of X-Acto work stand between you and your own Surfin' Monster diorama. Once you set up the wave, you'll find a beach complete with riddles, including two separate strings of code leading to an online component with more riddles.

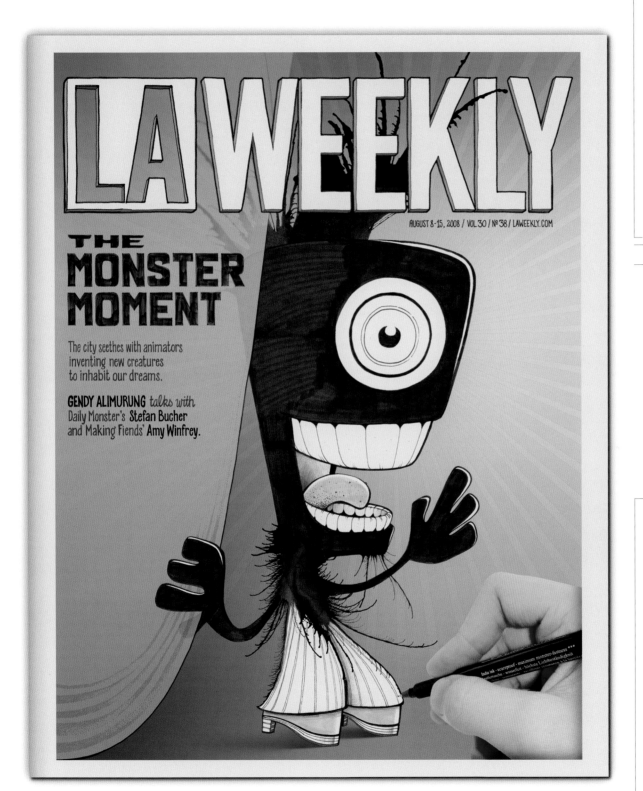

DESIGN FIRM
344 Design, LLC

LOCATION
Pasadena, California, USA

DESIGNER/ILLUSTRATOR
Stefan Bucher

CLIENT
LA Weekly

MATERIALS
Pen, ink

CHAPTER

03

LA WEEKLY
COVER

The *LA Weekly* wrote a very kind article about the Daily Monsters, and asked me to create the cover for that issue. Who am I to say no to an invitation like that. You can see a time-lapse video of me drawing this Monster (along with some behind-the-scenes goodies) at tinyurl.com/laweeklymonster.

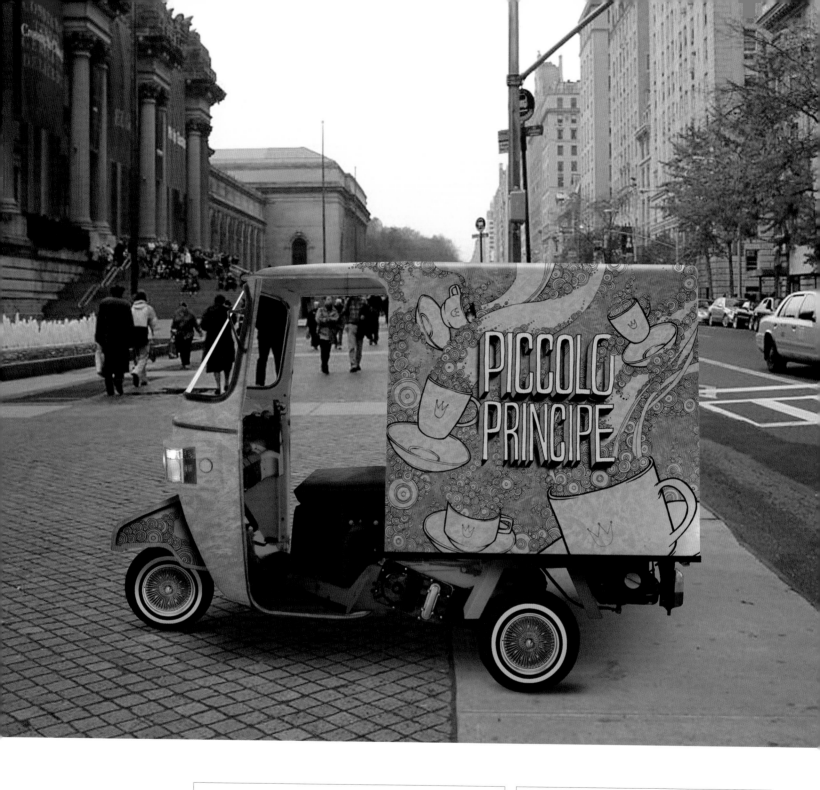

PICCOLO PRINCIPE

DESIGN FIRM
344 Design, LLC

LOCATION
Pasadena, California, USA

DESIGNER/ILLUSTRATOR
Stefan Bucher

CLIENT
Dagstani & Sons

MATERIALS
Pen, ink

Gastronomic entrepreneur Rajah Dagstani of Dagstani & Sons approached me about designing a logo for his new mobile cappuccino venture "Piccolo Principe"—the little prince—but neither one of us know how to leave well enough alone, so a logo turned into covering the entire van in gold leaf and classic flake gold paint. It's coming to a town near you as soon as we figure out the intricacies of the plumbing.

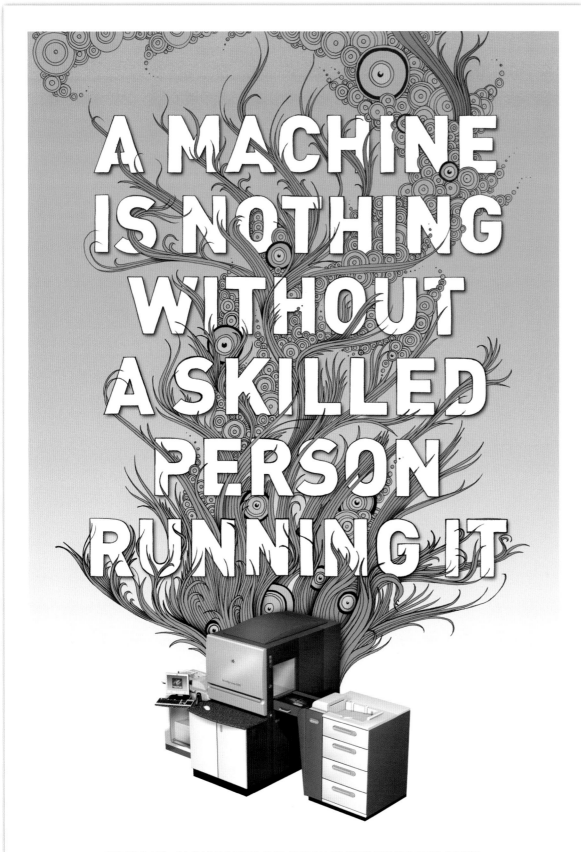

THAT SAID, PLEASE MEET OUR SHINY NEW **HP INDIGO 5500** PRESS

SHORT RUN DIGITAL PRINTING WITH REAL INK, NOT TONER NOW AVAILABLE WITH **TYPECRAFT QUALITY**

DESIGN FIRM
344 Design, LLC

LOCATION
Pasadena, California, USA

DESIGNER/ILLUSTRATOR
Stefan Bucher

CLIENT
Typecraft Wood & Jones

MATERIALS
Pen, ink

CHAPTER

HP INDIGO PRESS POSTER

Typecraft Wood & Jones print everything I do that doesn't get printed by my publishers. When they added a fancy new digital press to their range of services, they asked me to create a poster to introduce it. They held back on going the digital printing route until they felt that the quality was on par with their offset work and that they could offer the same quality they're known for, so the headline practically wrote itself. As for the illustration, that's just what I see when I look at that press. It's a glorious machine!

DESIGN FIRM
344 Design, LLC

LOCATION
Pasadena, California, USA

DESIGNER/ILLUSTRATOR
Stefan Bucher

COPYWRITING
Stefan Bucher

CLIENT
826la.org

PRINTING
Typecraft Wood & Jones

CHAPTER

03

SPELLING BEE POSTER

826LA is a part of novelist Dave Eggers' national nonprofit organization dedicated to supporting students ages six to eighteen with their creative and expository writing skills, and to helping teachers inspire their students to write. The Spelling Bee for Cheaters was their 2010 fundraiser, allowing those contestants who raised the most money to cheat their way into the finals. The poster grew out of my long association with 826LA as the designer of their Echo Park Time Travel Mart. This one worked like my "ink & circumstance" pieces, where I write it as I illustrate.

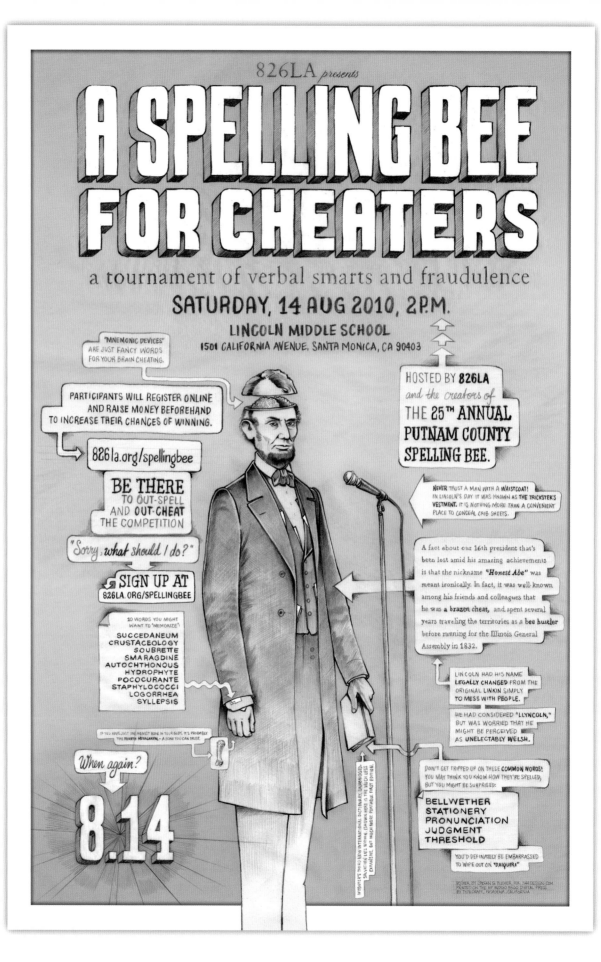

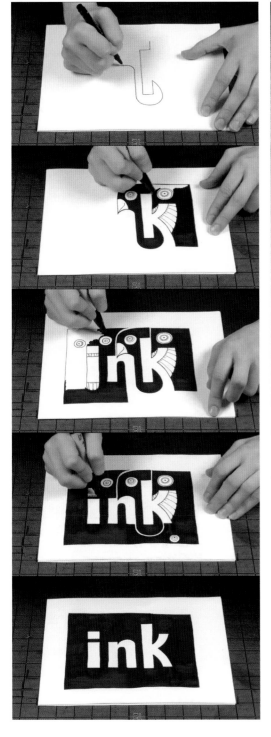

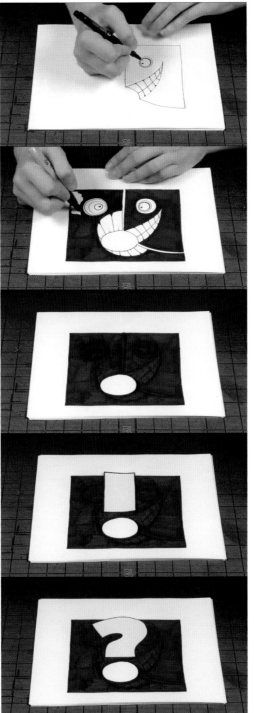

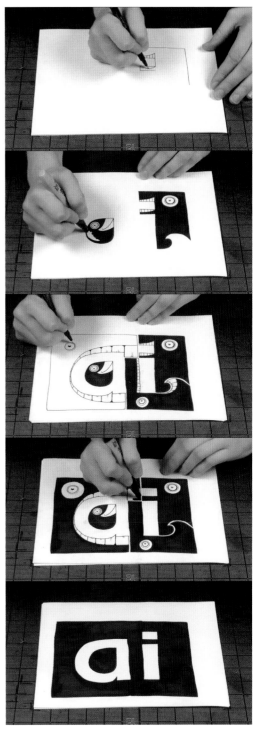

In the wake of the Daily Monsters' initial success, the brilliant folks at Sesame Workshop invited me to do some time-lapse drawings for their reboot of the classic children's show *The Electric Company*. You may remember Rita Moreno's "Hey, you guuuuys!" I created a series of drawings called "The Daily Letter," featuring Monsters that live in the negative space around letters. You can see the drawings take shape at tinyurl.com/electricmonsters.

DESIGN FIRM
344 Design, LLC

LOCATION
Pasadena, California, USA

DESIGNER/ILLUSTRATOR
Stefan Bucher

CLIENT
The Electric Company

MATERIALS
Pen, ink

CONTINUED ON P. 134

CONTINUED FROM PAGE 64

think of Juno or Napoleon or Max, struggling to navi-gate a world where they don't quite fit in.

Sound familiar?

Freehand letters also showed up on book cover designs (think Jonathan Safran Foehr's Extremely Loud & Incredibly Close), in advertising (remember those Popeye's commer-cials and HP "Hands" ads?), and were incorporated into the layouts of Flaunt, Details, and many other design-conscious monthlies. Much of this obsession with hand-drawn type could be tracked to the backlash against the so-called "clean" layouts of the 1990s, when designers first began reacting to computerized design. But through the 2000s, other factors were at work. The hand was fresh; stepping away from her Mac, a designer could always doodle on a napkin while having coffee with a friend. (In contrast, a design turned into digital data often erases all evidence of the human hand.) Blogging for Design Observer in the mid-2000s, celebrated New York designer Michael Bierut noted: "In an age where computer-generated this and special-effects that are within the reach of anyone who can afford a copy of Final Cut Pro, it takes real re-straint, not to mention confidence, to stick with a simple idea simply executed [by hand]."

Few have embodied this confident spirit better than McSweeney's, the San Francisco-based, Iceland-printed publisher of elegantly handcrafted (and occasionally outra-geous) books and magazines. Helmed by writer and designer Dave Eggers, McSweeney's Quarterly Concern, Believer film

EMBRACING INGREDIENT X

04

INK & PRESS

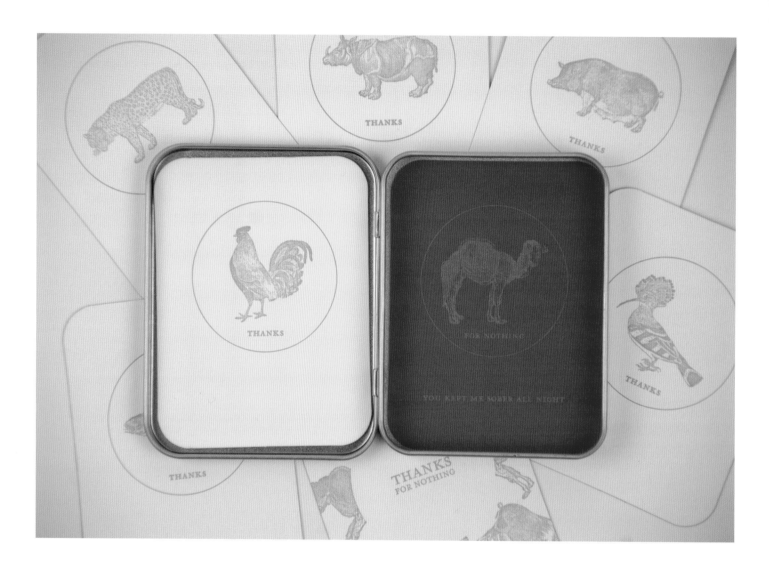

THANKS FOR NOTHING TIN OF CARDS

DESIGN FIRM
Gilah Press + Design

LOCATION
Baltimore, Maryland, USA

ART DIRECTOR
Kat Feuerstein

DESIGNER
Luke Williams

CLIENT
Gilah Press + Design

MATERIALS
Ink, Chandler & Price press, duplex paper, metal tins

PRINTER
Gilah Press + Design (cards); Effectuality (tins)

Thanks for Nothing is the answer to poor, irritating or otherwise terrible public experiences. One can use the cards to communicate true feelings regarding a particular public service in place of a monetary tip—a defense against taxi drivers, waiters, baristas, hair dressers and bar tenders—while minimizing confrontation. While the 'Thanks' side expresses the gratitude that could have been, 'For Nothing' grants the recipient a frustration similar to what you just experienced. The handmade quality of the craft is crucial to the bipolar nature of this piece: It's beautifully letterpress printed—and yet vicious in nature!

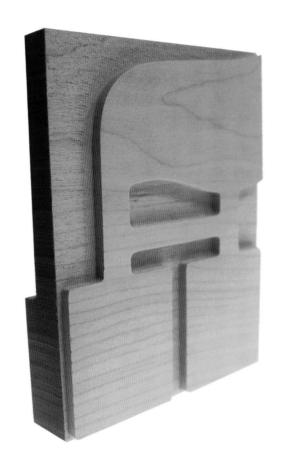

Designed to tie into an undergraduate research fellowship at North Carolina State University's College of Design, Combover (named after its wavy top serifs) is a typeface best set at two inches and larger. Outputting this Western Slab by letterpress printing became essential to maintain the integrity of the typeface; design objects that reference pre-digital technologies should live in analog form as well as digital. Once the typeface was designed digitally, characters were produced on a milling machine to be printed on a Vandercook press.

DESIGNER
Justin LaRosa

LOCATION
Raleigh, North Carolina, USA

ART DIRECTOR
Katie Meaney

MATERIALS
918 type high cherry wood,
CNL machine Vandercook press

PRINTER
Self-printed on Vandercook

COMBOVER WOOD TYPE

CHAPTER 04

DESIGN FIRM
Nothing:Something:NY

LOCATION
New York City, New York, USA

ART DIRECTOR
Kevin Landwehr

DESIGNERS
Kevin Landwehr, Devin Becker

CLIENT
Dave McLean

PRINTER
Burdge

CHAPTER

04

ALEMBIC BAR

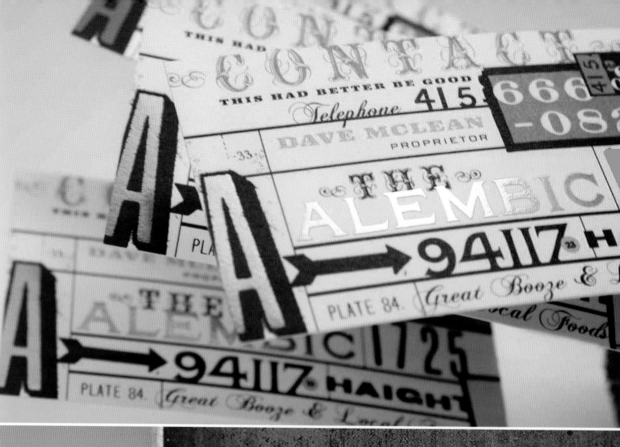

LOVE IS IN THE DETAILS

When restaurateur Dave McLean set out with the not-so-modest ambition of creating the best bar in America, Nothing:Something was asked to assist. The Alembic is a dedication to cocktological and culinary perfection at every level, so Nothing:Something developed a branding program loaded with process-perfect print materials and a five-pound waterjet cut steel menu holder housing the extensive liquor collection. After all, nothing says serious like a book you can hardly lift. Entertainingly effusive drink descriptions and a variety of mouthy slogans strike a balance with the serious tone of the interiors. The result? The Alembic was named "The Best Bar in America" by both *GQ* and *Esquire*.

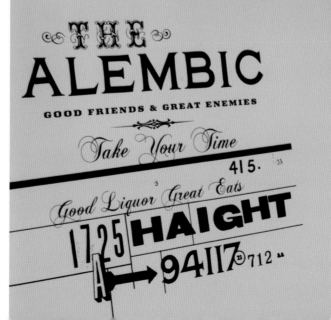

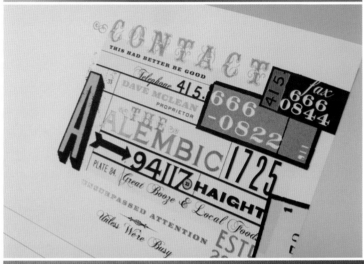

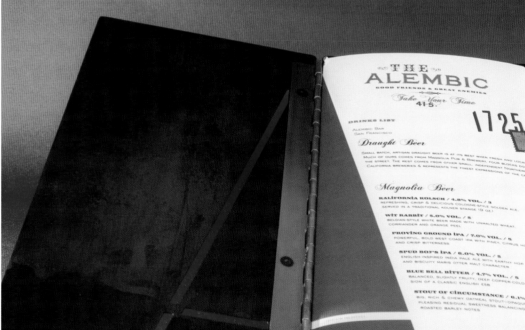

DESIGNERS
Shasta Garcia, David Muro II

LOCATION
San Francisco, California, USA

ART DIRECTOR
Shasta Garcia

CLIENT
Shasta Garcia

MATERIALS
Letterpress polymer plates,
French Pop-Tone paper

PRINTER
Shasta Garcia at
SF Center for the Book

CHAPTER

04

WORLD'S SMALLEST POSTER SHOW

This poster was created as a gift for those who attended The World's Smallest Poster Show. This second annual WSPS featured the collections of Dave Muro II and Shasta Garcia, which consist of many screenprinted and letterpress-printed posters from music shows. A giveaway poster that had a handmade feel was important since the majority of the featured posters have a handmade quality to them. An additional element of the handmade: The receiver of the poster is invited to cut out and fold the tent, creating an actual world's smallest poster show.

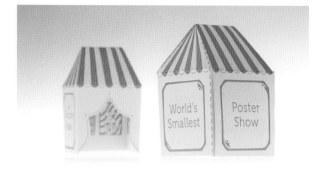

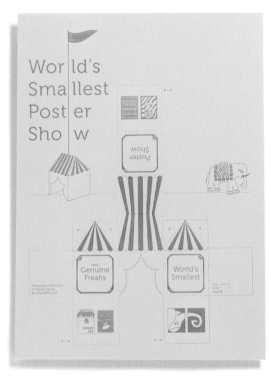

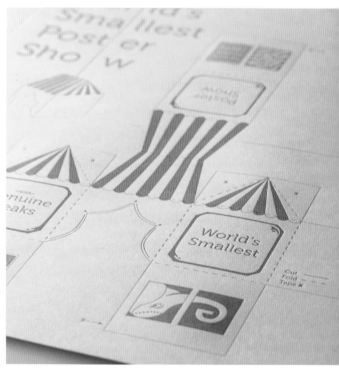

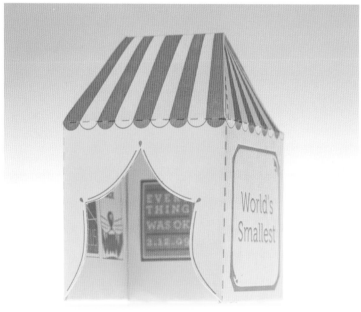

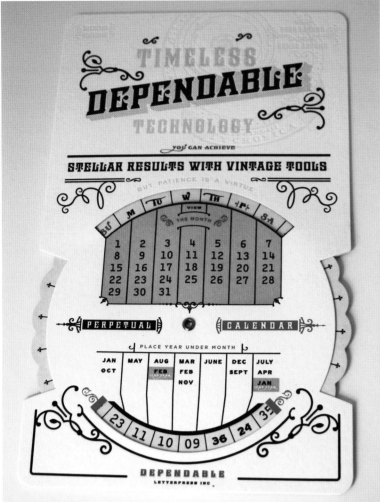

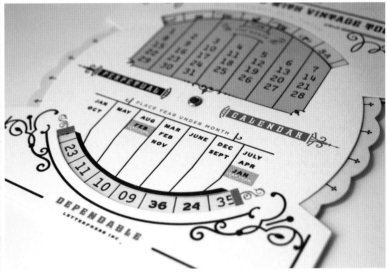

A friend gave me an old perpetual calendar, a feed store's promotional giveaway from the 1970s. I noted that the shape of the gizmo was similar to antique astronomical diagrams from the 1500s, and that was the germ of this project. I asked Jacquie Van Keuren of Rubber Design to design something that would be a real tour de force of letterpress printing—lots of colors, big solids, tight registration and, of course, the elaborate assembly. As a practitioner of an analog trade, I feel a kinship with the early scientists cited in the piece, who worked from their direct observations and with the simplest of tools.

DESIGN FIRM
Rubber Design,
Dependable Letterpress

LOCATION
San Francisco, California, USA

ART DIRECTOR
Joel Benson

DESIGNER
Jacquie Van Keuren

CLIENT
Dependable Letterpress

MATERIALS
Letterpress printed, die-cut

PRINTER
Dependable Letterpress

PERPETUAL CALENDAR

CHAPTER 04

DESIGN FIRM
Miriello Grafico

LOCATION
San Diego, California, USA

ART DIRECTORS
Ron Miriello, Dennis Garcia

DESIGNERS
Dennis Garcia, Tracy Meiners,
Sallie Reynolds-Allen,
Robert Palmer

CLIENT
Fox River Paper, Miriello Grafico

PRINTER
De France Printing

CHAPTER

04

EVERYTHING ITALIAN NOTE CARDS

Collaborations can bring the best out of everyone. In this case, Fox River Paper collaborated with Miriello Grafico's full creative team to find the perfect way to help launch a new line of paper to add to its popular ESSE Collection. The result was a series of eight exquisite letterpress note cards—labeled as "Everything Italian"—that would celebrate the detail of each textured sheet. Hand-drawn type, old Italian labels and illustrations were scanned to help illustrate the Old World feel and craftsmanship of Italy. In addition to the letterpress inks, a blind hit of the letterpress was added to achieve an embossing effect.

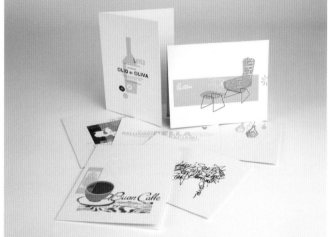

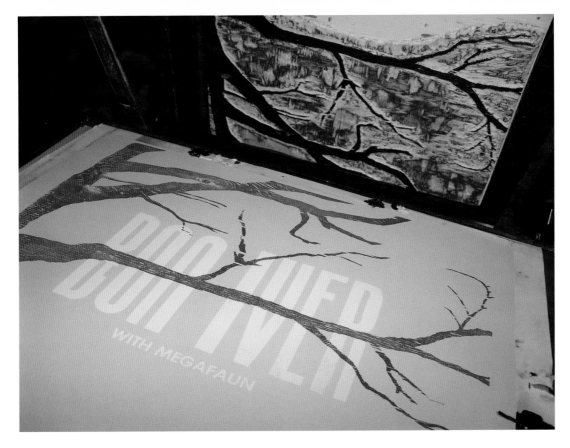

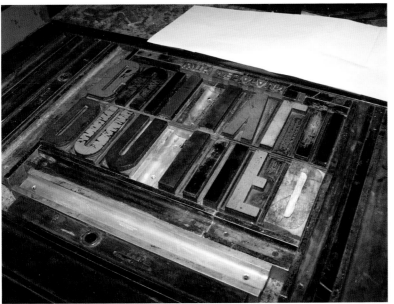

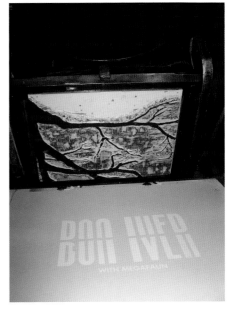

This poster was printed from hand-cut wood blocks from discarded plywood. The poster was printed one half at a time, since it was too large to fit entirely into the press. I doubled the "point size" of my limited wood type collection by using full letters as both the bottom and top portion of the band's name. With the raw and natural feel of Bon Iver's album, I felt that it was important to stay away from the computer as much as possible. Since the album was written in a small cabin in the woods, it seemed natural to use letterpress and to use the pre-existing wood type I own, along with recycled plywood for the image.

DESIGN FIRM
Type B Press

LOCATION
Lincoln, Nebraska, USA

DESIGNER
Bennett Holzworth

CLIENT
Bon Iver

MATERIALS
Hand-cut plywood block, circa 1918; 12" x 18" Chandler & Price letterpress, wood and metal type

PRINTER
Bennett Holzworth

**BON IVER
LETTERPRESS
POSTER**

CHAPTER 04

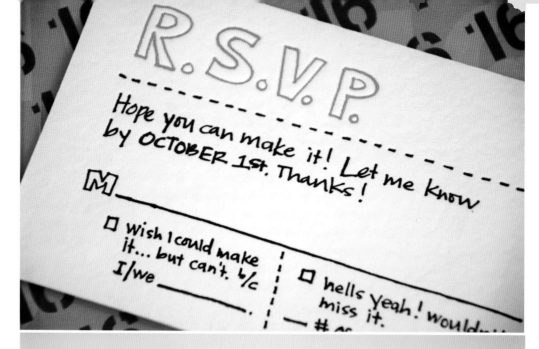

DESIGN FIRM
Porridge Papers

LOCATION
Lincoln, Nebraska, USA

ART DIRECTORS/ DESIGNERS
Jill Rizo, Carrie Ratcliff

CLIENT
Porridge Papers

MATERIALS
Handmade and commercial paper, letterpress, glitter

PRINTER
Porridge Papers

CHAPTER

04

SWEET 16 INVITATION

To celebrate its sixteenth anniversary, Porridge Papers threw itself a lavish Sweet 16 party. The invitation, which read like a note, was letterpress printed on the company's handmade paper. It set the tone of the party with hot pink, black and white colors. Porridge Papers has thrived by producing handmade papers, and the invite incorporated what it does best as a paper mill and letterpress studio. Wrapping the invite was a belly band—made from handmade bubblegum-scented paper—and a photo collage showing the company's growth along the way. The casual wording of the invitation in handwritten type held true to the down-to-earth and fun approach of the business.

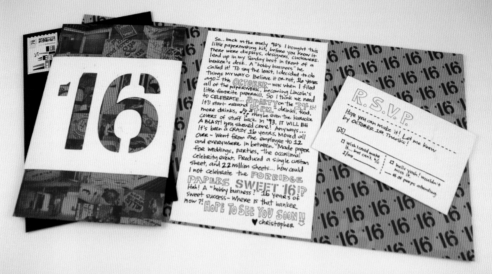

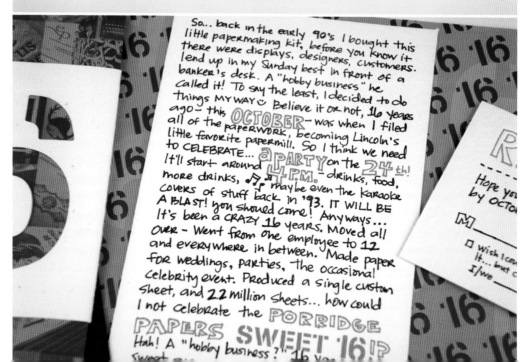

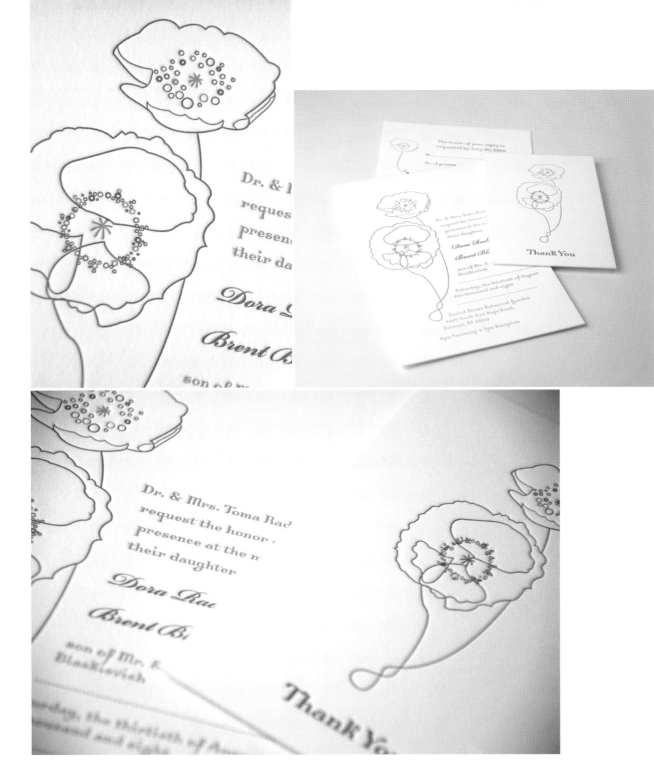

Letterpress wedding invitation pieces impart a warm, human touch to the final package and imbue it with a very unique style. Since the wedding took place in a botanical garden, I wanted the pieces to have a very tactile and romantic feel. There's something about letterpress—touching the paper and running fingers over the text—that makes people say, "Ooooooooh." They know it's something special and are more likely to think of the piece as a keepsake instead of throwing it away. Although I do a lot of design work on my computer, I try to use handmade elements whenever possible because of their uniqueness.

DESIGN FIRM
Dora Bee

LOCATION
Charlotte, North Carolina, USA

ART DIRECTOR/DESIGNER
Dora Blaskievich

CLIENT
Dora Blaskievich

MATERIALS
Letterpress

PRINTER
Crayton Printing

WEDDING INVITATION

CHAPTER 04

DESIGN FIRM
TOKY Branding + Design

LOCATION
St. Louis, Missouri, USA

ART DIRECTOR/DESIGNER
Jay David

CLIENT
AIGA St. Louis

MATERIALS
Letterpress

CHAPTER

04

20/20 POSTER

This poster was created as part of a show celebrating the AIGA St. Louis Chapter's twentieth anniversary. Twenty local artists and designers were invited to contribute a limited run of twenty pieces to the show. Handmade was important to the "Collective Unity" piece not only because of the small run, but also because it allowed subtle elements to come through in each layer, allowing each of the twenty pieces to be unique in themselves.

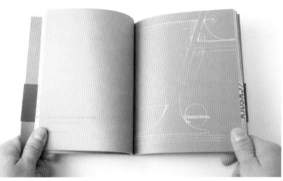

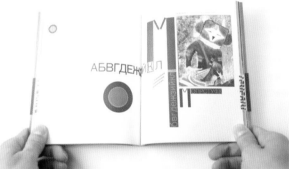

DESIGN FIRM
Lisi Design

LOCATION
Kansas City, Missouri, USA

DESIGNERS
Luke Lisi, Laura Rottinghaus, Ben Suh, Chi Hiu Yim, Tristan Telander

MATERIALS
Letterpress, belly bands hand-attached

PRINTER/CLIENT
University of Kansas

CHAPTER

KIOSK 37 ART & LITERATURE MAGAZINE

Each semester, the University of Kansas publishes the *Kiosk* magazine. The magazine represents the best photography, sculpture, illustration, design, painting, poetry and short stories the University of Kansas has to offer. *Kiosk 37* is the Type Edition. It takes the viewer through different eras and styles of typography. We custom letterpressed and hand-attached the bands to all 1,500+ copies of the book to help tie in the advent of Johannes Gutenberg's printing press and movable type, which date back to the 1400s.

DESIGN FIRMS
Anagram Press,
Springtide Press

LOCATION
Tacoma, Washington, USA

ART DIRECTORS
Chandler O'Leary,
Jessica Spring

DESIGNER
Chandler O'Leary

MATERIALS
Letterpress, ink, paper

PRINTER
Jessica Spring

CHAPTER

04

COME, COME, MY CONSERVATIVE FRIEND

This print is the first in the ongoing, collaborative Feminist Broadside series, which features quotes by historical feminists and places them in the context of contemporary issues. First, the artwork is completely hand-drawn, featuring original typography. The illustration is then scanned, given a digital colophon and converted to photopolymer plates for printing. It is letterpress printed on a Vandercook Universal One press, on paper made from recycled clothing. Printing the broadsides by hand lends a concrete weight and emotion to the words of the quote; hand-lettering the text adds a twist of extra craftsmanship to the traditional idea of the broadside. The labor and attention to detail involved gives the work a warmth and depth that can't be achieved any other way.

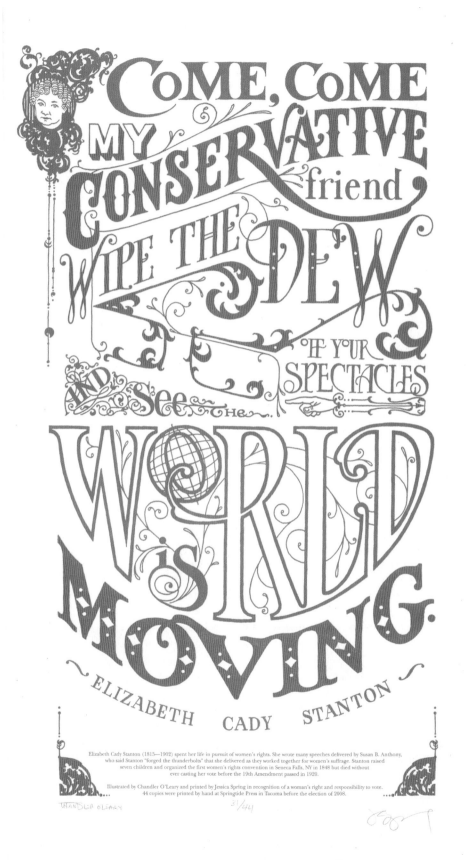

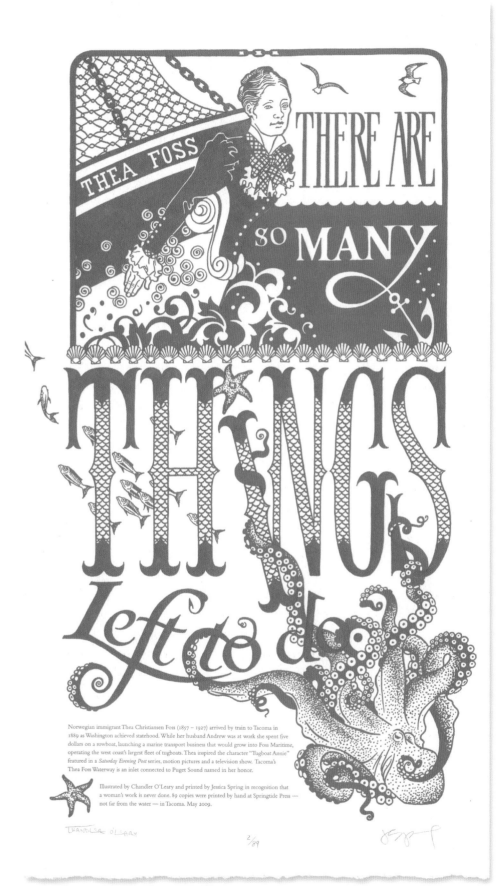

THEA FOSS

THERE ARE SO MANY THINGS Left to do

Norwegian immigrant Thea Christiansen Foss (1857 – 1927) arrived by train to Tacoma in 1889 as Washington achieved statehood. While her husband Andrew was at work she spent five dollars on a rowboat, launching a marine transport business that would grow into Foss Maritime, operating the west coast's largest fleet of tugboats. Thea inspired the character "Tugboat Annie" featured in a *Saturday Evening Post* series, motion pictures and a television show. Tacoma's Thea Foss Waterway is an inlet connected to Puget Sound named in her honor.

Illustrated by Chandler O'Leary and printed by Jessica Spring in recognition that a woman's work is never done. 89 copies were printed by hand at Springtide Press — not far from the water — in Tacoma. May 2009.

CHANDLER O'LEARY 2/89

DESIGN FIRMS
Anagram Press,
Springtide Press

LOCATION
Tacoma, Washington, USA

ART DIRECTORS
Chandler O'Leary,
Jessica Spring

DESIGNER
Chandler O'Leary

MATERIALS
Letterpress, ink, paper

PRINTER
Jessica Spring

CHAPTER

04

TUGBOAT THEA

"Tugboat Thea" is the fourth in the ongoing Feminist Broadside series; this piece was actually re-created from an oversized (3' x 6') hand-carved linoleum block print we created for a street festival in Tacoma, Washington. Printing from photopolymer allowed for more detail than carving in linoleum allowed, so the image is enhanced with nautical doo-dads. The print features a quote by Thea Foss, Tacoma's own feminist business pioneer and the inspiration for the "Tugboat Annie" stories and radio plays. Thea literally built Foss Maritime—one of the world's largest marine transport companies—with her own two hands, so the handmade elements are designed to highlight her achievements.

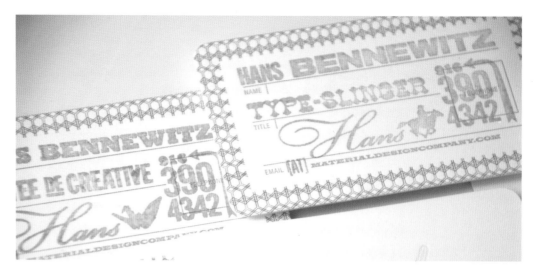

DESIGN FIRM
Material Design Co.

LOCATION
Citrus Heights, California, USA

ART DIRECTORS/ DESIGNERS
Matthew Stuart,
Hans Bennewitz

CLIENT
Material Design Co.

MATERIALS
Letterpress, hand-stamped

PRINTER
Full Circle Press

CHAPTER

04

MATERIAL DESIGN CO. IDENTITY

The name of the studio, Material Design Co., originated from the love of letterpress items, screenprinting and other textile mediums that are non-computer-based. When it was time to design an identity system, we wanted something that would fit and represent the company in a similar matter. In addition to printing on a thick #130 stock, we created a custom stamp that could be applied to give us the option to modify our information without a costly reprint and also added to the textured look of the entire system. When a card is handed out, everyone instantly admires the craftsmanship and quality of the cards, getting a better idea of what we can do for them. Mission accomplished.

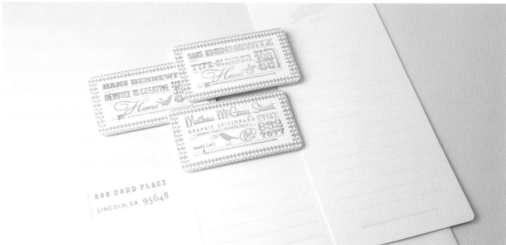

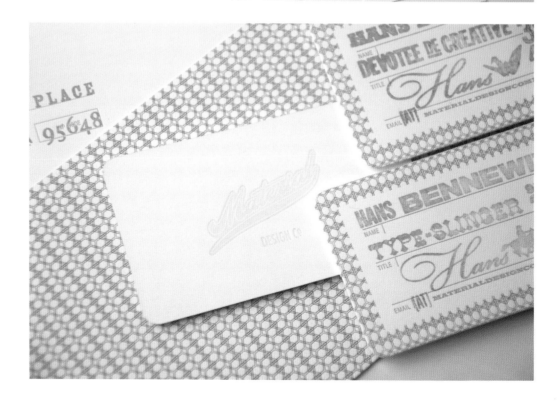

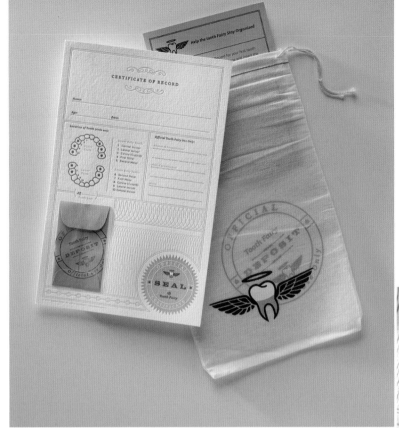

Inspired by the common question of what to do with all those baby teeth, we designed the Official Tooth Fairy Kit. An easy way for pack-rat parents to stow away their child's first tooth. Letterpress printing and lush cotton paper were essential to creating a piece worthy of a keepsake. Kids and the local Tooth Fairy enter details on which tooth is enclosed, how it was lost, and the amount of compensation. The hand-silkscreened cotton bag adds to the tactile experience and provides a reusable deposit bag for the loot.

DESIGN FIRM
Notion Farm

LOCATION
San Francisco, California, USA

ART DIRECTOR
Jacquie Van Keuren

CLIENT
Notion Farm

MATERIALS
Letterpress, hand-silkscreened bags

PRINTER
Dependable Letterpress

THE OFFICIAL TOOTH FAIRY KIT

CHAPTER

DESIGN FIRM
Type B Press

LOCATION
Lincoln, Nebraska, USA

DESIGNER
Bennett Holzworth

CLIENT
Eleven Productions

MATERIALS
12" x 18" Chandler &
Price press, metal type,
custom wood blocks

CHAPTER

04

NEKO CASE LETTERPRESS POSTER

The letters of Neko Case's name were printed from a custom pixel-like wood matrix that friend and carpenter extraordinaire Jack Sandeen created for me. Since Neko's sound harkens back to a bygone era of country music, I felt it very fitting to reference the iconic imagery of vintage letterpress show posters. While the wood grain and letterpress printing reference older country, the colors and typography speak of her new and relevant take on the genre.

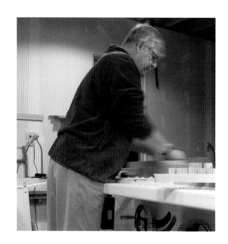

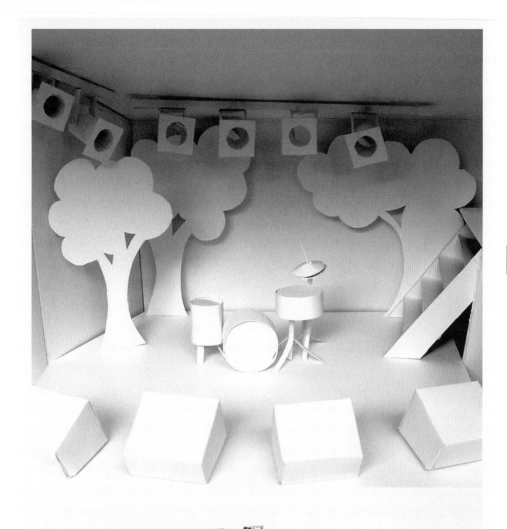

DIGGING DEEPER

The text was created with myriad techniques: the band names are hand-lettered; the "XX" was created by photographing giant sign letters that showed up throughout the festival materials and on the stage itself; the tagline is poorly applied press-type; and even "MERGE" was printed in Futura, then photographed in space to give it a sense of true dimensionality and human-handedness. The background image was offset printed, while the type and lettering were letterpress printed to carry through the sense of the handmade.

— Maggie Fost

Merge Records celebrated our twentieth anniversary in the summer of 2009 with a five-day festival at our hometown club, Cat's Cradle. The venue itself is a significant character in our history, so making it the centerpiece of the poster made perfect sense. I constructed a tiny paper model of the stage, which I photographed. The trees were added to suggest North Carolina in the summer. We liked them so much we constructed giant versions for the real stage.

DESIGN FIRM
Merge Records

LOCATION
Durham, North Carolina, USA

ART DIRECTOR/DESIGNER
Maggie Fost

CLIENT
Merge Records

MATERIALS
Offset, letterpress printing

PRINTER
Harperprints (offset);
Horse & Buggy Press
(letterpress)

**XX MERGE
FESTIVAL POSTER**

CHAPTER 04

DESIGN FIRM
Massive Graphic

LOCATION
Baltimore, Maryland, USA

ART DIRECTOR
Joe Galbreath

DESIGNERS
Joe Galbreath,
Kelley McIntyre (typesetter)

CLIENT
Maryland Institute College
of Art GD/MFA

MATERIALS
Wood and metal type

CHAPTER

04

GAIL ANDERSON
LECTURE POSTER

When you're an AIGA Design Legend, your arrival can be announced
with just your first initial... a very large, red initial. This poster pub-
licizes Gail Anderson's lecture at Maryland Institute College of Art.
Letterpress printed with wood and lead type.

legendary graphic designer
GAIL ANDERSON

creator of typographic identities and posters for countless BROADWAY
productions, longtime designer for ROLLING STONE magazine,
author of BOOKS on graphic design, winner of an AIGA 2008
GOLD MEDAL for lifetime achievement

FRIDAY, NOVEMBER 14, 1 PM
FALVEY HALL
FREE FOR MICA COMMUNITY

hosted by the gd-mfa program

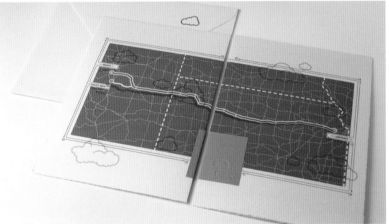

My love for letterpress as an undergraduate student only made it natural for me to choose this method to make announcements for graduation. I printed and hand-assembled more than forty announcements to send to friends and family. I believe letterpress is a necessity for all designers and creatives to experience because it makes one appreciate the intricacies and minute details of typography and handcraft.

DESIGN FIRM
Lisi Design

LOCATION
Kansas City, Missouri, USA

ART DIRECTOR/ DESIGNER
Luke Lisi

MATERIALS
Letterpress, individually hand-assembled

PRINTER
University of Kansas

GRADUATION ANNOUNCEMENT

CHAPTER 04

DESIGN FIRM
Markatos Moore

LOCATION
San Francisco, California, USA

ART DIRECTORS
Peter Markatos, Tyler Moore

CLIENT
Vintage 415

MATERIALS
Custom logotype, vintage map, chipboard, type blender marker

PRINTER
Dependable Letterpress

CHAPTER

04

AVENTINE

Aventine touches on a truly unique and historic piece of San Francisco: the Barbary Coast. This restaurant/bar resides in an original 19th-century building complete with authentic coal pits and chaseways that lead underground throughout the city. The idea was to celebrate this era in a contemporary way yet utilize components such as drink tokens and liquor lockers for rental. Diving deep into the building's library archives, we found inspiration in the treasured maps of the Barbary Coast. Translating elements from old ship crate boxes, maps and typography of the era, we created a collateral system that looked like it was found in the basement of this historic building.

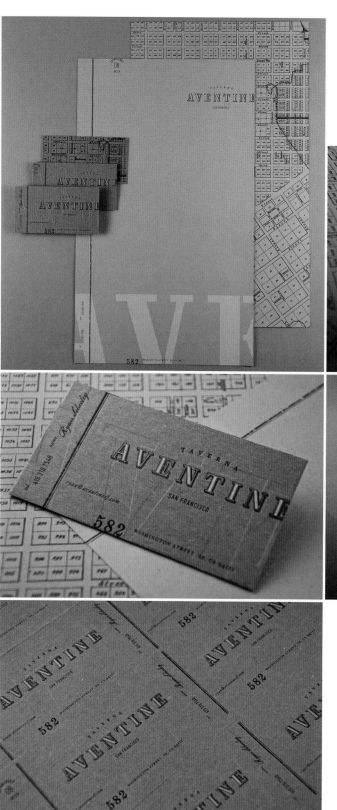

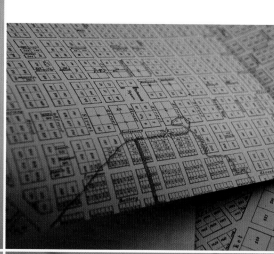

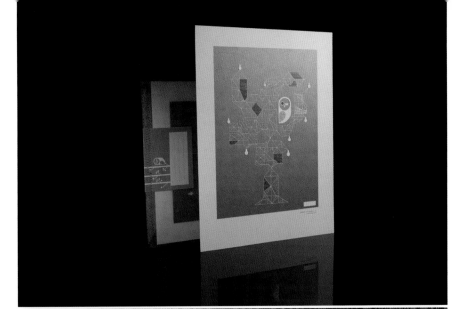

DESIGN FIRM
Office: Jason Schulte Design

LOCATION
San Francisco, California, USA

CREATIVE DIRECTOR/
DESIGNER
Jason Schulte

CLIENT
Office: Jason Schulte Design

MATERIALS
Emboss, hot stamp, sewn
glassine envelope

PRINTER
Kea Incorporated

CHAPTER

04

OFFICE HOLIDAY CARD

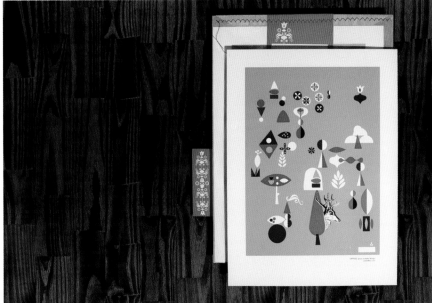

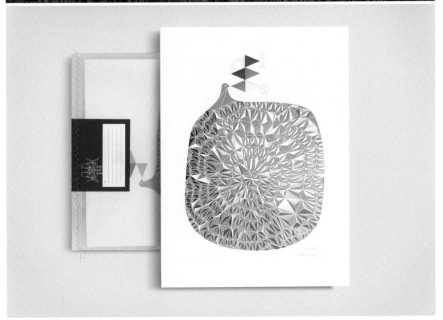

Each year, Office creates limited-edition holiday cards that we send to
our friends. We try to create something beautiful that makes us happy.

DESIGN FIRM
Markatos Moore

LOCATION
San Francisco, California, USA

ART DIRECTORS
Peter Markatos, Tyler Moore

DESIGNER
Kerry Williams

CLIENT
Dan Sheetz

PRINTER
Dependable Letterpress

CHAPTER

04

SHEETZ WEDDING INVITATION

For this project, the brief was simple: "We are getting married on two continents and we love travel." From that came an interesting passport-meets-plane-ticket wedding invitation that included a perforated tear-off RSVP card. Not only did this design save paper, it was also an economical way to go about printing an invitation kit.

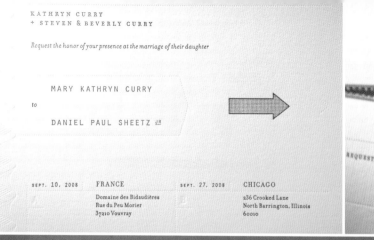

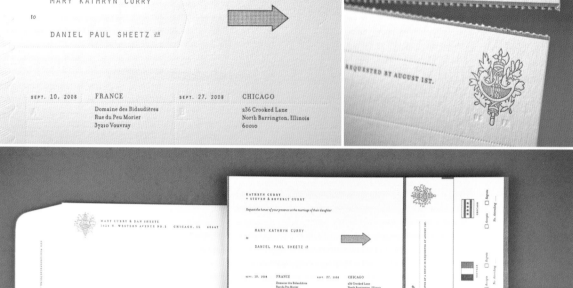

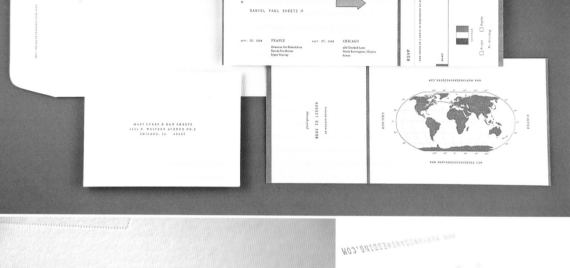

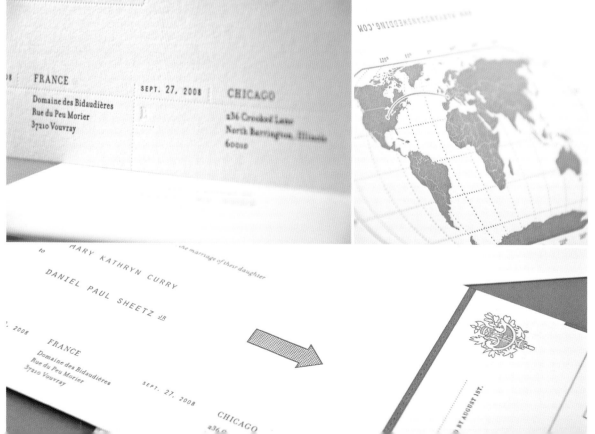

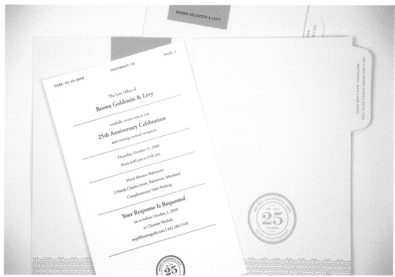

These twenty-fifth anniversary party invitations were designed for a Baltimore law firm. The invitations were housed in small file folders and were laid out to look like a mini legal brief. The file folder was mailed in a clear sleeve, with the return address letterpress printed on the tab. The extra thought and care put into these yielded an overwhelming response to the party and helped to set the tone for the evening—some business, mostly fun. The letterpress printing lent a tactile quality to the piece, taking it away from feeling too stodgy, and a bit more like an invitation.

DESIGN FIRM
Gilah Press + Design

LOCATION
Baltimore, Maryland, USA

ART DIRECTOR
Kat Feuerstein

DESIGNER
Nathalie Cone

CLIENT
Brown Goldstein Levy LLP

MATERIALS
Ink, Chandler & Price and Windmill presses, paper, steel rule die

PRINTER
Gilah Press + Design

BROWN GOLDSTEIN LEVY TWENTY-FIFTH ANNIVERSARY INVITATIONS

CHAPTER 04

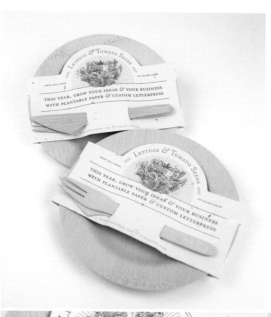

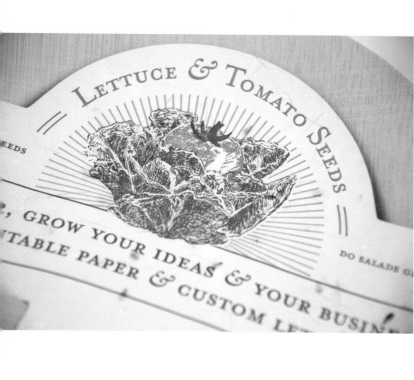

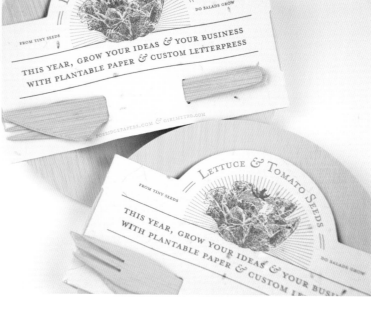

GROW YOUR IDEAS

DESIGN FIRM
Girl Metro, Inc.

LOCATION
Chicago, Illinois, USA

ART DIRECTOR/DESIGNER
Richelle Albrecht

CLIENT
Porridge Papers

MATERIALS
Plantable handmade paper,
letterpress, bamboo

PRINTER
Porridge Papers

We partnered with Girl Metro to produce a self-
promotional piece that not only shows what we do but
also gives back. With the trend to use greener papers
and processes, we produced a paper that is embed-
ded with tomato and lettuce seeds. This sheet is also
the packaging and gift that wraps around a plate, fork
and knife made from bamboo. We see this as a zero-
waste package and promotion. The idea is to plant
the package and wait for the tomatoes and lettuce to
be ripe enough to be picked. Then you can enjoy your
fresh homegrown salad on the bamboo plate. It does
not get greener than that!

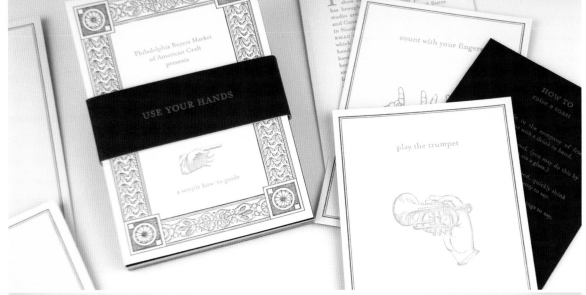

DESIGN FIRM/PRINTER
Gilah Press + Design

LOCATION
Baltimore, Maryland, USA

ART DIRECTOR
Kat Feuerstein

DESIGNER
Alison Yard Medland

CLIENT
The Rosen Group

MATERIALS
Ink, Chandler & Price press,
duplex paper

CHAPTER

04

USE YOUR HANDS
PROMOTIONAL MAILER

The Rosen Group provides American and Canadian artists with opportunities to grow their business and compete in the marketplace. One of the ways this is accomplished is through their trade show, the Philadelphia Buyers Market of American Craft. In order to get letterpress companies interested in applying for the show, a promotional guide of cards that humorously shows the many different ways one may use their hands—including how to play the trumpet, up to how to register for the show—was mailed out. Because of the elegant and timeless design of the cards, and because the audience was letterpress studios, letterpress printing lent itself perfectly to the project. One may also use their hands to enjoy the tactile quality that letterpress leaves behind.

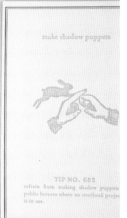

DESIGN FIRM
Pylon

LOCATION
Toronto, Canada

DESIGNERS
Scott Christie, Steve
Garwood, Sascha Hass,
Kevin Hoch, Liam Johnstone,
Brian Marchand, Colin Payson,
Robin Smyth, Janice Christie

ILLUSTRATOR
Hanna Chen

MATERIALS
Newspaper, linoleum block,
block printing ink

CHAPTER

04

**PYLON 2009
HOLIDAY MAILER**

Newspaper is a great item to start a fire with at home, but we wanted everyone, even those without fireplaces, to feel the warmth of the season. We block-printed by hand a large flame made up of holiday wishes on over 600 newspapers. We then stuffed them in block-printed envelopes and sent them on their way to spread some holiday cheer. Three printing blocks were produced, one for an envelope and two for the newspaper, all of which were cut from lino block. The newspapers were randomly selected without discretion (despite some awkward headlines). Everyone in our office had a hand in cutting out the design, and amazingly only one designer was harmed in the process. He will be fine.

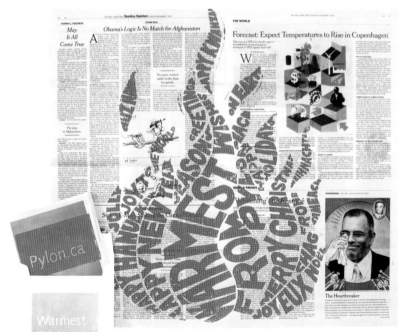

DESIGN FIRM
Rohner Letterpress

LOCATION
Chicago, Illinois, USA

DESIGNER
Allison Bogner

CLIENT
Allison Bogner

MATERIALS
Crane Lettra 100# cover

PRINTER
Rohner Letterpress

CHAPTER

04

VERTICAL
CITIES POSTER

The concept is pretty self-explanatory: an imaginary city re-imagined from the standard horizontal plane to a vertical one. Broadly speaking, the idea came about from a long-term immersion in the sprawling horizontal cityscape of Dallas, along with a childhood fascination with skyscrapers. Reimagining public transportation on a vertical plane (local and express elevators in lieu of subways) was a really fun thing to plan out, in addition to trying to determine which places of business to include and where in the schema.

CONTINUED ON P. 170

CONTINUED FROM PAGE 104

EMBRACING INGREDIENT X

magazine, and assorted novels, story collections, and gift books have for more than a decade fused creative individuality with elaborate métier, creating memorable keepsake editions whose layouts unfailingly dazzle. Cloth, fur, and die-cut covers; Z-shaped layouts; whimsical typography and iconography; eye-popping letterpress and foil designs—McSweeney's range has inspired countless designers while boldly giving the finger to those sibyls squawking about the End of Print. If you're a fan of the ambitious publisher, seek out Chronicle Books' recent Art of McSweeney's (2010), a reminder of the myriad ways in which the indie publisher's art directors have paid homage to traditional book design while at the same time moving it in new directions. "By hand" remains the essential descriptor for McSweeney's methods: hand lettering, original illustration, challenging layouts and folded casewraps, and hand-cut or -affixed or -assembled designs. The Chronicle collection displays many of the original sketches and napkin sketches that served as source materials for the publisher's final versions.

—— Other designers have lately pushed the handmade aesthetic in other directions, creating ornate, elaborately filigreed illustrations, letterforms, and stunning ornamental work: Si Scott in London and M/M Studio in Paris; Non-Format and Mario Hugo in New York. Yet if one artist could be singled out for elevating the a mano aesthetic to new levels of excellence, it would be a Canadian, Marian Bantjes, a self-proclaimed "lapsed graphic designer" whose meticulous hand—recently insured for $5 million—can evoke Islamic

05

SILK-SCREEN & HAND WORK

DESIGN FIRM
Blok Design

LOCATION
Mexico City, Mexico

ART DIRECTOR
Vanessa Eckstein

ILLUSTRATOR
Henrik Drescher

CLIENT
Émigré Film

MATERIALS
Letterpress, illustration

PRINTER
Anstey Bookbinding

CHAPTER

05

ÉMIGRÉ FILM 2008

The artist Henrik Drescher worked on this promotional poster, which had to express the emotional aspect of film as well as the random thoughts that guide the creative process. The entire poster is done in letterpress since this is a poster as much about a love of the arts as it is about the passion for detail and inspiration. The logo is blind debossed so as to become part of the poster. The make-readys of the posters were used to create blank give-away notebooks. The imagery was used randomly so different people in a room would receive very different gifts.

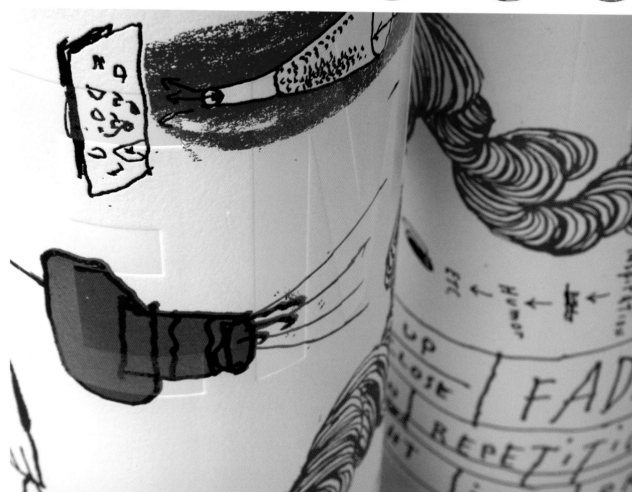

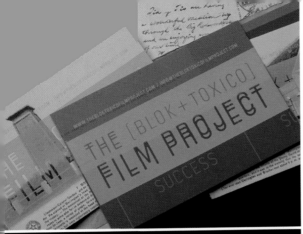

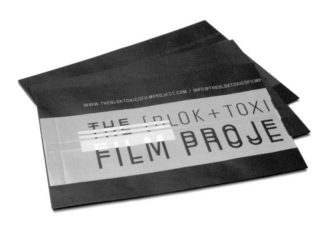

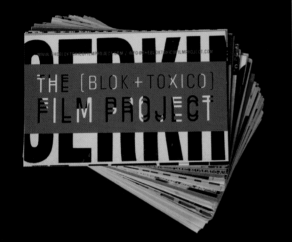

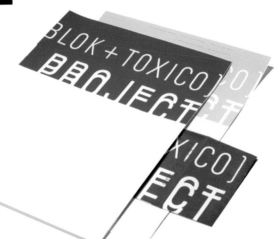

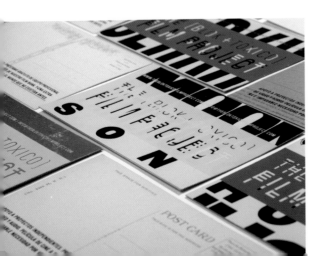

DESIGN FIRM
Blok Design

LOCATION
Mexico City, Mexico

ART DIRECTOR
Vanessa Eckstein

DESIGNERS
Vanessa Eckstein,
Patricia Kleeberg

CLIENT
The Blok + Toxico
Film Project

MATERIALS
Silkscreen

CHAPTER

05

**THE BLOK + TOXICO
FILM PROJECT**

Toxico created the film project to support independent filmmakers.
The identity itself had to express the smart use of resources as well
as creative risk, so we overprinted our logo on existing materials: Old
vinyl record covers were cut up to become postcards, and we silk-
screened leftover press-approval sheets, found ephemera... anything
that crossed our way.

DESIGN FIRM
The Small Stakes

LOCATION
Oakland, California, USA

ART DIRECTOR
Jennifer Sonderby

DESIGNER
Jason Munn

CLIENT
SFMOMA, Noise Pop

MATERIALS
Paint, brush,
screenprinted by hand

CHAPTER

05

**SFMOMA COLLEGE
NIGHT POSTER**

This image was for SFMOMA's College Night, which was a combination of live music, DJs and artist presentations. I decided to combine the music and the art by a making a record out of brushstrokes that were created by the needle/brush. Sam Wick—my intern at the time—is credited with adding the thin brushstroke between the record and the needle/brush; this detail makes the poster for me. Two-color screen-print using metallic silver ink.

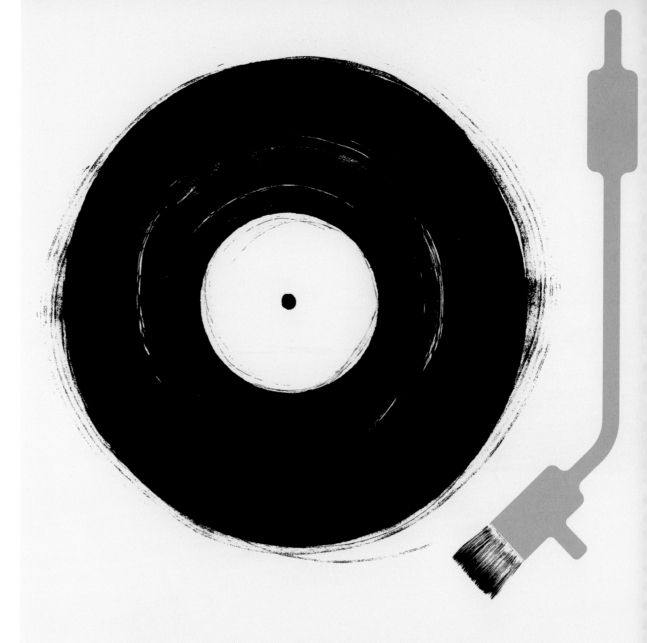

SAN FRANCISCO MUSEUM of MODERN ART
PRESENTS COLLEGE NIGHT WITH NOISE POP
FEATURING REX RAY, PARADISE BOYS, AND JIMMY TAMBORELLO
SEPTEMBER 21, 2006
6-9PM

D E E R
H U N
T E R

NOVEMBER 24

with TIMES NEW VIKING

GREAT AMERICAN MUSIC HALL

DESIGN FIRM
The Small Stakes

LOCATION
Oakland, California, USA

ART DIRECTOR/DESIGNER
Jason Munn

CLIENT
Deerhunter, Great American
Music Hall

MATERIALS
Brush, paint,
screenprinted by hand

PRINTER
Bloom Screen Printing

CHAPTER

05

DEERHUNTER POSTER

Concert poster for Deerhunter. A visual based on the band's live sound.
Image is a pattern of brushstrokes, repeated and printed in process
colors to create the static field. Four-color screenprint.

DESIGN FIRM
The Small Stakes

LOCATION
Oakland, California, USA

**ART DIRECTOR/
DESIGNER**
Jason Munn

CLIENT
Insound

MATERIALS
Various, Adobe Illustrator,
screenprinted by hand

PRINTER
Bloom Screen Printing

CHAPTER

INSOUND 20 POSTER SERIES

This was a series of twenty posters for online music retailer Insound—it was a collaboration between Insound, twenty bands and myself. Images were used on a line of limited-edition T-shirts, sweatshirts and posters. All the posters were screenprinted.

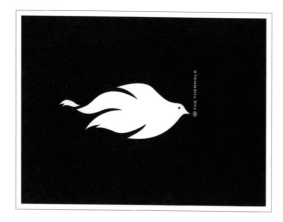

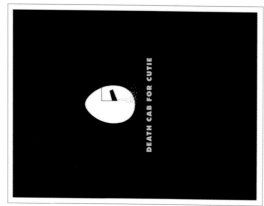

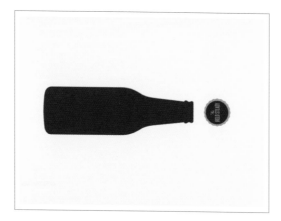

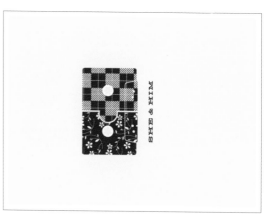

MAGNOLIA ELECTRIC CO.

BUILT TO SPILL

THE NEW PORNOGRAPHERS

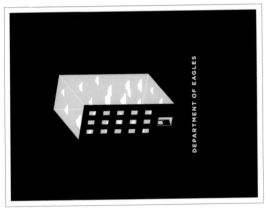

DEPARTMENT OF EAGLES

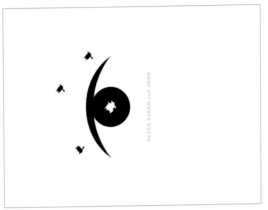

PETER BJORN and JOHN

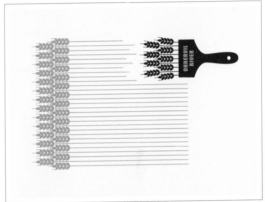

OKKERVIL RIVER

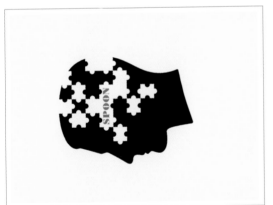

SPOON

GRIZZLY BEAR

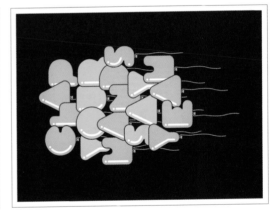

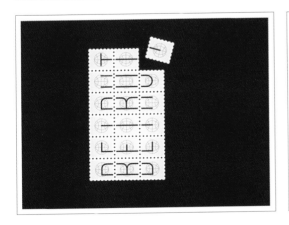

CALEXICO

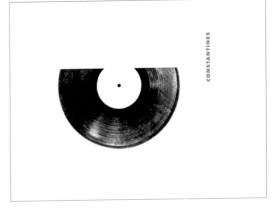

CONSTANTINES

PARTICIPATE

This AIGA design educators' conference addresses the social life of design. Graphic designers work with clients, institutions, users, and communities to make things happen in the world. Yet education often focuses on the individual voice. How are we preparing students for a lifetime of working with and for other people? How are our students connecting to the world? Come participate in a relaxed and stimulating weekend of lively discussions, hands-on workshops, and informal activities.

The Social Studies conference is a project of AIGA, sponsored by Adobe Systems. The conference is hosted by the Maryland Institute College of Art (MICA).

www.SocialStudiesConference.org

PAPERS

Please submit short abstracts (250 words maximum) for presentations addressing the following areas: typography, collaboration, activism, authorship, craft and making, time and interaction, social media, and entering the profession.

WORKSHOPS

Propose ideas for hands-on workshops designed to test drive innovative ideas for the classroom. In your proposal, specify the maximum number of participants, the required materials and facilities, and the desired educational outcome as well as describing the workshop activity itself.

MFA PANEL DISCUSSION

A panel of graduate students will report on what's happening in their MFA programs. How is your program organized? What projects are students working on? What are the driving issues and ideas? We invite proposals from graduate students who wish to represent their MFA program.

CHAPTER 05

AIGA DESIGN EDUCATORS CONFERENCE CALL FOR PROPOSALS

DESIGN FIRM
MICA GD/MFA

LOCATION
Baltimore, Maryland, USA

DESIGNERS
Joe Galbreath, Lindsey Muir

CLIENT
MICA GD/MFA

MATERIALS
Found book leaves, screenprinting

PRINTERS
Joe Galbreath, Lindsey Muir

These calls-for-proposals targeted graphic design MFA programs that were invited to participate in an AIGA Design Educators' Conference. Books that alluded to the "Social Studies" theme—family vacations, urban planning, gender roles and etiquette—were carefully dismantled into individual leaves and then screenprinted. The resulting stack of one-of-a-kind mailers displayed a range of still-visible type, diagrams, highlighted passages and margin notes. The labor and care involved in procuring the materials and printing by hand created a set of unique proposals that felt more like personal invitations for involvement than cold-call solicitations.

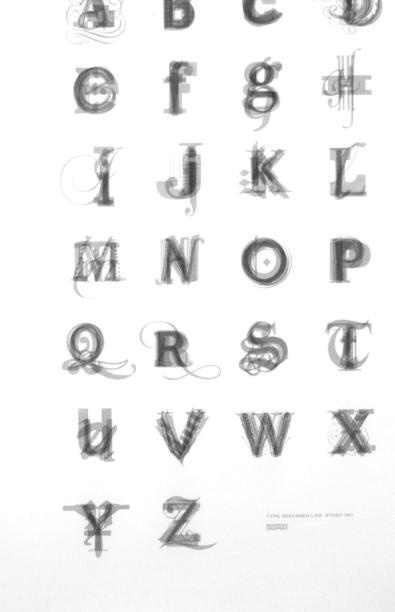

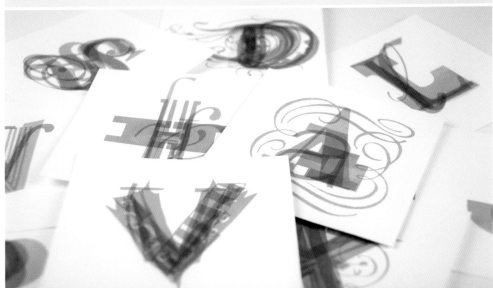

TYPE SPECIMEN LAB: STUDY 001

MASSIVE
GRAPHIC

DESIGNER
Beth Shirrell

LOCATION
Goshen, Kentucky, USA

ART DIRECTOR
Kelly Holohan

MATERIALS
Illustration, silkscreening

PRINTER
Tory Franklin

CHAPTER

05

KALAKARI DISPLAY

Kalakari translates from Hindi to mean "ornamentation." I explored typographic expression by creating a display font that captures and reflects the ornate culture of India. Taking cues from paper samples I collected while traveling through the country, I decided to showcase Kalakari Display in a series of silkscreened posters. Specifically, the posters take impetus from the location's architecture, the ancient art of henna painting and Hindu iconography. The richness of Indian culture's history, politics, beliefs and artwork (from commercial to spiritual art) are driven by handmade elements. Each uses the font to highlight a specific cultural influence in Hindi or Sanskrit and is explained in English.

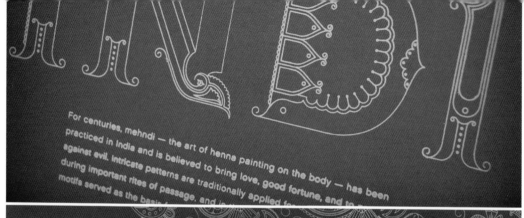

For centuries, mehndi — the art of henna painting on the body — has been practiced in India and is believed to bring love, good fortune, and to protect against evil. Intricate patterns are traditionally applied for during important rites of passage, and ho motifs served as the basis

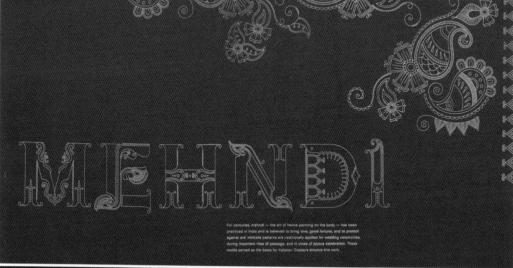

For centuries, mehndi — the art of henna painting on the body — has been practiced in India and is believed to bring love, good fortune, and to protect against evil. Intricate patterns are traditionally applied for wedding ceremonies, during important rites of passage, and in times of joyous celebration. These motifs served as the basis for Kalakari Display's sinuous line work.

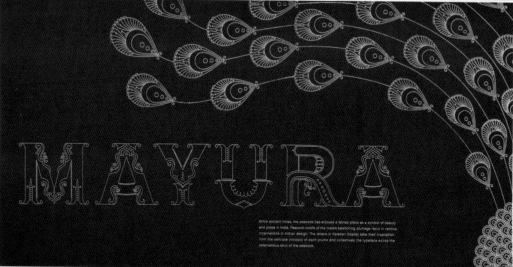

Since ancient times, the peacock has enjoyed a fabled place as a symbol of beauty and poise in India. Peacock motifs of the male's bewitching plumage recur in various incarnations in Indian design. The letters in Kalakari Display take their inspiration from the delicate intricacy of each plume and collectively the typeface echos the ostentatious strut of the peacock.

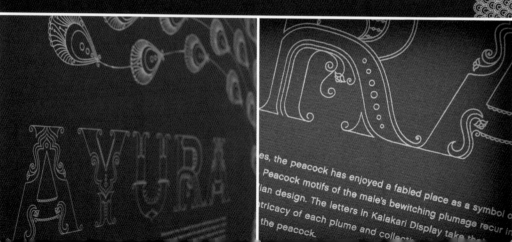

...es, the peacock has enjoyed a fabled place as a symbol o
Peacock motifs of the male's bewitching plumage recur in
...ian design. The letters in Kalakari Display take th
...tricacy of each plume and collecti
the peacock.

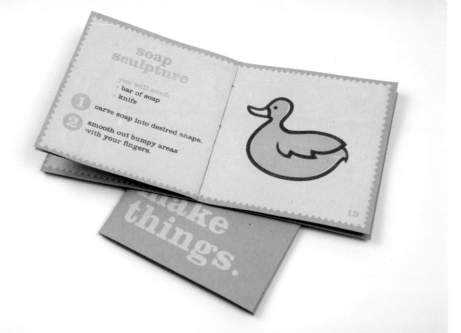

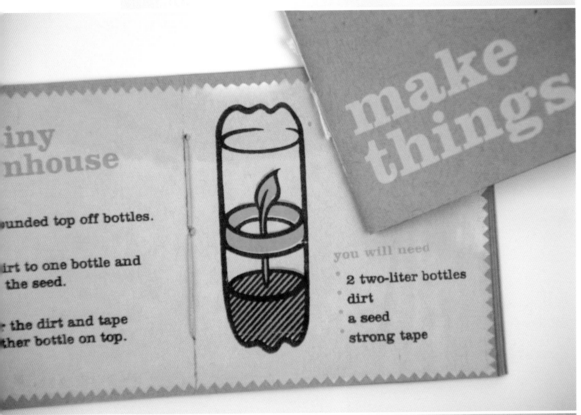

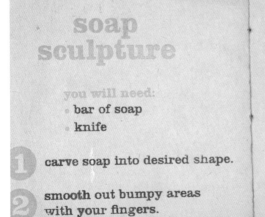

DESIGN FIRM
Valerie Jar

LOCATION
Salt Lake City, Utah, USA

ART DIRECTOR/ DESIGNER
Valerie Jar

MATERIALS
Screenprinting

PRINTER
Valerie Jar

CHAPTER

05

MAKE THINGS ZINE

I have always loved and been drawn to the feel of something made by hand. When I created this zine, the intent was for it to be fun, straight-forward and easy to use. The zine consists of five simple things to make, and it seemed fitting that the book's production match its mo-tive. It was hand-screenprinted in three colors on recycled paper.

DESIGN FIRM
Office:Jason Schulte Design

LOCATION
San Francisco, California, USA

CREATIVE DIRECTORS
Jason Schulte, Jill Robertson

DESIGNERS
Rob Alexander, Will Ecke,
Gaelyn Mangrum, Jeff Bucholtz

CLIENT
826 Valencia

MATERIALS
Screenprinting, hand painting,
hand application

CHAPTER

05

826 VALENCIA PIRATE SUPPLY STORE PRODUCTS

826 Valencia is a nonprofit tutoring center that also houses San Francisco's only pirate supply store. The unique storefront helps draw kids into the free creative programs held in the back. Office helped reinvigorate the pirate supply store by developing a new identity and nearly fifty new products, including a poster series that was inspired by the store's wildly imaginative, inspiring experience. The posters are available for sale at www.826valencia.org/store. All proceeds benefit 826 Valencia's programs.

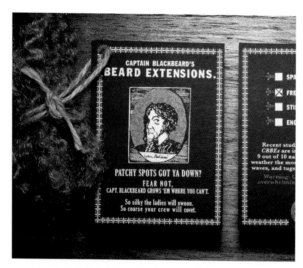

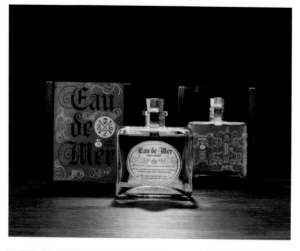

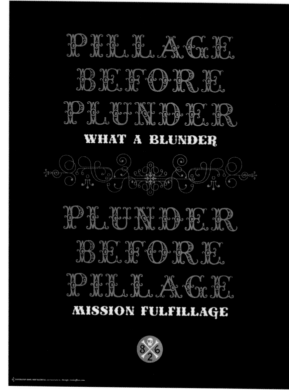

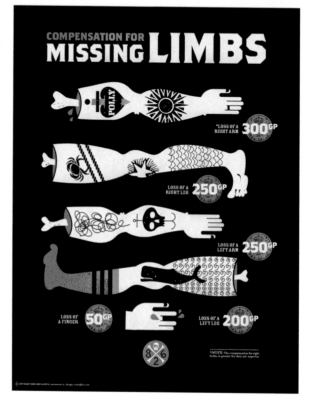

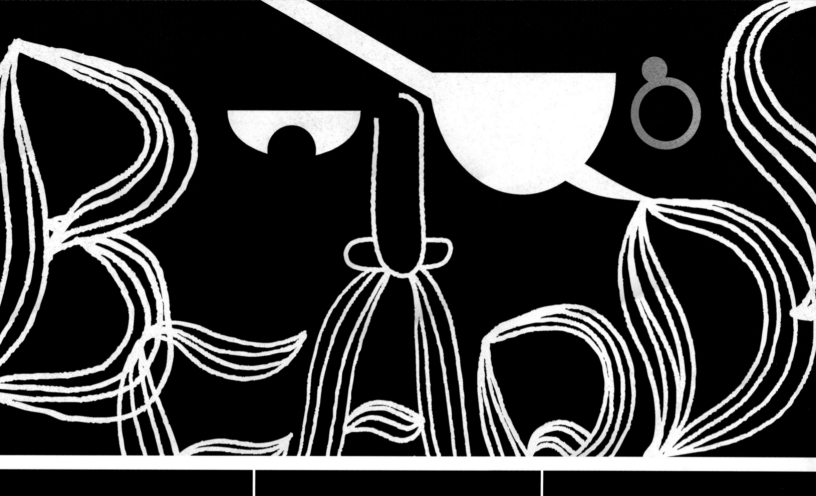

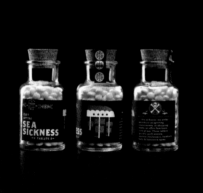

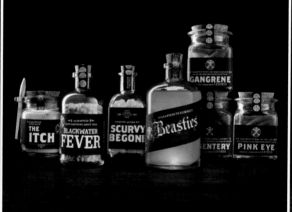

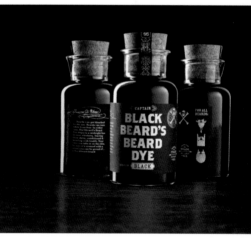

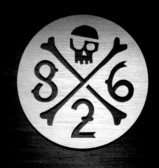

fue en ese viaje a Italia cuando alguno de tus amigos tuvo la oc

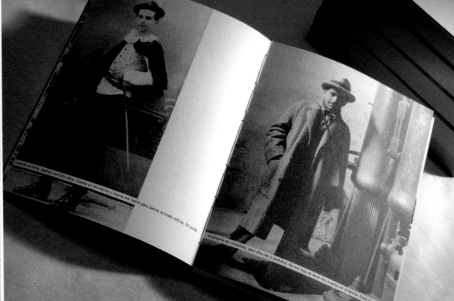

CHAPTER 05

EL OTRO BLAS BOOK

DESIGN FIRM
Explorare

LOCATION
Puebla, Mexico

DESIGNER
Juan Carlos Henaine

CLIENT
Blas Cernicchiaro Maimone

MATERIALS
MADS (digital offset);
Celeste (screenprinting)

Our client, Blas Cernicchiaro, came into Explorare with several photographic albums taken during the 1920s by his late father of the same name. Blas made a proposal to us: "I want to make an homage to my father, to his artistic vein: photography, music. Let's see what you come up with." We went through the material brought to us and realized that Don Blas had a real talent. Even though he was not a professional, it was clear to us that what we had in our hands was more than a hobby: it had a peculiar look inherent, full of irony and humor.

DIGGING DEEPER

We started by evaluating each and every album in search of the outstanding material that could give us a clue of where to start. We discarded right away the possibility of making a simple recollection of pictures; we wanted to go further. So, the idea of telling a story that bonded two generations started to develop. When we gathered the right material to tell a story, we started with the editorial design work. We arranged the photos in simple grids, keeping the rhythm from one page to the other. In most cases the photos are presented in their original form, and in others, we had to frame them differently to give them a more contemporary look and a documentary reference. Suddenly, the theme of the project was clear: the presence of a horizontal band that runs through each and every one of the pages.

The majority of the pictures were scanned right from the photo albums; in other lucky cases, we encountered the picture negatives. After recovering the images, a long process of digital restoration took place. The handling was respectful, preserving the tonal range typical of printed photos. The details that needed retouching were dealt with, and all alterations were justified. As the print run was small, two hundred copies, we selected digital offset for its reproduction. We selected a textured paper, and for each chapter cover, glossy screenprinted color plasters.

The number of copies and nature of the project, public and intimate, past and present, memory and homage, all at once drove us to hand bind each of the copies. For the end pages we opted for a floral tapestry motif in red. For the cover of the book, we chose something very simple: the title was reproduced in color register embossing to bring out the texture of the cardboard to the touch. The envelope was made to close through a string and button closure, and when opened, it displays flaps that include quotes from the narration.

— Juan Carlos Henaine

DESIGN FIRM
Exit 10

LOCATION
Baltimore, Maryland, USA

ART DIRECTORS
Scott Sugiuchi,
Jonathan Helfman

DESIGNERS
Scott Sugiuchi, Liz Merchant

CLIENT
HampdenFest

PRINTER
D&L Screenprinting

CHAPTER

05

**HAMPDENFEST
POSTERS**

Both posters (main festival, film festival) were created for a one-day event in the Hampden section of Baltimore. The festival brings together the seemingly random populations of the area, which range from artisan to working class. The concept was to feature a character that was an unusual mix of two unrelated animals and these would represent the two hybrid cultures of the Hampden area. Thus was born the Llamatee. The handmade elements of the poster are essential in conveying the flavor of this festival, which includes a DIY craft area, a "one day film festival/contest" and several indie rock bands. The headline type and illustrations are all by hand, processed on a copier and rescanned on a computer. The main poster was produced using silkscreen.

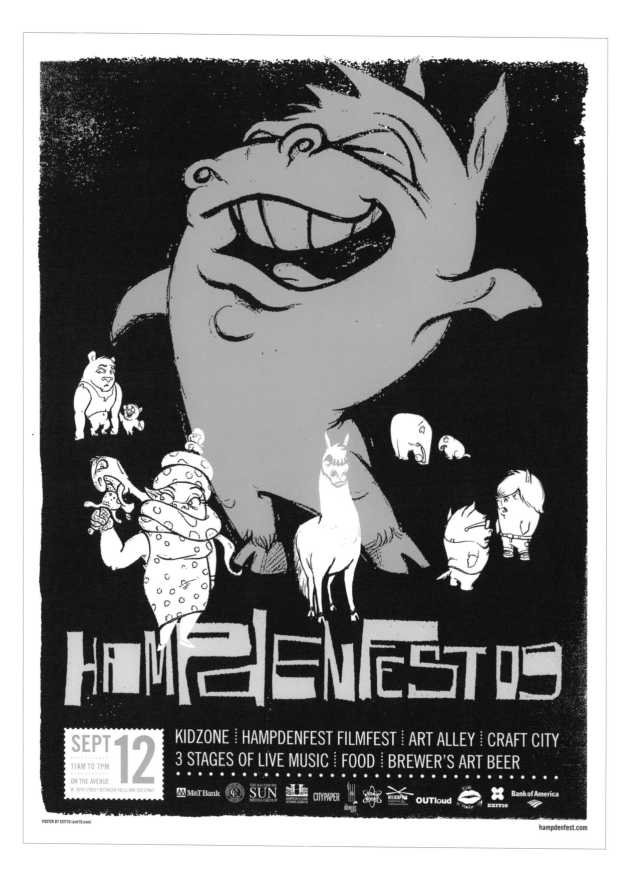

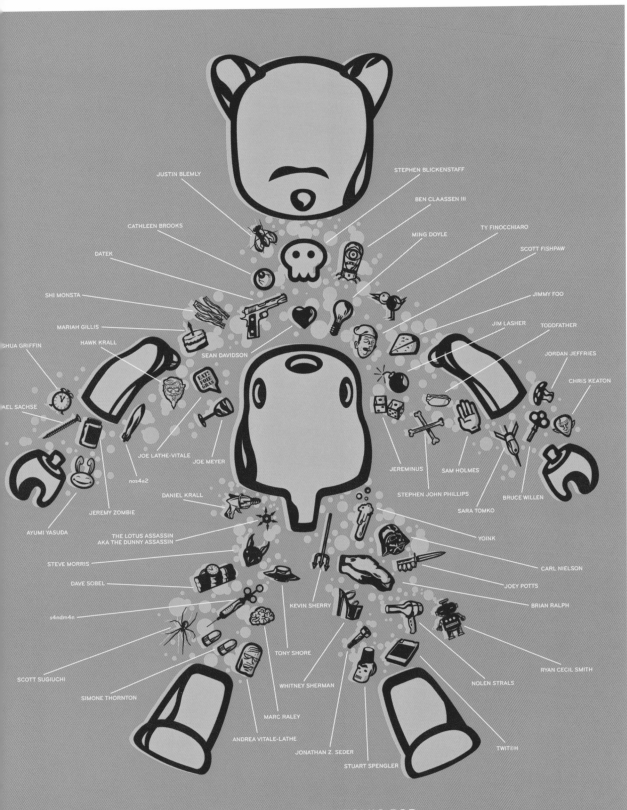

DESIGN FIRM
Exit 10

LOCATION
Baltimore, Maryland, USA

ART DIRECTORS
Scott Sugiuchi,
Jonathan Helfman

DESIGNER
Scott Sugiuchi

CLIENT
Atomic Pop

PRINTER
Patent Pending Industries

CHAPTER

05

VINYLMORE POSTERS

The explosion of so-called designer vinyl toys prompted Baltimore bookstore Atomic Books' toy offshoot, Atomic Pop, to host an artist-driven custom vinyl toy show. The show featured over forty artists, and each artist was represented by a "part" of the overall vinyl "Qee" (the blank vinyl character central icon to this poster). We figured vinyl figures and the visual culture surrounding them had a tendency to look slick at times. In order to counterbalance this, the hand-pulled poster was printed using silkscreen, a visceral, non-mechanical printing technique. We also thought that the very nature of the art represented in the show—one of a kind, hand-painted—was fitting.

you've never really been sure of this, but I can assure you that this quirk you're so self-conscious of is intensely endearing. Just please accept that this piece of you escapes with your smile and those of us who notice are happy to catch it in passing. Time spent with you is like chasing and catching small birds, but without the scratches and bird shit. That is to say, your thoughts and words flit and dart, disconcertingly elusive at times but when caught and examined — ahh! Such a wonder, such a delightful reward. There is no passing time with you, only collecting; the collecting of moments with the hope for preservation and at the same time release. Impossible? I don't think so. I know this makes you embarrassed, I'm certain I can see you blushing... I know it! but I just have to tell you because sometimes I hear your self doubt and it is so crushing to think that you may not know how truly wonderful you are... how inspiring and delightful and really, truly the most completely

wonder sometimes if you remember that time many years ago when you lived in that place... and you were so certain you were wrong about all of it you were ready to give up. And look now, what happened since and how much has changed. Do you recognize yet that you are purposeful? That you have a heart, not of gold, but of pure, rich, living, pumping blood, that gives so much passion despite the small nicks and tears (and fears) you've endured over time? Can you accept now that you deserve forgiveness, that you've earned love, and happiness is right here at your fingertips waiting for you to pick it up? And as for this belief that you were better in your 20s, or that last year you were better, or last month, or yesterday, I really want to knock it into your head that it is today and always today and now and now and now that you are better. With each year you become richer and fuller and more of everything you want to be... I am really hoping after all this time, you see that this is the very

CHAPTER 05

2009 VALENTINES

DESIGNER
Marian Bantjes

LOCATION
Bowen Island,
British Columbia, Canada

CLIENT
Self

For my 2009 valentines, I wrote four fragments of letters; each has no beginning and no end, and each is carefully crafted to hopefully have some resonance with most people. Each recipient got one fragment. My hope was that the recipients would read the letters at least twice and that on second or third readings, they would find something in it for them, something that made them believe that somehow through unknown means, I have known something about them all along.

and it's because of this and because of the way you move, and how you hold a glass in your hand, and that contemplative look you get, as though you were far away before you, flicker forward again like a 1960s TV set correcting itself—and I know it's not very romantic to be compared to a TV set—but it's about the light and the image presence, you know? How you come and go, flickering and shining—this is what I mean, I know you think yourself dull, but you must—you really must—see the absurdity of this and know that really it's the opposite of dull—a sparkling, a vivacity, a wit that draws us around you like beggars warming our hands. And OK, you think this is over the top and maybe even bad prose, because you've always had better taste than I... But I just wanted you to know that this is the answer to those mysterious looks you sometimes complain about; you assume the worst and it makes you all the more adorably foolish for your mistaking the obvious. So how can I

said this of your voice, that it was like the thrum of a leaf pulled by the wind without ever letting go of the branch. I was envious of the perfection of this description, and that I hadn't said it myself. But despite all that I know it is hard, it's always been hard; life is just that way. But you and I both know that if it were easy we wouldn't be interested. And yes we've had those times, those tender moments of cow eyes or kitten breath or python squeezes, or whatever turns your fancy—because god knows I've certainly never known that—when you and whoever or I and whoever or perhaps all of us at the same time in some distant way, we all together felt we knew and understood and figured it all out. But it always passes doesn't it? It passes but then it comes back again and that's the important thing to remember is that it comes back again. So please don't just stare at the ceiling thinking it has nothing to do with you, because you are the maker and the giver, and you have to do that first before

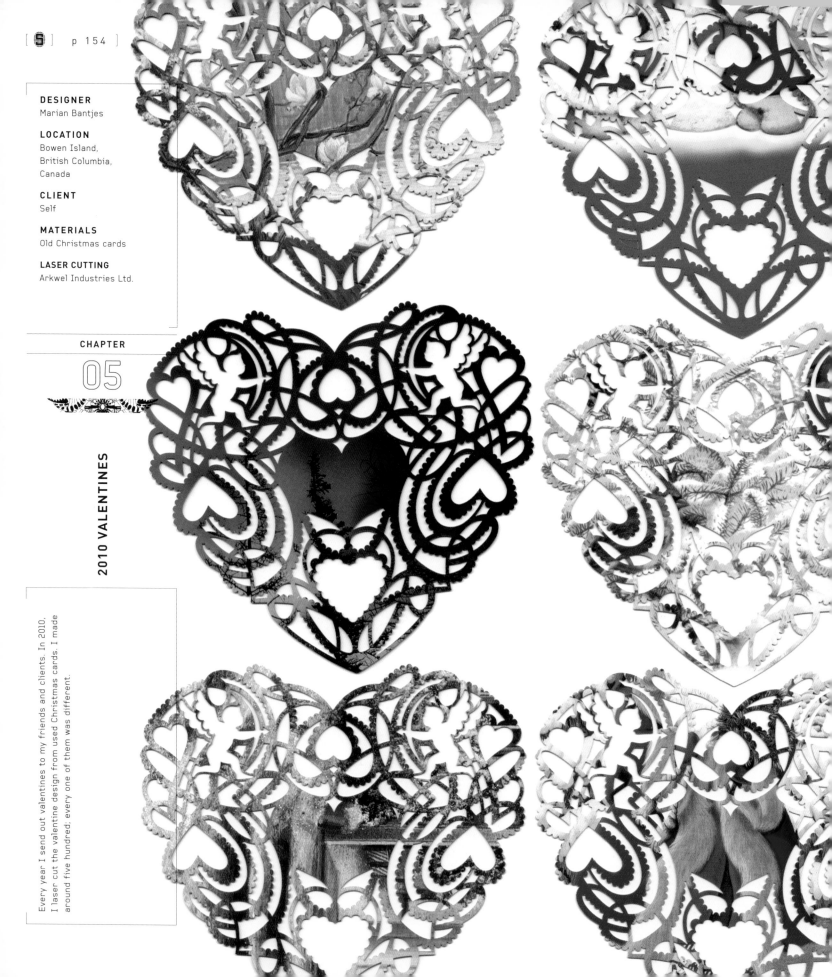

DESIGNER
Marian Bantjes

LOCATION
Bowen Island,
British Columbia,
Canada

CLIENT
Self

MATERIALS
Old Christmas cards

LASER CUTTING
Arkwel Industries Ltd.

CHAPTER

05

2010 VALENTINES

Every year I send out valentines to my friends and clients. In 2010, I laser cut the valentine design from used Christmas cards. I made around five hundred; every one of them was different.

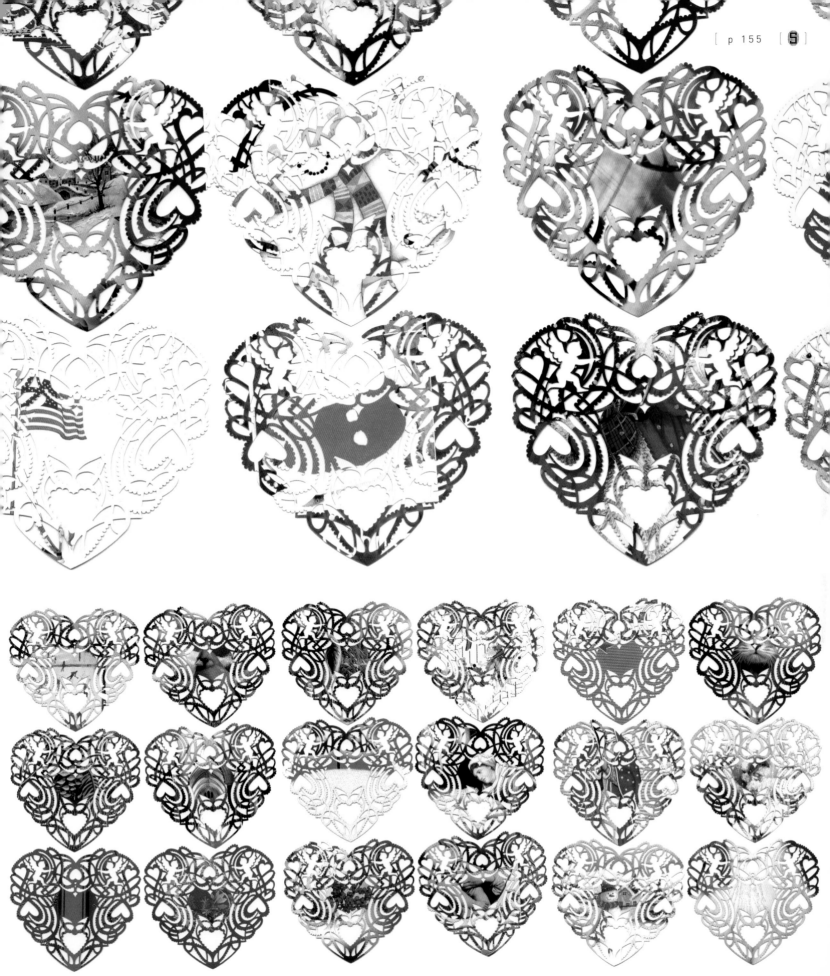

DESIGN FIRM
Exit 10

LOCATION
Baltimore, Maryland, USA

ART DIRECTOR
Scott Sugiuchi,
Jonathan Helfman

DESIGNER
Scott Sugiuchi

CLIENT
Atomic Books

PRINTER
Patent Pending Industries

CHAPTER

05

**ATOMIC BOOKS
POSTERS**

Exit 10 created these posters for underground bookstore Atomic Books. Both posters were printed at the same time and featured two versions of the same visual element and color scheme. The Mash-Up poster was a promotion for an in-store lecture and signing series featuring authors from different genres of fiction. We imagined the two authors speaking at the same time and naturally they would have the same body but with four legs. Handmade elements of drawn type and collage were used to emphasize the authors' DIY approach to publishing and writing. The Minutemen poster promoted a documentary featuring the legendary punk band. The idea was simple: three band members' legs intertwined as a metaphor for the band's dynamic interplay.

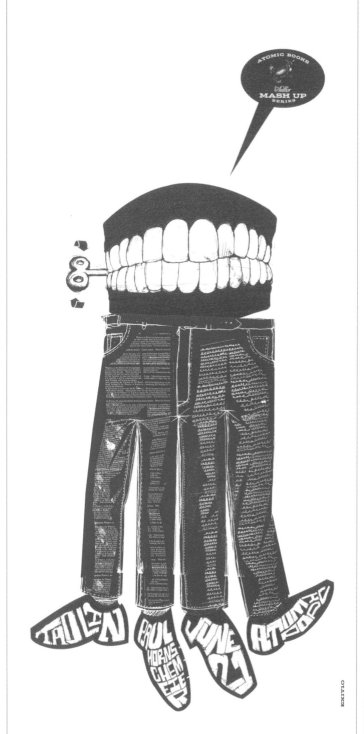

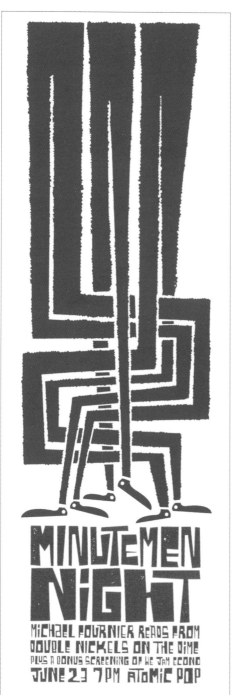

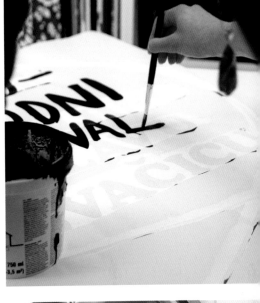

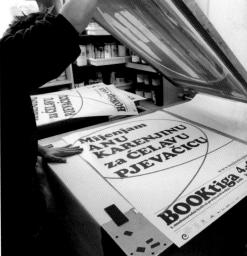

MEĐUNARODNI FESTIVAL PROČITANIH KNJIGA

Trg Marafor, Poreč

www.knjiznicaporec.hr

BOOKtiga 23.-25.IV.2009.

The Poreč festival of used books is held for a second year. Since many posters have remained from last year's festival, we have decided not only to use them, but also to feature the element of used goods. So the posters were painted over, with details of the old poster still visible, carrying the message that used goods, cleverly employed, can have the same value as the new ones. The concept was also used in the rest of the campaign (recycled commercial, reprinted old sponsor T-shirts and bags).

DESIGN FIRM
Studio Sonda

LOCATION
Poreč, Croatia

ART DIRECTORS
Kristina Poropat,
Jelena Simunovic, Sean Poropat

DESIGNERS
Ana Bursic, Tina Erman,
Aleksandar Zivanov

CLIENT
Gradska knjiznica Poreč

MATERIALS
Screenprinting, handwriting

BOOKTIGA 2009
PROMOTIONAL
POSTER

CHAPTER 05

DESIGN FIRM
Altitude

LOCATION
San Francisco, California, USA

ART DIRECTOR
Brian Singer

ILLUSTRATORS
Juliana Coles,
David Cuesta, Julie Sadler,
Erin Elizabeth Partridge,
Melissa McCobb Hubbell

CLIENT
SFMOMA

CHAPTER

05

SFMOMA 1000 JOURNALS EXHIBITION ANNOUNCEMENT

Six pieces of art mix with four different screenprints to make twenty-four different combinations. Because of the nature of the project (contributions to journals that traveled the world), ensuring the announcements felt handmade was our priority. The layered approach of printing, debossing and sticking, then screenprinting, sewing and hand-marking created a level of uniqueness not often found in printed promotions. The effort of producing six thousand of these was rewarded by an overwhelmingly positive response and word-of-mouth exposure for the exhibition, very much like the 1000 Journals Project itself.

DESIGN FIRM
Wink, Incorporated

LOCATION
Minneapolis, Minnesota, USA

ART DIRECTORS
Richard Boynton,
Scott Thares

DESIGNER
Richard Boynton

CLIENT
Rebel Green

MATERIALS
Various, silkscreen

CHAPTER

05

REBEL GREEN

Silkscreened with soy-based inks on organic cotton canvas with an eye for craftsmanship, the bags demand long-term reuse, as the inevitable patina will only add to its charm. The return to quality has landed Rebel Green products on shelves everywhere from Fred Segal to Whole Foods Market, as well as La Grande Épicerie de Paris.

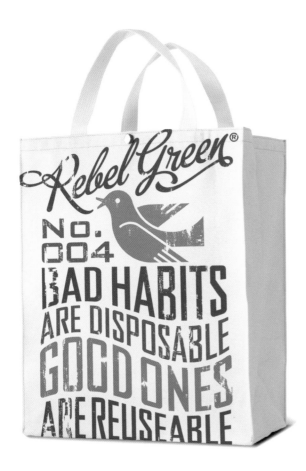

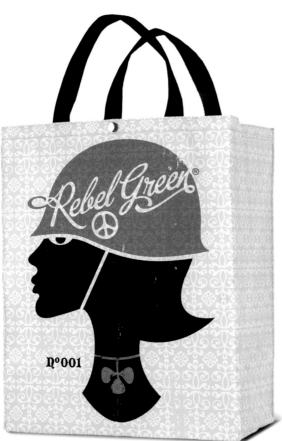

DIGGING DEEPER

Sometimes a step backwards can be a way forward. Today the ever-evolving eco-friendly marketplace is being inundated by new products, each extolling the virtues of reducing, reusing, and recycling. Rebel Green products was about to join a long list of reusable totes, lunch bags, and veggie washes that already had their own turf in specialty gift shops across the country.

But Rebel Green is a new breed of responsibly made products with a simple insight: many items billed as "green" are shipped to the US from overseas manufacturers, thereby negating their ecological intent. Additionally, by ceding manufacturing oversight, there is no guarantee that promises like "soy-based inks, and 100% organic cotton" will be kept. Moreover, the brand needed to find a more appealing story than the "rebel"—as in skulls and motorcycles—mantra in order to spark distribution.

The first thing we did was to reexamine the strategy. By simply removing the word "rebel" from the brief and changing it to a more target-friendly "sass" we expanded the conceptual and thematic playing field. It gives us more to work with, and it allows room for growth. But more importantly, it allows us to pair the benefits responsible manufacturing with a uniquely American vernacular. One that reminds us of a time before consumerism became rampant, when reusing and recycling were the norm and not merely a marketing pre-requisite.

The result is a brand that's authentic and a product line that's uniquely Eco-Americana, with just a dash of "you're not the boss of me" thrown in for good measure.

— Richard Boynton

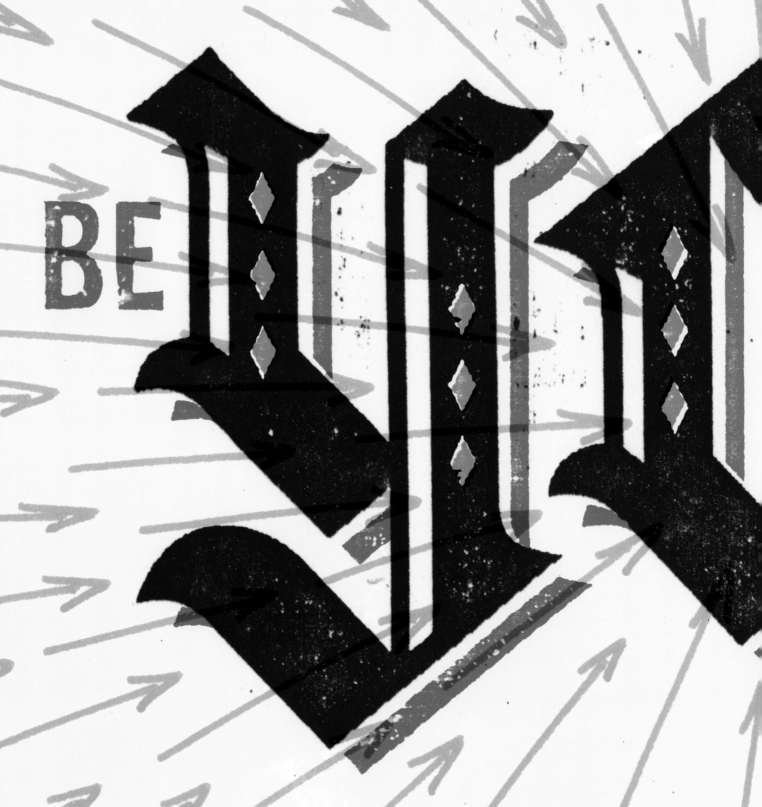

I BELIEVE PEOPLE CONNECT MORE DEEPLY WITH WORK THAT SHOWS THE HUMAN HAND. THERE'S

HEART ARE ALL THERE ON THE PAGE, EVIDENT FOR EVERYONE TO SEE. AND THAT IS INNATELY BEAUTIFUL.

...CE BECAUSE, UNAVOIDABLY, THERE'S A PIECE OF YOU IN THE WORK, YOUR QUIRKS, MISTAKES AND

BE YOU

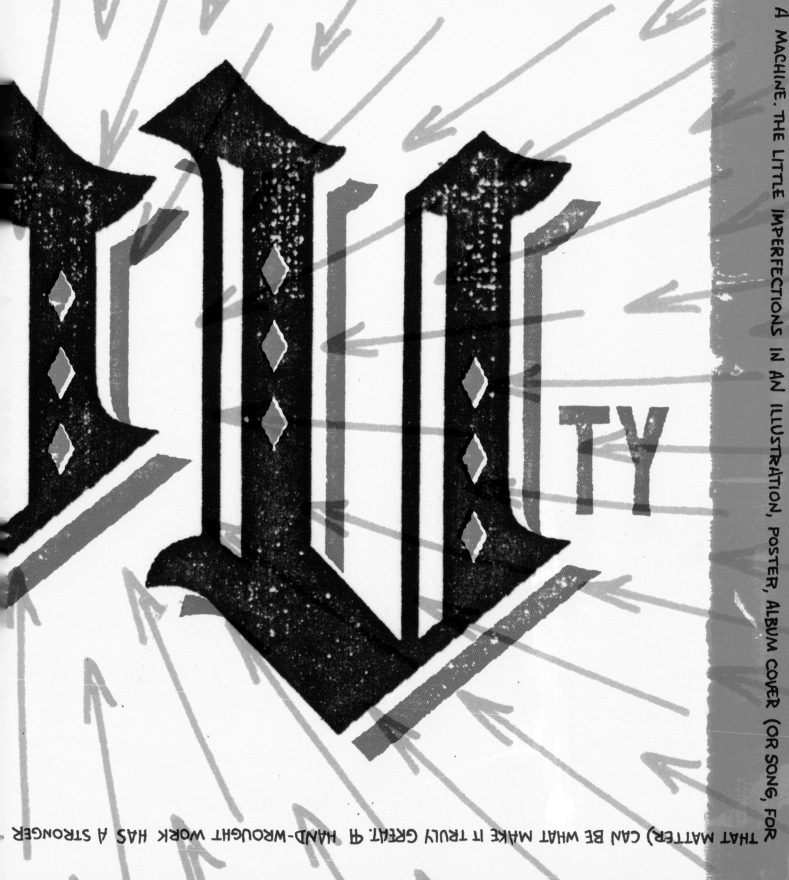

E KINSHIP THAT WE EXPERIENCE WITH DESIGN THAT FEELS CRAFTED BY A "REAL PERSON," RATHER

THAN A MACHINE. THE LITTLE IMPERFECTIONS IN AN ILLUSTRATION, POSTER, ALBUM COVER (OR SONG, FOR

THAT MATTER) CAN BE WHAT MAKE IT TRULY GREAT ¶ HAND-WROUGHT WORK HAS A STRONGER

CHRISTIAN HELMS, HELMS WORKSHOP

TY

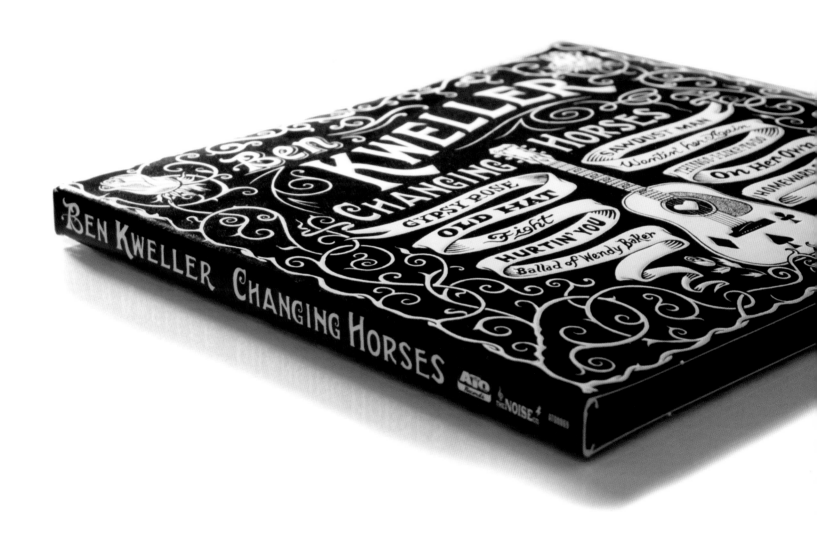

Ben recorded an album that was more organic and traditional than his previous fare, so I built packaging to match. We put together loose sketches and then worked with Madame Talbot, an illustrator whom we were never allowed to speak to directly—only through her medium, who went by the name "Lucky."

DESIGN FIRM
Helms Workshop

LOCATION
Austin, Texas, USA

ART DIRECTOR/DESIGNER
Christian Helms

CLIENT
Ben Kweller & ATO Records

BEN KWELLER
CHANGING HORSES
CD PACKAGING

CHAPTER 05

DESIGN FIRM
Helms Workshop

LOCATION
Austin, Texas, USA

ART DIRECTOR/ DESIGNER
Christian Helms

CLIENT
American Poster Institute

MATERIALS
Screenprinted with real BBQ sauce!

PRINTER
Geoff Peveto, Decoder Prints

CHAPTER

05

FLAT STOCK BBQ SAUCE POSTER

I earned a degree in journalism at UNC before finding design, and often my writing background makes its way into my work. Flatstock is a music poster conference that's also become a family reunion of sorts for all of the gig-poster artists from across the country, and the Austin event is always accompanied by a BBQ. When I was asked to design a promotional poster, it seemed like a great excuse to poke fun at Texas clichés, to make the other artists laugh and for my partner Geoff and I to try something we'd talked about for years: screen printing with BBQ sauce. He did a hell of a job on the printing, and the posters still smell great.

COME ALL! VISIT THE

FLAT STOC

SEE AESTHETIC APPARATUS! MEET THE SMALL STAKES! SMELL JAY RYAN!

THERE'S B

ALMOST LIKE REAL ART
SHIT LOOKS GREAT WITH YOUR COUCH

FREE
ADMISSION DAILY

11-6
FRI-SATURDAY

1-6
THURSDAY

POSTER CONVE

DURING SOUTH BY SOUTHWEST IN

AUSTIN, TX
AT THE BIG CONVENTION CENTER

COMPLETELY OPTIONAL COME COMFY

THAT'S A JOKE. COVER YOUR JUNK.

THEN COME BUY US A BEER AND ANOTHER BEER

HELL YES INDEED THERE WILL BE A

SEE THOUSANDS OF MUS
ART BY HILLBILLIES, DRUNKS AND EX-
AND CHEAPSKATES; TELL A FRIEND,

BUY
SHIRTS
& OTHER
STUFF
YOU DON'T
NEED

BEFORE FLATSTOCK AFTER

STIMULATE THE ECONOMY,
YOU DIRTY WHORE. MAKE ME A S

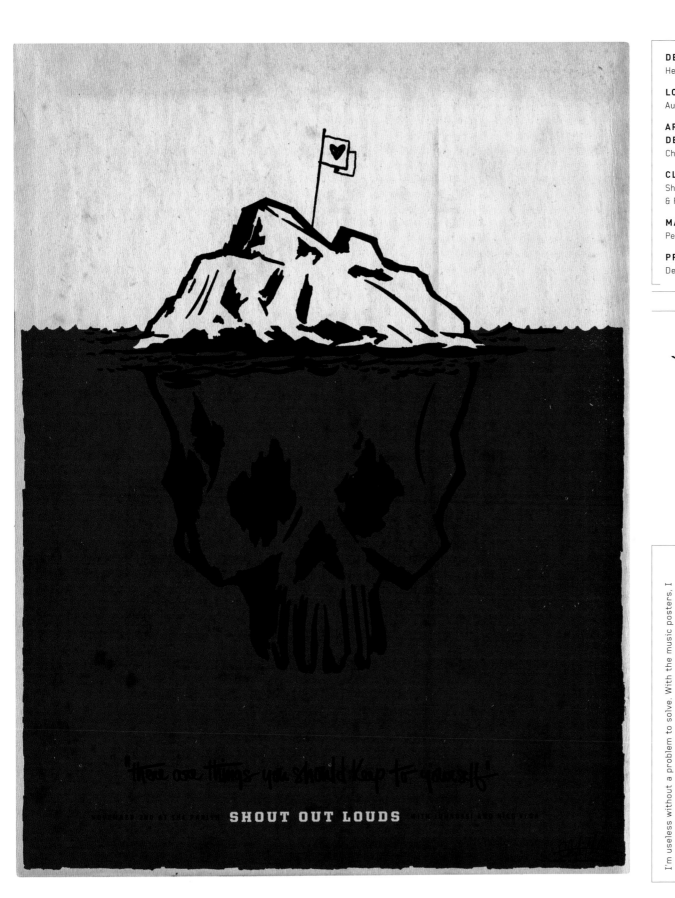

DESIGN FIRM
Helms Workshop

LOCATION
Austin, Texas, USA

ART DIRECTOR/
DESIGNER
Christian Helms

CLIENT
Shout Out Louds
& PMC Presents

MATERIALS
Pen

PRINTER
Decoder Prints

CHAPTER

05

SHOUT OUT LOUDS
POSTER

I'm useless without a problem to solve. With the music posters, I gravitate towards the band's lyrical content in search of an assignment I can create for myself. I pour through the content, building a loose matrix of themes until I can identify an overarching narrative or core sentiment for the album. Then I try to find a unique visual metaphor to communicate it. Sometimes it all lines up perfectly, sometimes not.....

DESIGN FIRM
Helms Workshop

LOCATION
Austin, Texas, USA

**ART DIRECTOR/
DESIGNER**
Christian Helms

CLIENT
Franks

MATERIALS
Pen

CHAPTER

05

PORK MILITIA

Frank is an Austin, Texas, mecca for bacon lovers, beer guzzlers and encased meat enthusiasts. Sausage is not a modest food, and the brand collateral reflects its pride and majesty. Frequent, loyal diners and visiting dignitaries earn induction into the Pork Militia—a secret society of the highest order. The illustration is based on our dog Scatter, who vigilantly protects our home with every ounce of her 18-lb. frame.

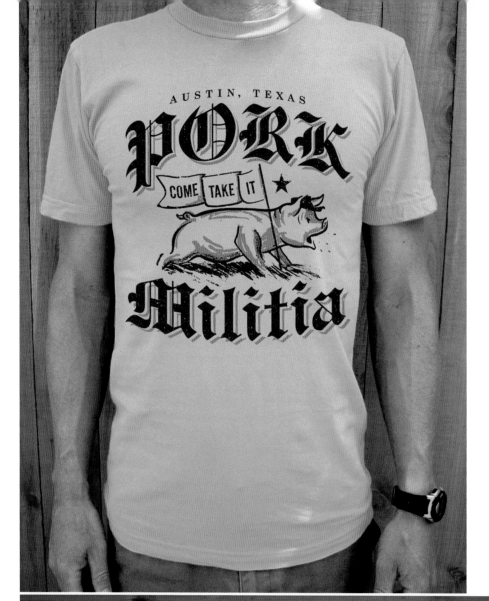

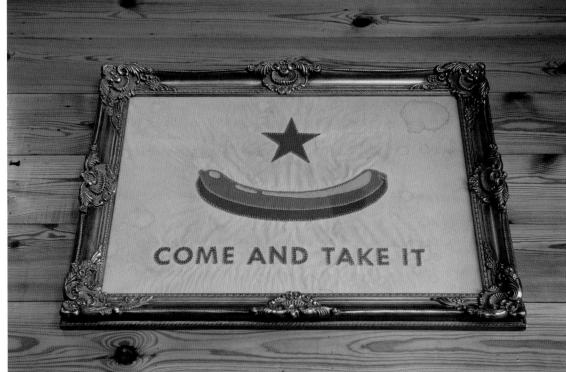

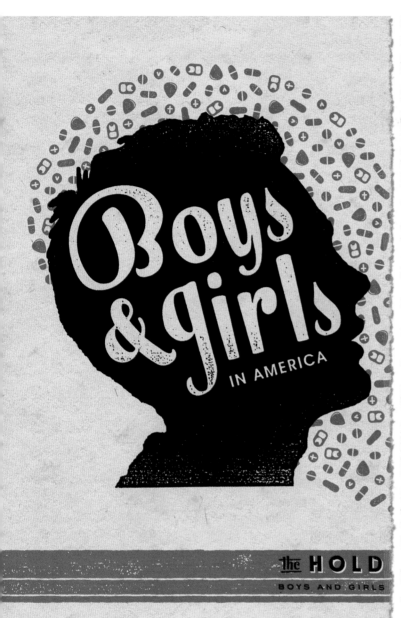

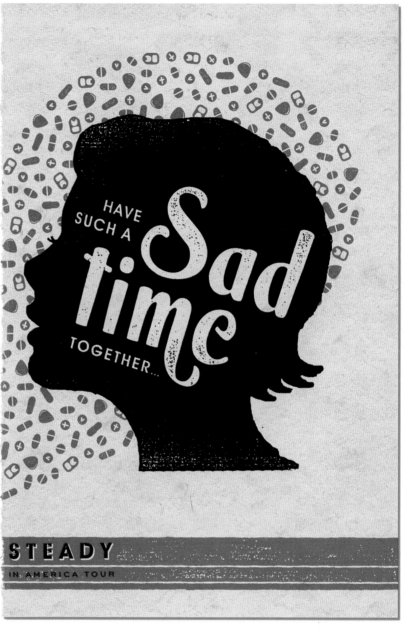

The band's *Boys and Girls in America* album revolves around this central quote from Kerouac, and each of over one thousand posters were hand-torn to reinforce the theme. It's moments like these that separate the good interns from the great. Thanks to Bernie Berry and David Pappenhagen for all the hard work (and paper cuts).

DESIGN FIRM
Helms Workshop

LOCATION
Austin, Texas, USA

ART DIRECTOR/ DESIGNER
Christian Helms

CLIENT
The Hold Steady

MATERIALS
Pen

PRINTER
Decoder Prints

THE HOLD STEACY
BOYS & GIRLS
IN AMERICA
TOUR POSTERS

CHAPTER 05

CONTINUED ON P. 202

CONTINUED FROM PAGE 134

calligraphy, tangled tree roots, human capillaries, and Irish lace with equal grace. Bantjes' organic, jubilant designs first caught the public eye in 2004, with custom lettering and illustrations for *Details*; since then, she has created an exquisite portfolio of hand-drawn typography, vector drawings, original fabrics, playful and labyrinthine signage, embellished typefaces, laser-cut Valentine's Day cards, and exquisite promotional pieces for Saks Fifth Avenue. Bantjes is industrious and prolific, and admits her style is (like much in design) a trend. "The pendulum of art and design has always swung between austerity and ostentation," she says. "We were in austerity for a while and, for whatever reason, people have found ornamentation beautiful again."

EMBRACING INGREDIENT X

What do these international design superstars have to do with this book—the one you're holding in your own creative hands? Everything, of course. If the desire behind all good design is to communicate—an idea, a thought, a message—clearly, Fingerprint No. 2 exists to prove how in certain settings, that communication can be most effective if it reveals evidence of the human hand. Flip through these pages and this will become obvious: from the gold-dripping letterpress graphics for the Alembic Bar in San Francisco to the recycled, overpainted silkscreen designs for the used-book festival in Porec, Croatia, those projects that reveal their creators' fingerprint speak to their audience with a clarity and an integrity, a real-ness no pixel-pusher can match. Each designer's work included here contains a pinch of handmade necessary to tug at hearts, minds, and consciences, to say:

06

WOOD, IRON, FOOD & FABRIC

DESIGN FIRM
Taxi Studio

LOCATION
Bristol, England

CREATIVE DIRECTORS
Ryan Wills, Olly Guise

ILLUSTRATOR
Tom Lane

CLIENT
Clarks

MATERIALS
Collage made of actual
shoe materials

CHAPTER

06

CLARKS ORIGINALS
POINT OF SALE

Clarks wanted to celebrate the handcrafted aspect of their world-famous range of Originals footwear. The posters were to be displayed in windows of their stores across the world. We devised the line "I Love My Originals," then lovingly presented each product with details and features that are evocative of each shoes' name or purpose.

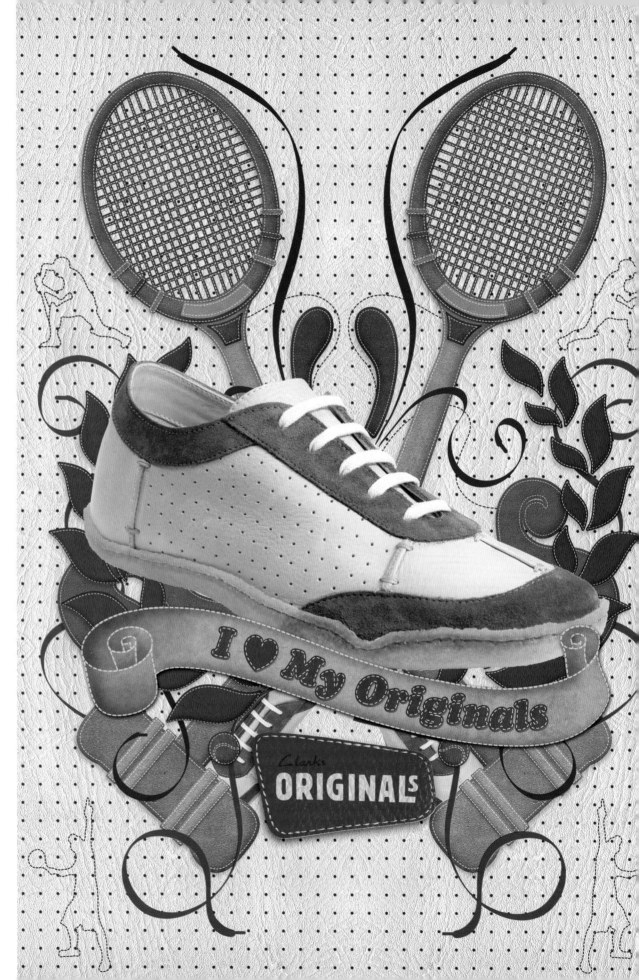

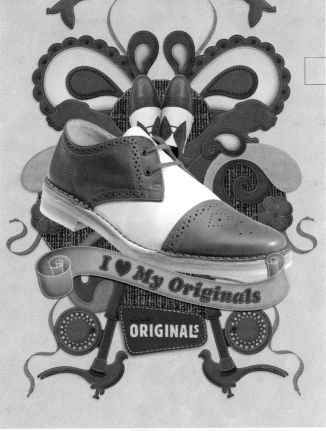

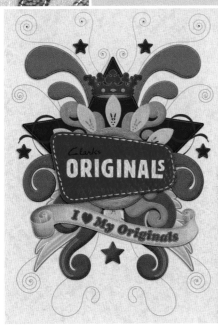

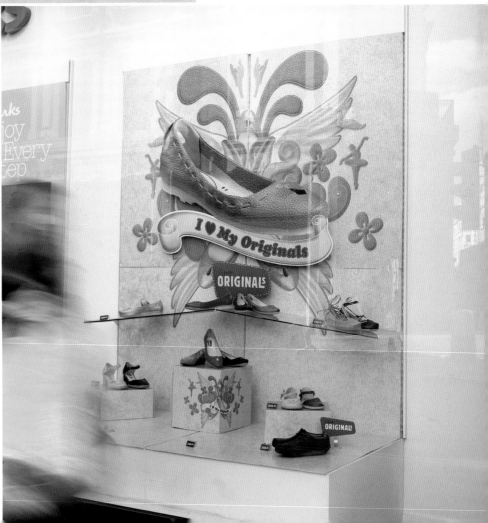

DIGGING DEEPER

We were briefed by Clarks shoes to create a compelling set of point-of-sale displays for the Clarks Originals brand. The brief was to highlight the exquisite details and materials used to create the Clarks Originals products (which include the iconic Desert Boot) whilst representing the individual style of each product.

To demonstrate the craftsmanship, we commissioned illustrations to create works of art that celebrate unique details of the latest shoes in the range whilst also representing the specific trend that the shoe embodies (such as the ballerina pump or the tennis shoe).

We dissected the shoes, played around with the materials and created detailed sketches in order to give the illustrator (Tom Lane) a firm understanding of exactly what we were after.

— Ryan Wills

DESIGN FIRM
Taxi Studio

LOCATION
Bristol, England

CREATIVE DIRECTOR
Spencer Buck

DIRECTOR
Ryan Wills

CLIENT
Clarks Shoes

MATERIALS
Various to create
interesting typography

CHAPTER

06

CLARKS ORIGINALS AUTUMN/WINTER CATALOGUE

Clarks Originals is a well-established worldwide brand, ionized by the famous Desert Boot and Wallabee shoe. They needed a sales tool to help sell their Autumn/Winter 2007 range into retail outlets from the USA to the UAE. We used intriguing and bespoke typography to explain the stories of the season's range.

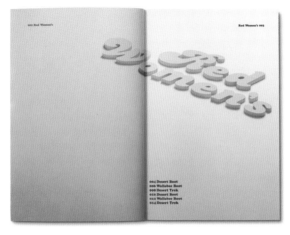

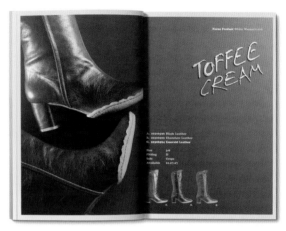

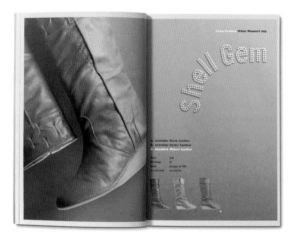

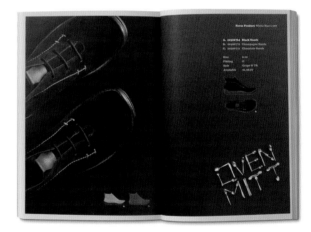

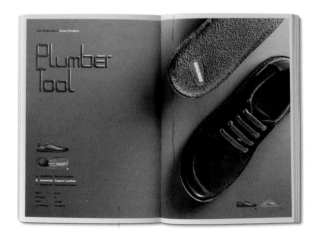

CINCINNATI, OH
INDIANAPOLIS, IN
MANCHESTER, TN

ATLANTA, GA
CHARLOTTE, NC
COLUMBIA, MD

RED BANK, NJ
NORTHAMPTON MA
NEW YORK, NY
BROOKLYN, NY
BOSTON, MA
SHELBURNE, VT

TORONTO, ONT
KONGSBERG, NORWAY
COPENHAGEN, DENMARK
MONTREUX, SWITZERLAND
SUFFOLK, ENGLAND, APX

GLASGOW, SCOTLAND
DOUR, BELGIUM
TORINO, ITALY
BENICASSIM, SPAIN
DULUTH, MN

WINNIPEG, MAN
CALGARY, ALB
EDMONTON, ALB
VANCOUVER, BC
SEATTLE, WA

TROUTDALE, OR
BERKELEY, CA
SAN DIEGO, CA

LOS ANGELES, CA
DENVER, CO
AUSTIN, TX

wilco
sky blue sky tour

Poster to promote Wilco's tour for their album *Sky Blue Sky*. In order to capture the imagery used in their album and to visually describe Wilco's indie sound, the poster has been created using handmade methods. The bird is made from a cloud stamp on muslin, and the digital type has been distressed to emulate the block-printed look of the bird. Getting away from the computer and learning new disciplines is important to me; it is an escape. I picked up linoleum block printing as a hobby, and quickly fell in love with the process. It is a cheap printing technique that is unique with every print and surprisingly versatile in application.

DESIGN FIRM
Ivy Knight

LOCATION
Austin, Texas, USA

DESIGNER
Ivy Knight

MATERIALS
Fabric, stamp, stencil,
Adobe Photoshop

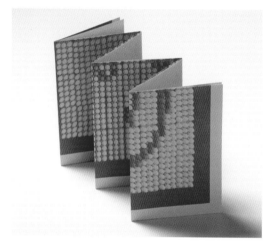

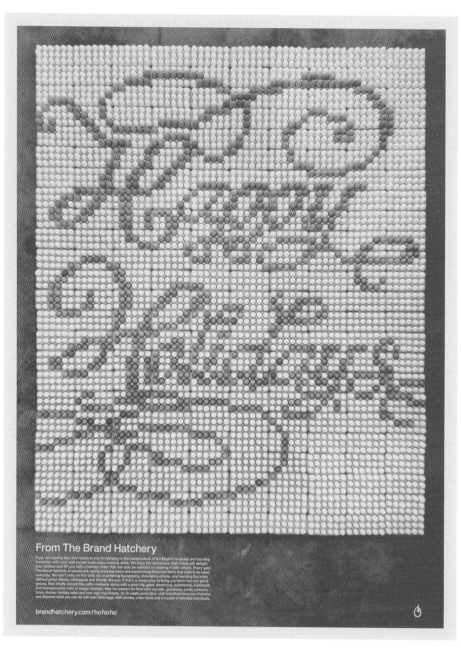

From The Brand Hatchery

If you are reading this, then kudos to you for carrying on the advancement of the English language and taunting humanity with your well-honed body-copy-reading skills. We hope the sentences that follow will delight your senses and fill you with a holiday cheer that can only be satisfied by sharing it with others. Every year The Brand Hatchery is tasked with taking everyday items and transforming them into items that want to be used, everyday. We can't carry on this bold act of polishing typography, stimulating retinas, and bending the brain without great clients, colleagues and friends like you. If that's a cheap ploy to bring you back into our good graces, then kindly accept this paltry endeavor along with a great big, giant, enormous, substantial, mammoth and immeasurable wish of happy holidays. May the season be filled with warmth, goodness, pretty pictures, funny stories, holiday sales and new egg nog recipes. Or, to waste some time, visit brandhatchery.com/hohoho and discover what you can do with over 5000 eggs, 4000 photos, a few hours and a couple of talented individuals.

brandhatchery.com/hohoho

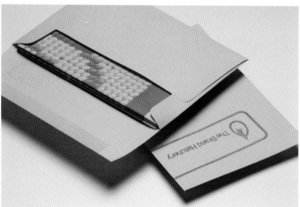

CHAPTER 06

2008 BRAND HATCHERY HOLIDAY POSTER

DESIGN FIRM
The Brand Hatchery

LOCATION
Dallas, Texas, USA

ART DIRECTOR
Blake Wright

CREATIVE DIRECTOR
Aaron Opsal

DESIGNER
Frances Yllana

CLIENT
The Brand Hatchery

MATERIALS
Eggs, people, photos and video

PRINTER
Texas Graphic Resource

The project started by trying to find an economical solution to our 2008 holiday card by doing something all typographical—something simple we could quickly design in house. But, there's a saying that "money chases great ideas." And that's exactly what happened. We hit up just about every grocery store in the neighborhood (over twelve different stores) to assemble more than five thousand eggs. We originally wanted to do the "Happy Holidays" in white eggs, surrounded by the brown eggs, but we couldn't get a hold of enough browns eggs on our timeline to pull it off.

DIGGING DEEPER

At first glance everyone thinks it's a Photoshop trick, but 100 percent of it was done by hand, in camera, in person and with a ton of ready-to-be-fried-up eggs. It was a blast to put it all together, and yes, there were a few mishaps and practical jokes along the way. We had a loose visual guide that we used to place all the eggs. It looked like one of those Scantron test cards where you just colored in pictures and words instead of actually answering test questions. It was created with four thousand still photographs that were stitched back together for a time-lapse, making-of video. (You can see it at www.vimeo.com/2446611). The clean up wasn't quite as pretty as the poster. For the unfortunate fallen eggs, we had to call in a special dumpster dump to rid the studio of any evidence and excessive odor. And the others were packed neatly back in their cases and donated to all the omelet lovers in the community. It was a simple idea, with a fairly simple execution. People, eggs, film, fun. Who knows? Maybe one of the type foundries will pick up our new "Faberge Blake" typeface.

— Blake Wright

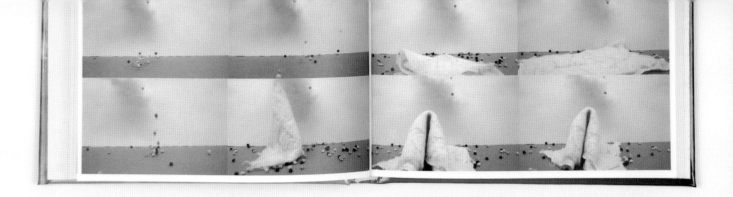

THE STORY OF WEAVER BOOK

DESIGN FIRM
Vida Sacic

LOCATION
Indianapolis, Indiana, USA

ART DIRECTOR/DESIGNER
Vida Sacic

CLIENT
Self

MATERIALS
Wool roving, dye,
gouache, photography

This project centers around five handmade figures whose adventures are documented in book and poster format. The book and posters fall into the category of children's books for adults or adult books for children, as they feature emotionally charged content delivered through simple visual elements. It was important to the author to truly own the process of creating the work and give it the immediate personal touches that handmade elements provide. All characters and props were crafted using homemade felt created from organic sheep roving that was dyed, cut and sewn.

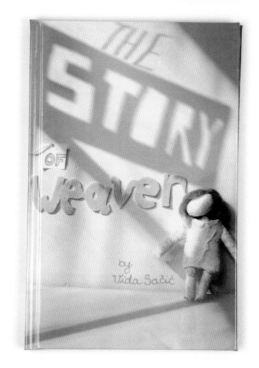

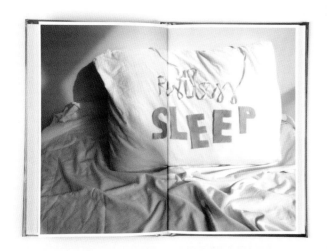

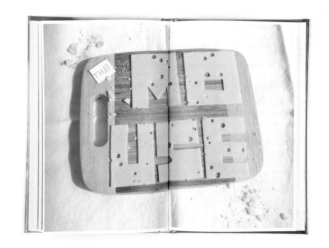

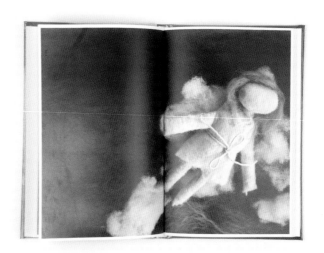

DESIGN FIRM
Vida Sacic

LOCATION
Indianapolis, Indiana, USA

**ART DIRECTOR/
DESIGNER**
Vida Sacic

CLIENT
Self

MATERIALS
Wool roving, dye,
thread, photography

CHAPTER

WEAVER POSTERS

These posters were created to advertise the book *The Story of Weaver*, which centers around five handmade figures whose adventures are documented in book and poster format.

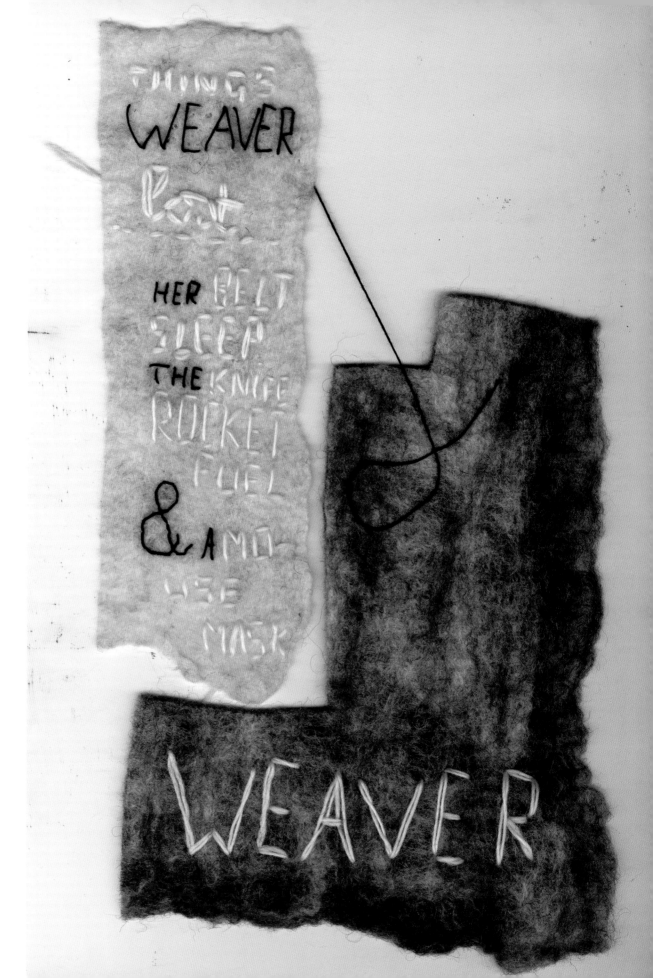

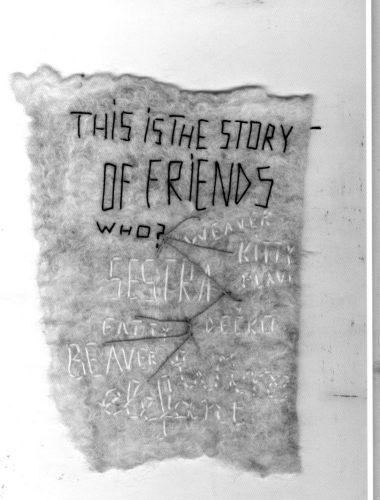

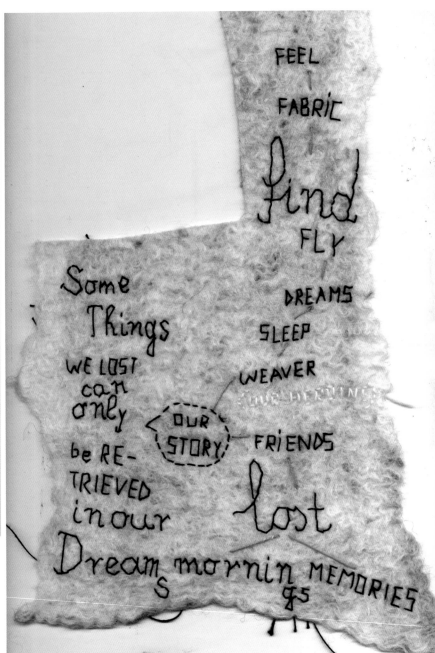

CHAPTER 06

THERE'S NO PLACE LIKE HOME

DESIGN FIRM
Sparks

LOCATION
London, England

ART DIRECTOR
Michael Gough

DESIGNER
Liz Cowie

CLIENT
Ella Doran

MATERIALS
Sauces, seasoning, condiments, paper

PRINTER
Ella Doran

Sparks was asked by homeware designer Ella Doran to create a set of limited-edition placemats based on the theme "There's no place like home" for a silent auction for Shelter, a UK-based homeless charity. We decided to have some fun using different types of condiments to create playful typographic images of colloquial English phrases that you might hear around the kitchen table. As the phrases are fairly common-place, we wanted to reflect the informality in the designs. We thought the best way to capture this was by creating all the typography with a piping bag and knife and then photographing it.

DESIGN FIRM
Aufuldish & Warinner

LOCATION
San Anselmo, California, USA

ART DIRECTOR
Bob Aufuldish

CLIENT
California College of the Arts

MATERIALS
Silk flowers, scanner

PRINTER
Oscar Printing Company

CHAPTER

06

FALL 2007 CCA ARCHITECTURE LECTURE SERIES POSTER

The speakers in this lecture series are architects who use unconventional materials in inventive ways; in fact, the working theme for the series was "inventiveness." I decided to try and make the poster in the same spirit that the architects brought to their work, and I arrived at the idea of constructing the type out of silk flowers. After a number of trips to craft stores, I bent the flowers into letterforms and scanned them directly, each letter as one scan. The structure of the poster is based on the grid that the images of the letters made.

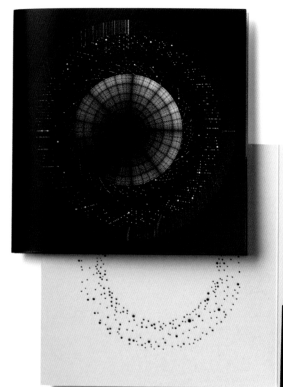

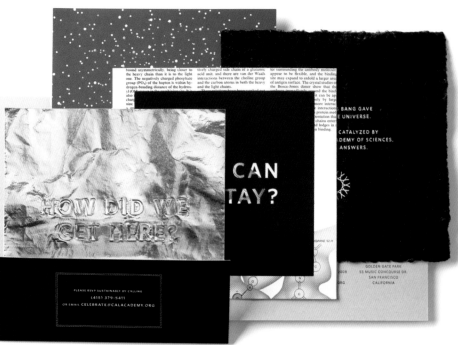

CHAPTER 06

CALIFORNIA ACADEMY OF SCIENCES OPENING DINNER INVITATION

DESIGN FIRM
Elixir Design

LOCATION
San Francisco, California, USA

ART DIRECTOR
Jennifer Jerde

DESIGNERS
Aine Coughlan, Syd Buffman

CLIENT
California Academy of Sciences

MATERIALS
Laser die-cut cover, silkscreen Nori Seaweed, letterpressed aluminum foil and 100% recycled chipboard, reused pages from *Scientific American* magazines

PRINTER
Press Arts

Since 1853, the California Academy of Sciences has been dedicated to exploring, explaining, and protecting the natural world. To herald the reopening of the facility in 2008, the Academy planned an opening gala—The Big Bang—to benefit education programs, and two dinners to honor the leaders and philanthropists whose vision and generosity had made the new building a reality. Elixir's designs for the three events reinforced the new Academy brand and invited recipients to come closer, asking "How did we get here? How can we stay?"

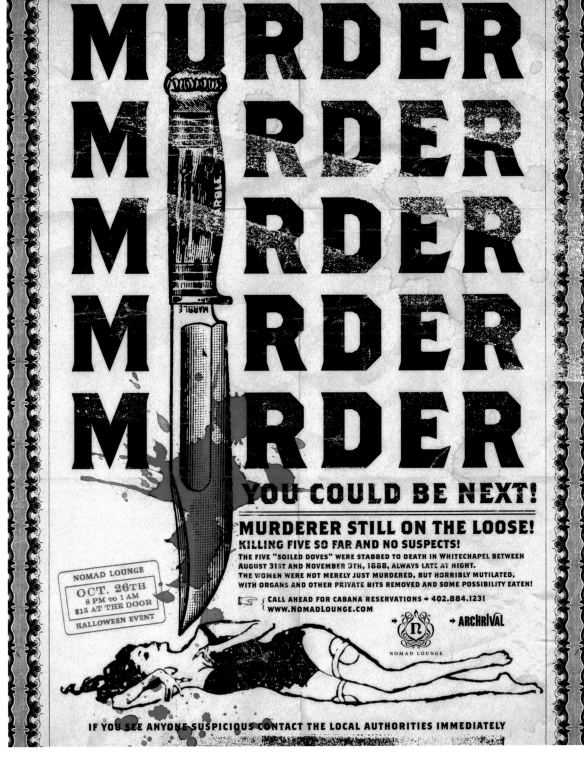

DESIGN FIRM
Archrival

LOCATION
Lincoln, Nebraska, USA

ART DIRECTOR
Joel Kreutzer

DESIGNER
Joel Kreutzer

CLIENT
Nomad Lounge

MATERIALS
Tea-stained paper, pen, ink,
hand stamp, fake blood

CHAPTER

06

NOMAD LOUNGE HALLOWEEN PARTY

This was a promotional piece done for a Halloween event at the Nomad Lounge, known for over-the-top parties. The theme for the party was Jack the Ripper. The promotional materials were designed to emulate old wanted posters posted by the Scotland Yard, and hand-written letters similar to the ones that the killer used to taunt the police. The materials were printed on tea-stained papers, folded and tattered to look vintage. The posters were tacked up with nails and knives around the bar, and blood splattered as a finishing touch.

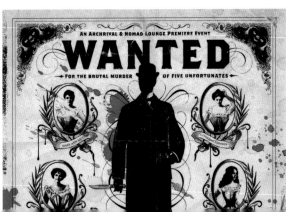

DESIGN FIRM
TOKY Branding + Design

LOCATION
St. Louis, Missouri, USA

ART DIRECTOR
Eric Thoelke

DESIGNERS
Jay David, Katy Fischer

CLIENT
Art Fix

MATERIALS
Wallpaper, paint chips,
silkscreen, letterpress

CHAPTER

06

ART FIX

Rebuilding Together–St. Louis—an organization providing low-income homeowners with free repair work—asked TOKY to create the promotional materials for its fundraiser/art auction event entitled Art Fix. We embraced the organization's mission: a DIY mentality that promotes the repurposing and reuse of materials. We silkscreened posters onto repurposed wallpaper to promote the event and then letterpress printed the event tickets onto various paint chips.

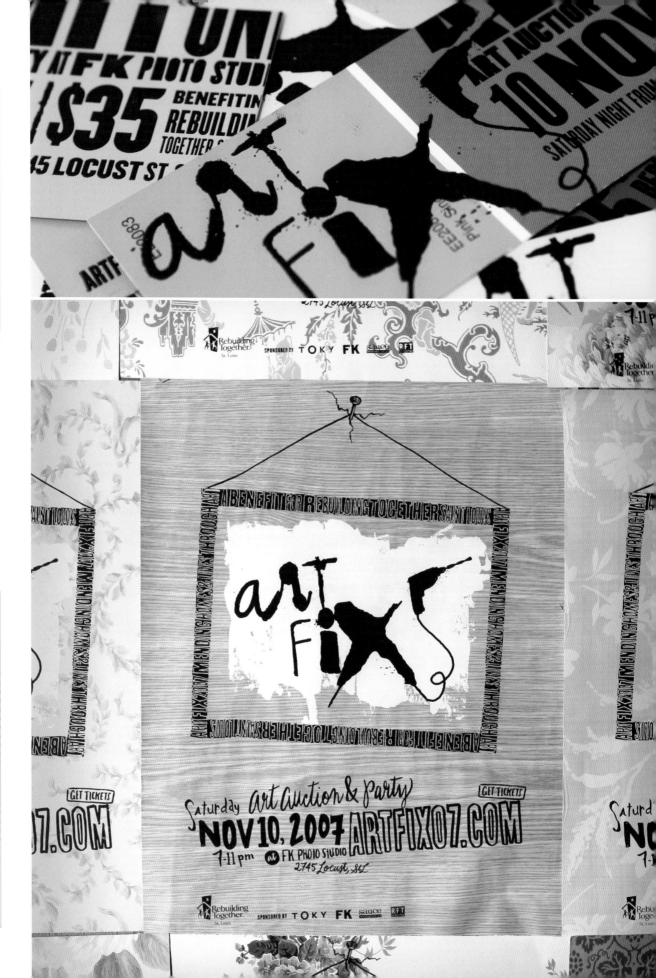

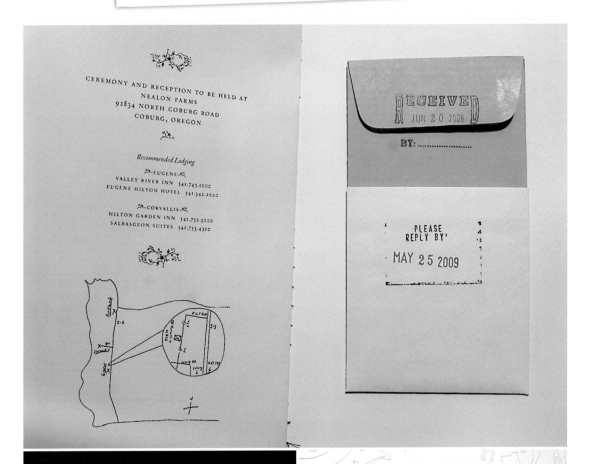

JUNE 20, 2009

KINDLY RESERVE THIS EVENING
FOR THE MARRIAGE OF
ELLYN CATHERINE MARBLE CANFIELD
TO ANDREW DENNIS NEALON
ON NEALON FARMS IN COBURG, OREGON.

PLEASE HOLD

JUN 20 2009

FORMAL INVITATION TO FOLLOW.

æ

CEREMONY AND RECEPTION TO BE HELD AT
NEALON FARMS
92834 NORTH COBURG ROAD
COBURG, OREGON

Recommended Lodging

EUGENE
VALLEY RIVER INN 541-743-1000
EUGENE HILTON HOTEL 541-342-2000

CORVALLIS
HILTON GARDEN INN 541-752-5000
SALBASGEON SUITES 541-753-4320

RECEIVED
JUN 20 2009

BY:

PLEASE
REPLY BY
MAY 25 2009

THE WEDDING
of
ANDREW & ELLYN

WE WILL SHARE THIS ROAD WE WALK
AND MIND OUR MOUTHS AND BEWARE OUR TALK
'TILL PEACE WE FIND TELL YOU WHAT I'LL DO
ALL THE THINGS I OWN I WILL SHARE WITH YOU
IF I FEEL TOMORROW LIKE I FEEL TODAY
WE'LL TAKE WHAT WE WANT AND GIVE THE REST AWAY
STRANGERS ON THIS ROAD WE ARE ON
WE ARE NOT TWO WE ARE ONE.

From The Kinks' "Strangers"

DESIGN FIRM
Ashley Stevens

LOCATION
Brooklyn, New York, USA

**ART DIRECTOR/
DESIGNER**
Ashley Stevens

CLIENT
Andrew & Ellyn Nealon

MATERIALS
Adobe InDesign,
rubber stamps, thread

CHAPTER

06

WEDDING INVITATION

Handmade wedding invitation for two friends, who are both avid writers. The invitations were first created digitally using clean, classical typography. Stamps were created, and the invitations were hand-stitched to evoke the feel of a book and library cards. The handmade elements were essential to give the invitations the DIY feel that was infused throughout the entire wedding and to provide an appropriate contrast to the traditional typographic treatments.

DESIGN FIRM
Cblakemore Design

LOCATION
Newington, Connecticut, USA

**ART DIRECTOR/
DESIGNER**
Christina Blakemore

CLIENT
Megan Frazer,
Nathan Blakemore

MATERIALS
Letterpress, wood veneer,
brass name plate, thread

CHAPTER

06

FRAZER & BLAKEMORE
WEDDING INVITATION

This is a custom letterpress invitation. Most important to the client was that the final design would reflect both of their passions. The card-catalog drawer design was created to reference the bride's background as a writer and librarian. A hand-finished wood veneer with a brass nameplate was used for the cover and spoke for the groom's passion for woodworking. The ceremony information page was designed to read as if it were a card-catalog card, and to stay true to the tradition, it was typed on a typewriter then made into a polymer plate for letterpress. The RSVP was a library book return card with the return date as the RSVP By date. A map of the area was used as a pocket to hold the directions.

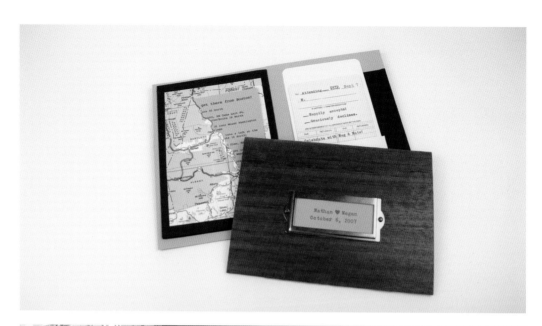

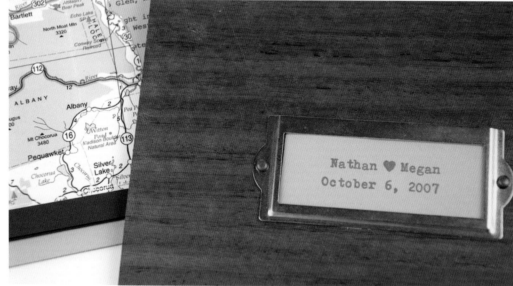

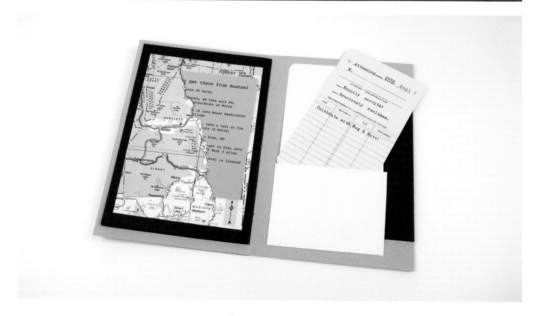

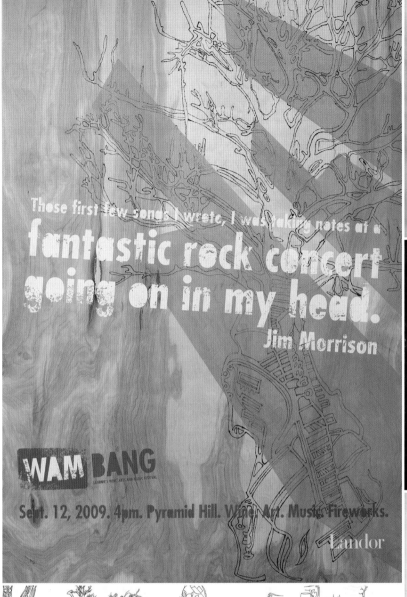

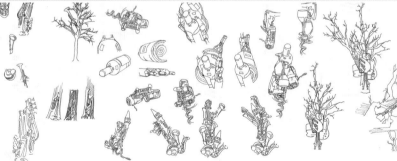

Landor was providing its employees with a great evening of music, wine, art and fireworks, and I wanted a design that merged the main themes of the event. I created a series of illustrations that combined these elements in a sculptural way. I decided to use wood burning to bring to life the firework element of the event and to allow the sculptural illustrations to jump off the wood panels that acted as my canvas. I painted the graphic shapes with acrylic to minimize the cost. Screenprinting was used to apply the words onto the boards.

DESIGN FIRM
Landor Associates

LOCATION
Cincinnati, Ohio, USA

ART DIRECTOR
Steve McGowan

DESIGNER
Elizabeth Bone

CLIENT
Landor Associates

MATERIALS
Multimedia

PRINTER
The BLDG, Fanattik,
Arnold Printing

WAMBANG: LANDOR'S WINE, ARTS AND MUSIC FESTIVAL

CHAPTER 06

DESIGN FIRM
Sagmeister Inc.

LOCATION
New York City, New York, USA

ART DIRECTOR
Stefan Sagmeister

DESIGNERS
Richard The, Joe Shouldice

CLIENT
Experimenta, Urban Play

MATERIALS
250,000 Eurocents

CHAPTER

06

OBSESSIONS MAKE MY LIFE WORSE AND MY WORK BETTER

I rarely obsess about things in my private life. I fail to care about the right shade of green for the couch, the sexual secrets of an ex-lover or the correct temperature of the meeting room AC. I don't think I miss much. However, I do obsess over our work and think that a number of our better projects came out of such an obsession.

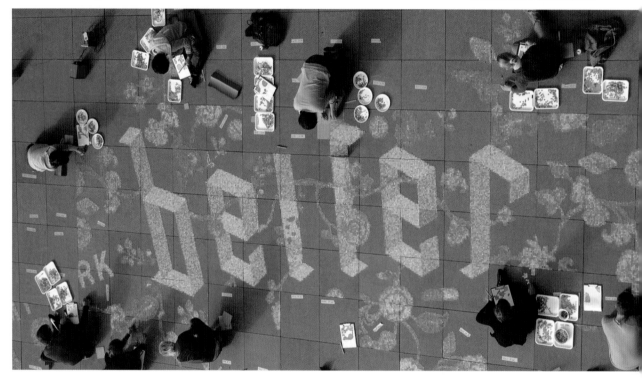

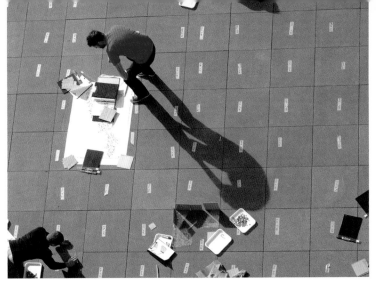

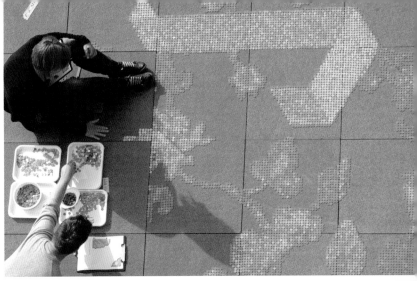

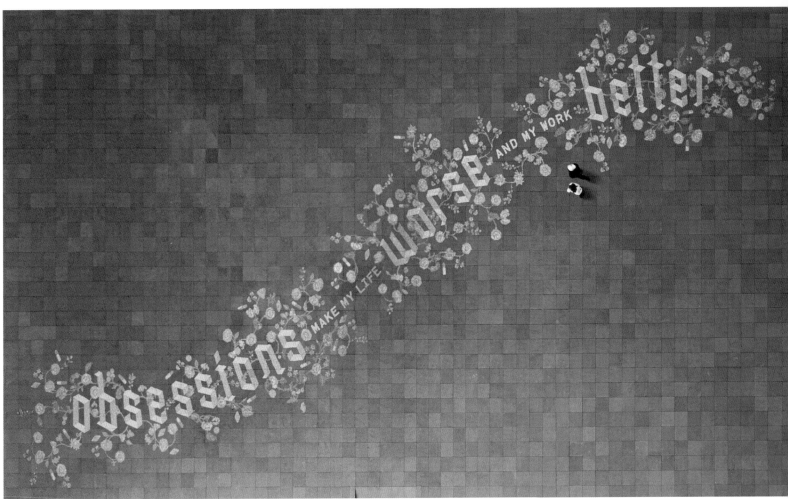

DIGGING DEEPER

On September 13, 2008, Sagmeister Inc. began the installation of 250,000 Eurocents on Waagdragerhof Square in Amsterdam. Over the course of eight days and with the help of more than one hundred volunteers, the coins were sorted into four different shades and carefully placed over this 300 sqm area, according to a master plan. The coin mural spelled out the sentence "Obsessions make my life worse and my work better." After completion, the coins were left free and unguarded for the public to interact with. Fewer than twenty hours after the grand opening, a local resident noticed a person bagging the coins and taking them away. Protective of the design piece the person had watched being created, he called the police. After stopping the "criminal," the police—in an effort to "preserve the artwork"—swept up every remaining cent and carted them away.

— Stefan Sagmeister

DESIGN FIRM
CO:Lab

LOCATION
Hartford, Connecticut, USA

**ART DIRECTOR/
DESIGNER**
CO:Lab

CLIENT
Sunrise Pictures

MATERIALS
Iron, iron transfer
paper, sandpaper

CHAPTER

06

SUNRISE PICTURES
POSTER MAILER

Direct-mail promotion sent out by Sunrise Pictures. Using iron-on transfers, the images were adhered to 8" plywood. Then the posters were sanded by hand to give them the appropriate amount of wear and tear. They were sent out via the mail and were hang-ready once delivered.

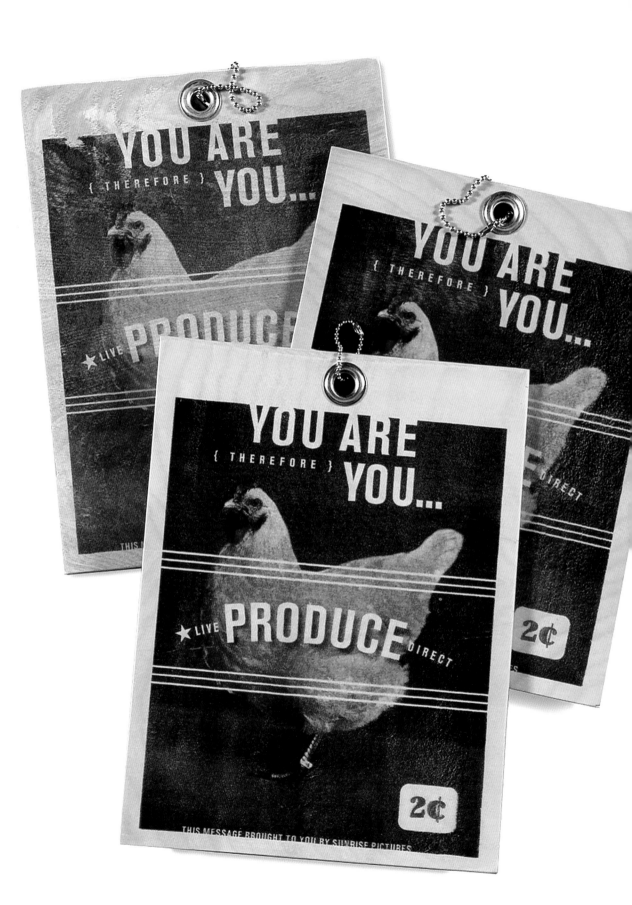

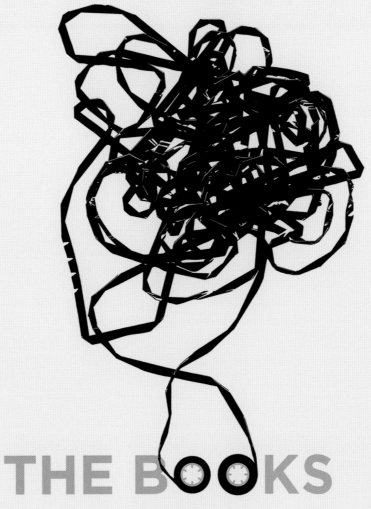

THE BOOKS

GREAT AMERICAN MUSIC HALL

APRIL 17, 2006

W/ CLOGS

The Books write their own compositions and songs, combining them with samples of found sound ephemera. Image was created by taking apart a cassette and unraveling it on my scanner in a few random ways.

DESIGN FIRM
The Small Stakes

LOCATION
Oakland, California, USA

ART DIRECTOR/DESIGNER
Jason Munn

CLIENT
The Books,
Great American Music Hall

MATERIALS
Cassette tape, Illustrator,
screenprinted by hand

PRINTER
Jason Munn

THE BOOKS' POSTER

CHAPTER 06

DESIGN FIRM
Sagmeister Inc.

LOCATION
New York City, New York,
USA

ART DIRECTOR
Stefan Sagmeister

DESIGNER
Mark Pernice

CLIENT
Anni Kuan

MATERIALS
Clothespins

CHAPTER

06

ANNI KUAN MAILER

Many, many clothespins were used. More than six hundred pins were laid on the pavement in circular array and then were photographed being washed away. Vintage clothespins were included to make the A in Anni.

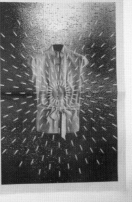

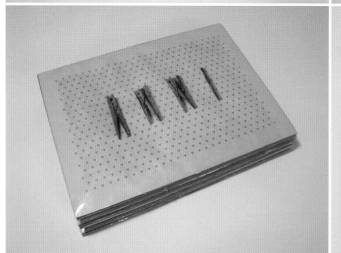
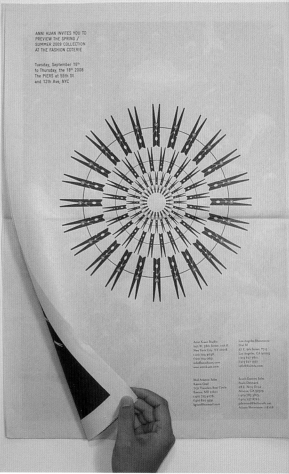

ANNI KUAN INVITES YOU TO
PREVIEW THE SPRING /
SUMMER 2009 COLLECTION
AT THE FASHION COTERIE

Tuesday, September 16th
to Thursday, the 18th 2008
The PIERS at 55th St
and 12th Ave, NYC

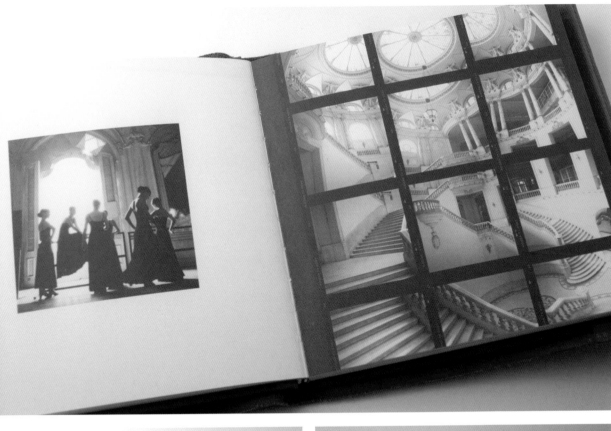

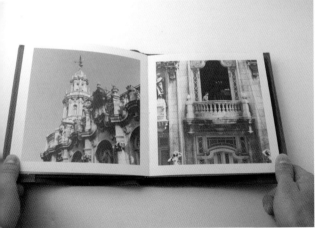

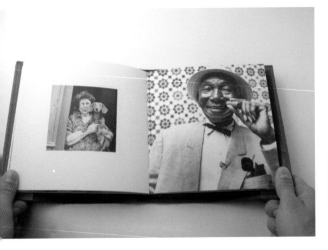

DESIGN FIRM
Jock McDonald

LOCATION
Santa Fe, New Mexico, USA

ART DIRECTOR
Jock McDonald

CLIENT
Jock McDonald

MATERIALS
Wood, leather, branding iron

CHAPTER

06

CUBA BOOK

The creation of an experience in book form is a thrilling journey in its own right. It can never replicate the experience, because it is its own experience.

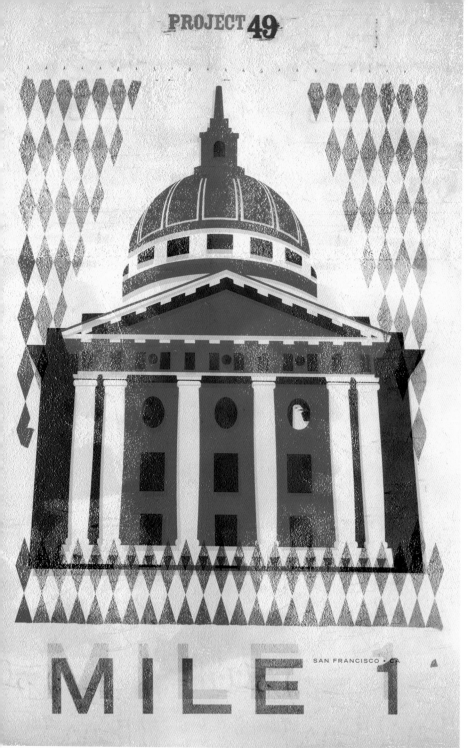

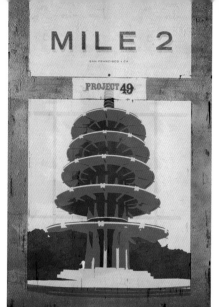

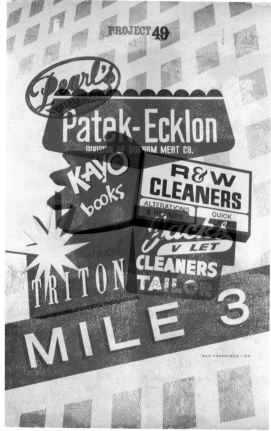

DESIGN FIRM
JTP Design

LOCATION
San Francisco, California, USA

ART DIRECTOR/DESIGNER
Jeremy Payne

MATERIALS
Handcut linoleum, photographs, bits of metal, wood and rock, Illustrator, Photoshop

PRINTER
Thurston

Project 49 is an exploration and interaction with the city of San Francisco. It's taking a look at those landmark postcard images of places that have been circulating for decades and finding something new. San Francisco is bustling and diverse, beautiful and filthy. Using handcrafted elements and objects found along the way to help create these posters is the best way to share, explore and represent the particular areas each poster represents. These elements help us see familiar things and places for the first time, again.

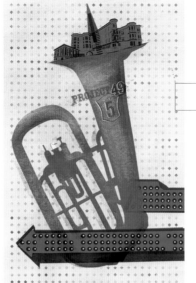

DIGGING DEEPER

The process for creating the posters is quite straightforward. I begin by walking the mile of the San Francisco 49 Mile Scenic Drive that will be featured. Along the way I photograph everything from the big classic views to micro shots of peeling paint, graffiti, the sidewalk, or anything else that seems significant. I'll also collect bits of interestingness such as paper, metal and bits of wood along the way. Back at the studio, the booty is spread out, arranged, scanned, drawn on, painted or whatever else needs to happen to build the image and communication that eventually winds up in Photoshop and Illustrator, and on the final poster.

— Jeremy Payne

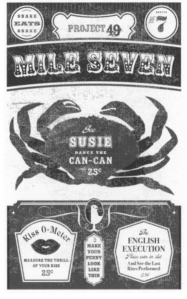

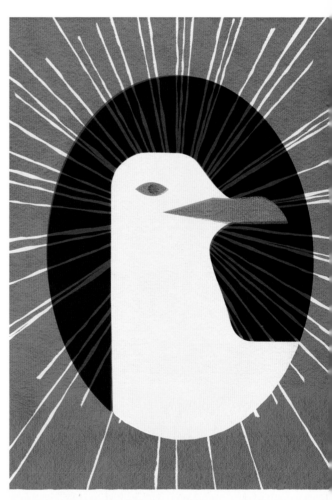

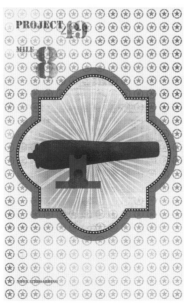

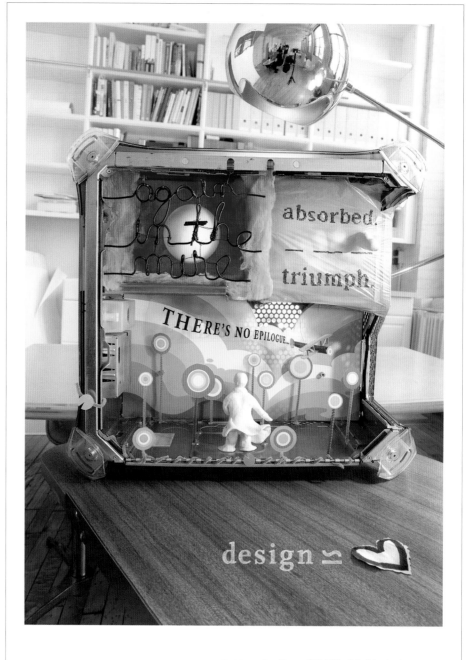

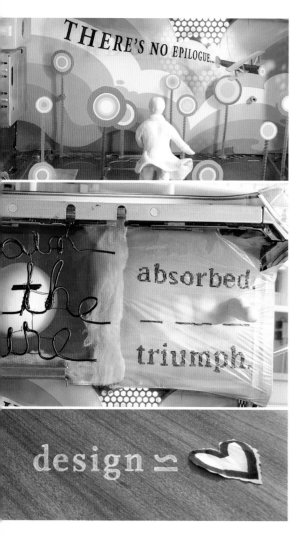

**DESIGN IS LOVE
POSTER**

DESIGN FIRM
CO:Lab

LOCATION
Hartford, Connecticut, USA

ART DIRECTOR/DESIGNER
CO:Lab

CLIENT
Design Is Love

MATERIALS
Apple G4 Tower, clay, pipe
cleaner, paper, balloons, plastic,
insulation, wire, cardboard, tape,
blood, sweat, tears of joy

PRINTER
Thames Printing Company

This poster was created as the first in a series of
materials to promote creative exploration. A decon-
structed Apple Power Mac G4 was handcrafted into
a fantasy world using a myriad of elements including
clay, balloons, pipe cleaner, insulation, wire, paper,
plastic and anything else we could get our hands
on. By making this poster interactive in the form of
a comic haiku, we invite the viewers to provide the
piece with alternate meanings.

The main poster:

MYERS SCHOOL OF ART ❖ THE UNIVERSITY OF AKRON

ALUMNI FOCUSED EXHIBITION 2006

COMING HOME

AUGUST 7 – SEPTEMBER 1

EMILY DAVIS GALLERY

FEATURING

Josh Azzarella ❖ Dragana Crnjak ❖ Brittyn DeWerth

Joe Galbreath ❖ Allen Harrison

Jody Hawk ❖ Nichola Kinch ❖ Joe Nanashe

Kevin Shook ❖ Angie White

Panel Discussion ✕ Wednesday August 30 ✕ 6pm ✕ Life After Myers School of Art

DESIGN FIRM
Massive Graphic

LOCATION
Baltimore, Maryland, USA

DESIGNERS
Brittyn DeWerth,
Joe Galbreath

CLIENT
Myers School of Art,
The University of Akron

MATERIALS
Rubber, screenprint

PRINTER
Joe Galbreath

CHAPTER

06

**COMING HOME
ALUMNI EXHIBITION**

Created for an alumni show comprised of the top students from the past decade, the material used for this screenprinted poster and banner set alludes to Akron's reputation as the rubber capital. The cross-stitch typography juxtaposed against the industrial material complements the working-class, Midwestern city.

DESIGN FIRM
Kuro Interactive

LOCATION
Long Beach, California, USA

ART DIRECTOR
Justin Dionisio

DESIGNER
Serena Chang

CLIENT
Frias Holding Co.

MATERIALS
Letterpress, wood, vintage curios, cast iron, burlap, leather

CHAPTER

A COWBOY'S DREAM BED & BREAKFAST IDENTITY AND COLLATERAL

The handmade element was so crucial to the development of this identity/collateral project because, to complement the intentionally intricate aesthetic of the property itself, each item needed to have a unique sense of tradition and heritage. We wanted each piece to be a keepsake in its own right. Hand setting the fonts, hand staining the wood, hand illustrating all of the design elements, and the slight imperfections that resulted are what give the system a human quality. Combining the use of wood, engraving machinery, burlap, letterpress, metal, iron, paper and vintage curios, we feel we were able to charmingly communicate an air of history while instilling a fresh take on "Old West" nostalgia.

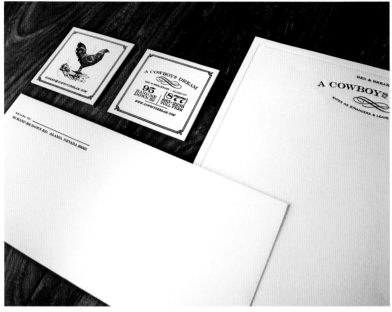

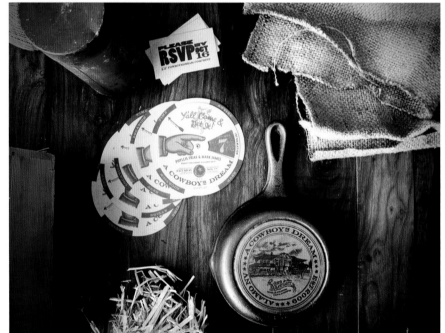

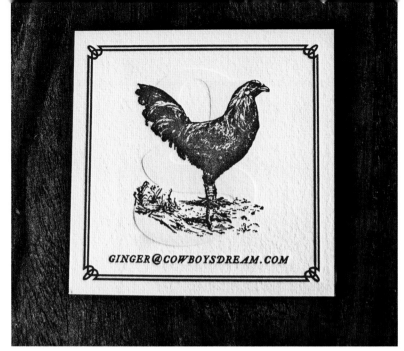

GINGER@COWBOYSDREAM.COM

RETURN TO:
95 HAND ME DOWN RD. ALAMO, NEVADA 8900

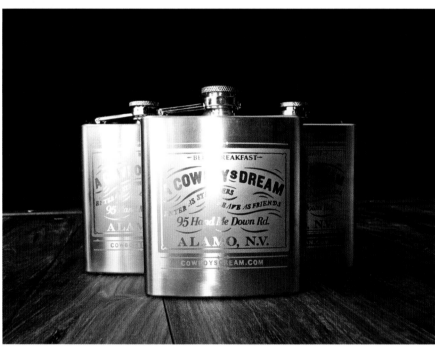

-BED & BREAKFAST-
A COWBOYS DREAM
ENTER AS STRANGERS LEAVE AS FRIENDS
95 Hand Me Down Rd.
ALAMO, N.V.
COWBOYSDREAM.COM

GS SUNSET WILL BE AT:

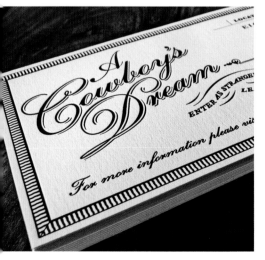

A Cowboy's Dream
ENTER AS STRANGERS LE
For more information please vis

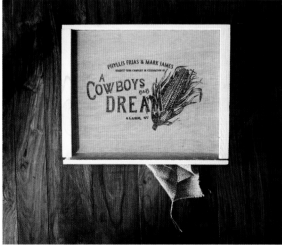

PHYLLIS FRIAS & MARK JAMES
REQUEST YOUR COMPANY IN CELEBRATION OF
A Cowboys and DREAM
ALAMO, NV

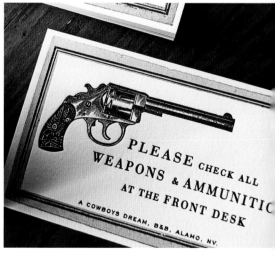

PLEASE CHECK ALL
WEAPONS & AMMUNITIO
AT THE FRONT DESK
A COWBOYS DREAM, B&B, ALAMO, NV.

CONTINUED FROM PAGE 170

EMBRACING INGREDIENT X

Take note: a human being has been here. *Each succeeds in establishing that perfect imperfection, in creating a thread of human connection.*

In addition, you'll notice here how the hand is beginning to enter—or, more accurately, re-enter—previously underutilized realms, as designers begin recognizing this power of ingredient X and including it in their portfolios. Again, I cite two examples: Dallas branding firm Brand Hatchery's brilliant holiday video, made using only brown and white hen eggs laid out, stop-motion style, into an eight-square-foot grid. The effect of seeing something so lovely and heartfelt emerge from such a simple medium—I'm trying to incorporate the word eggs-ilated here—renews my faith that designers will always rise (or hatch, I suppose) to the occasion. Likewise, Brooklyn designer Tonya Douraghy's frantic music video, "First Day," by the English rock band Futureheads, combines hand-drawn type with the skills of stop-motion to create a three-minute orgasm of textual overload. Awesome.

This is just the beginning. Handmade design is a cultural and professional reaction to a number of developments: first, to the overwhelming power of technology; second, to global economic austerity; and third, to the lack of genuine tactility—to the human touch we're all missing so much. Handmade communicates deeper emotion and passion, an agreement that beyond aesthetics, beyond clean lines and smooth surfaces, design is about human connection and communication between two entities. Handmade marks the place where all these trends intersect, and Fingerprint No. 2

07

CDA
GALLERY

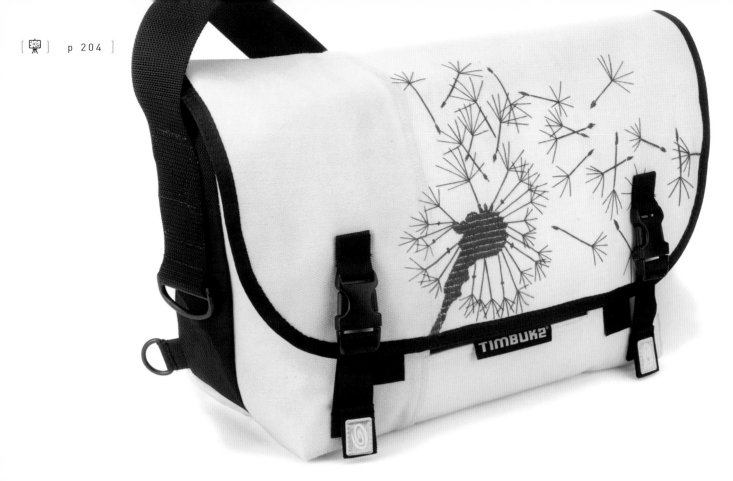

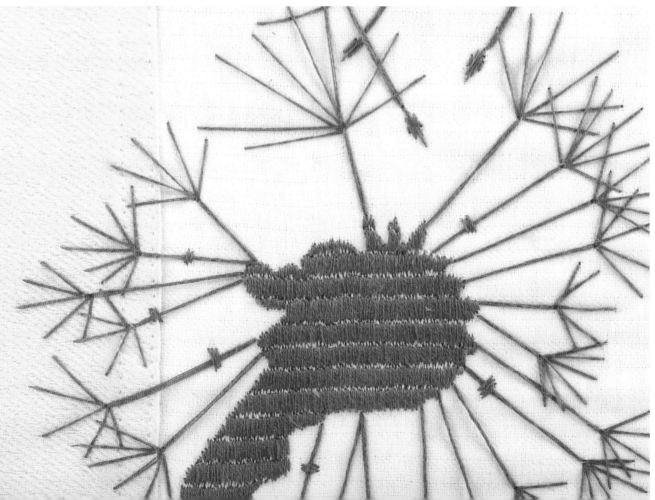

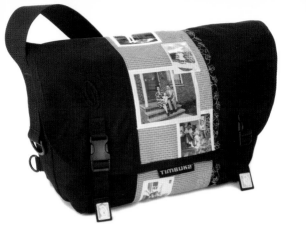

DESIGN FIRM
Chen Design Associates

LOCATION
San Francisco, California, USA

ART DIRECTOR
Joshua C. Chen

DESIGNERS
Kathrin Blatter, Max Spector,
Joshua C. Chen, Jennifer Tolo

CLIENT
Timbuk2

MATERIALS
Inks, paints, fabrics, thread,
needle, buttons, photographs

CHAPTER

07

PEACE BEGINS HERE
MESSENGER BAGS

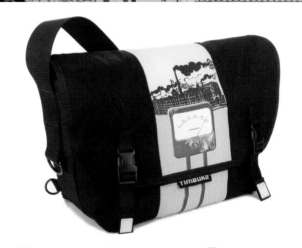

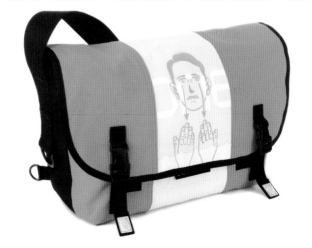

Based on our *Peace: 100 Ideas* book project, we designed and produced five one-of-a-kind messenger bags for Timbuk2's "Artist's Originals Program." Our custom bags were among other original designs auctioned off by Timbuk2 for as much as $500 each to support San Francisco Bay Area charities. Designer Kathrin Blatter re-interpreted by hand the artwork for these five bags using a variety of materials and methods—embroidery, silkscreen, spray paint, buttons, and even toothpick pointillism. The result is a diverse range of ways to express the message of peace, much in line with the approach for the original book project.

DESIGN FIRM
Chen Design Associates

LOCATION
San Francisco, California, USA

ART DIRECTOR
Joshua C. Chen

DESIGNER
Max Spector

CLIENT
HOW magazine

MATERIALS
Rubylith, X-Acto knife

CHAPTER

07

**HOW MAGAZINE
FEBRUARY 2007
COVER**

"I swear I smelled strawberry fruit roll-up," says designer Max Spector, after spending hours in extreme close-up with the rubylith, carefully hand-cutting out the *HOW* masthead and the plant illustration. In addition to conveying the experimental and exploratory nature of this issue on typography, for the first time *HOW* also needed to incorporate a gate-fold into the cover to reveal a two-page advertisment. Needless to say this posed an extra level of challenge for the design, but in the end, a strategically-placed "Are You Ready?" sticker along with questions designers might find themselves asking during the creative process allows the final design to communicate on many levels.

DESIGN FIRM
Chen Design Associates

LOCATION
San Francisco, California, USA

ART DIRECTOR
Joshua C. Chen

DESIGNER
Max Spector

MATERIALS
Hand-distressed laser prints, hand-cut letters, various textured and printed papers, digital

CHAPTER

07

2010 MOVING
ANNOUNCEMENT

Inspired in part by paper crafts and dioramas I constructed in grade school, the illustration reveals a wide-eyed, hopeful sensibility; the same spirit with which we approached our relocation. It expresses both the collective personality of our team (eager, approachable, unpretentious), and our approach to graphic design (idea-driven, playful, layered, detailed). As a minor bonus to those personally involved, the design also casts a subtle aspersion on our previous landlord, from whose dominion we were grateful to depart.

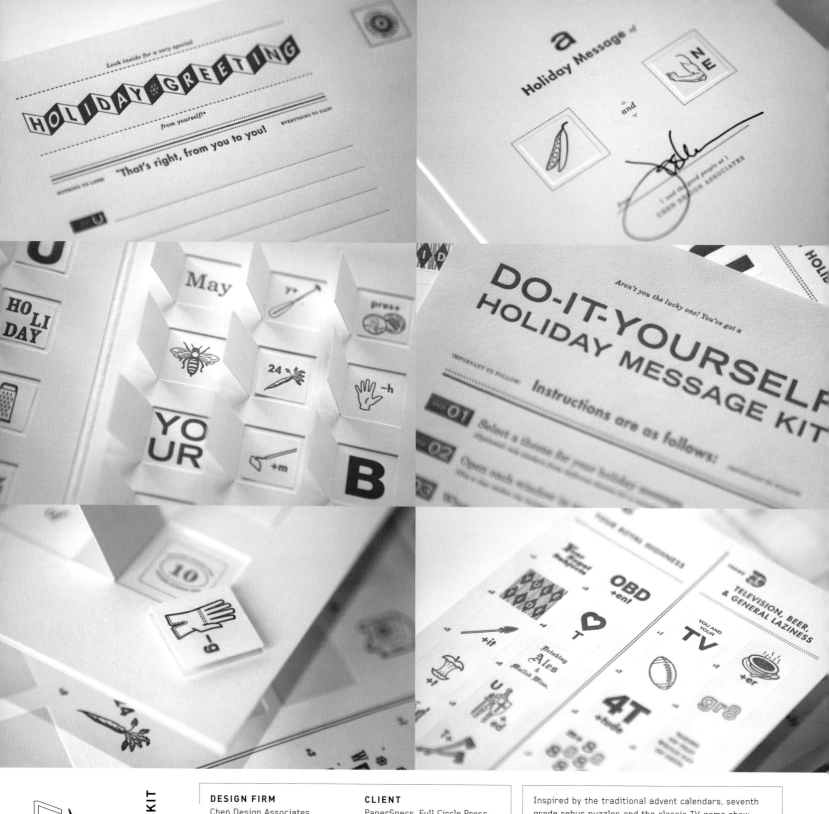

DO-IT-YOURSELF HOLIDAY MESSAGE KIT

DESIGN FIRM
Chen Design Associates

LOCATION
San Francisco, California, USA

ART DIRECTOR
Joshua C. Chen

DESIGNER
Max Spector

CLIENT
PaperSpecs, Full Circle Press, Chen Design Associates

MATERIALS
Label stock, Neenah paper, glassine envelope, custom die cut

PRINTER
Full Circle Press

Inspired by the traditional advent calendars, seventh grade rebus puzzles and the classic TV game show *Concentration*, CDA developed a "do-it-yourself" holiday message kit perfectly suited for the postmodern soul. We came up with five themes that people could select—from the more standard "happy holidays" to the quirky "television, beer & general laziness"—to customize their own holiday message, *à la* advent calendar, by opening a window each day and placing a sticker when prompted. At the end of the 24 days, a meaningful (or not so) message will appear.

DESIGN FIRM
Chen Design Associates

LOCATION
San Francisco, California, USA

ART DIRECTOR
Joshua C. Chen

DESIGNER
Max Spector

CLIENT
Stanford Lively Arts

MATERIALS
Label stock, blotter paper,
textured wrap, rubber stamp

CHAPTER

STANFORD LIVELY ARTS INVITATIONS

For several seasons, Stanford Lively Arts held a series of wine-tasting events in conjunction with certain performances as a way of thanking donors for their philanthropic support. Yet awareness and attendance were quite poor. With the invitations, we saw a previously untapped potential for the artwork, materials and production methods to create a more intimate sensibility—framing the events as opulent and exclusive but also highly personal. To this end, we employed hand-stamped elements, textured papers and letterpress printing. The results: increased visibility and buzz, a record-setting 30% response rate, and more funding for the arts.

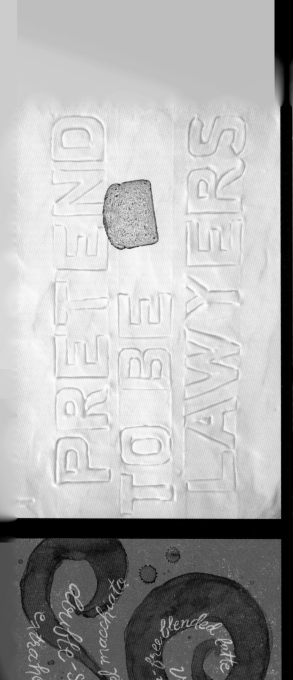

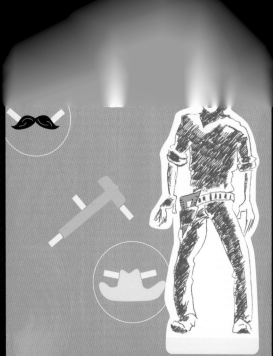

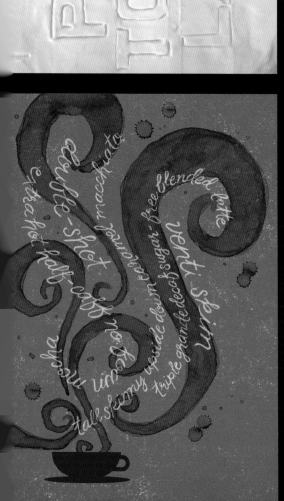

1

12

8

08 / 09

AIGA SF
STUDIO TOURS

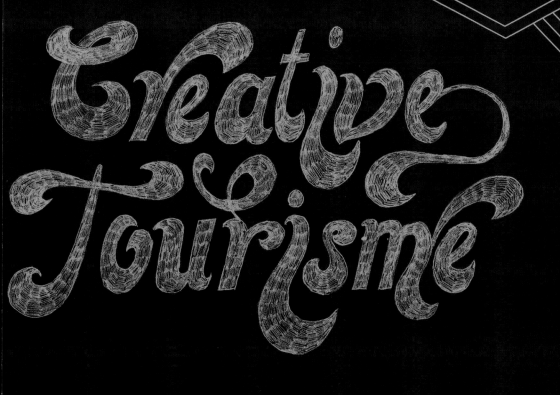

DESIGN FIRM
Chen Design Associates

LOCATION
San Francisco, California, USA

CREATIVE TEAM
Kathrin Blatter, Laurie
Carrigan, Jure Gavran,
Kathryn Hoffman, Vincent Lo,
Max Spector, Joshua C. Chen

CLIENT
AIGA San Francisco

MATERIALS
Coffee, margarine, pen,
pencil, paint, old coupons

CHAPTER

07

**CREATIVE TOURISME
EVENT COLLATERAL**

AIGA San Francisco tapped CDA to kickoff the 2008–09 studio tours as well as develop the theme and design. In order to highlight more than a list of studio names and dates, we collected fun, irreverent, little known facts from all twelve studios and designed a visual to represent each of them, using a variety of materials including margarine and coffee. Flatulent dogs not included. We dubbed the events "Creative Tourisme" and drew the logotype in pencil.

AIGA San Francisco invites you to Creative Tourisme (passports, shots and airport security not necessary). Pack your curiosity and openness to being inspired. Explore 12 of the Bay Area's most sought-after design studio destinations. Mutual intellectual stimulation and creative rejuvenation guaranteed.

10

CONTINUED FROM PAGE 202

EMBRACING INGREDIENT X

captures the best and brightest producers in the business.

A final illustration to make my point. When I was a little boy, growing up in Colorado, my parents took my siblings and me on a family vacation, a car trip deep into the American southwest. It was the 1960s, in summer; we were Celtic WASPs, and at some point we stopped at a Navajo reservation in northern Arizona where, in the air-conditioned shade of the gift shop, I passed over the leather-thonged tomahawks and rubber-skinned ceremonial drums to pick out a beaded Indian belt. The belt was a real beauty, hand-made, with a clinking brass buckle and an angular pixilated pattern of rich colors fashioned from small beads. Yet when I looked closer—and don't kids always look closer?—I noticed a flaw: one white bead sitting smack in the middle of a field of red ones, an interloper among the natives, a mistake. As a writer, looking back at the moment from the present day, the image is rich with metaphor: a white object out of place among the red ones. But back then I just thought it was a mistake. With a child's naïveté, I asked the woman at the counter: Did you notice this, here? I pointed to the misplaced bead. Slowly and politely, she explained to me how the beltmakers in her culture actually introduced such tiny defects purposely into their designs, not out of carelessness but out of humility and respect. To make something without flaws would be arrogant, narcissistic, she explained. Only deity can make something perfect.

... making stuff seems to feel particularly good.

Let me say that again: Only deity can make something perfect. In an age when perfection in design is so often defined by the satin, saccharine smoothness of digital tools, when anyone with a copy of InDesign can create a logo or a layout or a line of digital type, there's something comforting about the fact that handmade design is thriving, that it contains that je ne sais quoi, that ingredient X, that elevates it not so much above the computerized competition but into a different frequency, a universe of imperfect perfection. Because, while handmade may not make use of the latest software or most advanced digital tools, it does make use of the brain and the heart: the original software, and two tools designers carry—within themselves. Tools that give them have always carried—within themselves. Tools that give them a modern edge, without which it would be impossible to create meaningful, beautiful, perfectly imperfect, truly personal design.

DIRECTORY

MITRE AGENCY
306 East Market Street, Suite 2
Greensboro, NC 27401
(336) 230-0575
mitreagency.com
>> 090–091

MODERN DOG DESIGN CO.
7903 Greenwood Avenue North
Seattle, WA 98103
(206) 789-7667
moderndog.com
>> 056–060, 061, 062, 063

MOTORCYCLE GANG
Baltimore, MD
(330) 256-7539
>> 055

NATHANIEL ECKSTROM
81 Silver Street
Marrickville, NSW
New South Wales 2240
Australia
(612) 948-72700
nathanieleckstrom.com
>> 073

NEVER SLEEPING INC.
1203 E. Walnut Street #C
Columbia, MO 65201
(816) 560-7102
neversleeping.com
>> 047

NO WORK/NO PLAY
130A Langton Street
San Francisco, CA 94103
(415) 829-2854
noworknoplay.com
>> 032, 033

NOTHING: SOMETHING: NY
242 Wythe Avenue Studio #7
Brooklyn, NY 11211
(646) 221-9972
nothingsomething.com
>> 108–109

NOTION FARM
375 Alabama Street Suite 228
San Francisco, CA 94110
(415) 626-2990
notionfarm.com
>> 121

OFFICE: JASON SCHULTE DESIGN INC
1060 Capp Street
San Francisco, CA 94110
(415) 447-9850
visitoffice.com
>> 127, 146–147

PLAZM & STUDIO J
P.O. Box 2863
Portland, OR 97208
(503) 528-8000
plazm.com
>> 031, 068–069

PORRIDGE PAPERS
1422 South Street
Lincoln, NE 68502
(402) 742-5415
porridgepapers.com
>> 114

PYLON
204-171 East Liberty Street
Toronto, ON M6K 3P6
Canada
(416) 504-4331
pylon.ca
>> 132

ROHNER LETTERPRESS
3729 N Ravenswood #117
Chicago, IL 60613
(773) 248-0800
rohnerletterpress.com
>> 067, 133

SAGMEISTER INC.
206 West 23rd Street, Fl 4
New York, NY 10011
(212) 647-1789
sagmeister.com
>> 084–085, 190–191, 194

SHASTA GARCIA & DAVID MURO II
872 Rhode Island Street
San Francisco, CA 94107
(530) 519-7776
shastablasta.com
>> 110

SPARKS
21 Whiston Road
London E2 8EX
44 (020) 749-6969
sparks-studio.com
>> 182

STOLTZE DESIGN
15 Channel Center St. #603
Boston, MA 02210
(617) 350-7109
stoltze.com
>> 043, 050

STUDIO SONDA
Pazinska 15
52 440 Porec
Croatia
(385) 52-433-613
www.sonda.hr
>> 157

SWINK
106 East Doty, Suite 200
Madison, WI 53703
608.442.8899
swinkinc.com
>> 034–035, 036, 037, 038, 039

TASTE INC.
18-10 Minami-machi, Kyashima
Neyagawa-city
Osaka
572-0825 Japan
072-824-5538
Tasteinc.net
>> 020–021, 022, 023

TAXI STUDIO
93 Princess Victoria Street
Clifton, Bristol BS8 4DD
England
44 (01179) 735151
taxistudio.co.uk
>> 076, 172–173, 174

THE BRAND HATCHERY
3906 Lemmon Avenue #222
Dallas, TX 75219
(214) 252-1690
brandhatchery.com
>> 176–177

THE SMALL STAKES
3878 Whittle Avenue
Oakland, CA 94602
(510) 507 9466
thesmallstakes.com
>> 138, 139, 140–141, 193

TOKY BRANDING + DESIGN
3001 Locust Street Fl 2
St Louis, MO 63103
(314) 534-2000
toky.com
>> 066, 082, 086, 092, 116, 186

TOMORROW PARTNERS
2332 5th Street
Berkeley, CA 94710
(510) 644-2332
tomorrowpartners.com
>> 083

TONYA DOURAGHY
327 14th Street #2
Brooklyn, NY 11215
(408) 425-7322
thedyelab.com
>> 071

TRINE DESIGN ASSOCIATES
1008, Toa Payoh North
#05-14/15
Singapore 318996
65 (6476) 4533
trine.com.sg
>> 093

TYPE B PRESS
3175 Puritan Avenue
Lincoln, NE 68502
(402) 560-5011
bennettholzworth.com
>> 113, 122

VALERIE JAR
Salt Lake City, UT
(801) 673-0185
valeriejar.com
>> 145

VIDA SACIC
919 N. Pennsylvania St. #301
Indianapolis, IN 46204
(317) 654-3640
vidasacic.com
>> 178–179, 180–181

VOICE
852 Kulani Street
Honolulu, HI 96825
(808) 395-0089
>> 052–053, 054

VOLUME INC.
2130 Harrison Street, Suite B
San Francisco, CA 94110
(415) 503-0800
volumesf.com
>> 094–095

WINK, INCORPORATED
126 N. 3rd Street #100
Minneapolis, MN 55401
(612) 455-2642
wink-mpls.com
>> 160–161

WORKTODATE
York, PA
(717) 683-5712
worktodate.com
>> 046

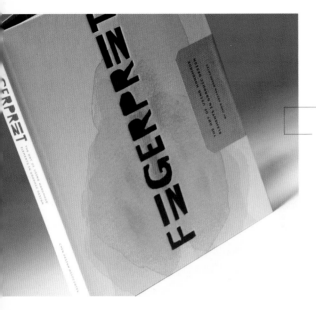

IF YOU LIKED *Fingerprint No. 2,*
CHECK OUT THE ORIGINAL
Fingerprint!

Design is at a turning point. Our infatuation with—and the backlash against—technology is over. Today's best designers have learned to embrace its advantages and think beyond its limitations by combining the power of the computer with the tactile qualities of handmade elements.

===== Inside this book, you'll find examples of work that showcase a variety of design methods, including mixed media, illustration, letterpress, screenprinting and collage. You'll find inspiration in examples from outstanding designers and see how traditional elements can make a more powerful statement than anesthesized computer-only work. *Fingerprint* also includes insightful essays on the power of the handmade by Debbie Millman, Jean Orlebeke, Jim Sherraden, Martin Venezky and Ross Macdonald.

===== The projects in this book are beautiful, technical, simple, layered and powerful. Explore them page by page.

#Z0344, 176 pages, hardcover, ISBN: 978-1-58180-871-1

Find this book and many others at MyDesignShop.com or your local bookstore.

Special Offer *From HOW Books!*

You can get 15% off your entire order at MyDesignShop.com! All you have to do is go to **www.howdesign.com/fingerprint2offer** and sign up for our free e-newsletter on graphic design. You'll also get a free digital download of the latest issue of *HOW* magazine.